VLL e4 Mul

B7973

D1392870

KENT·INSTITUTE
OF·ART·&·DESIGN
LIBRARY

eady

Book No. B7973. Class No./Mark 759.2 MUL
PO1
This book is to be returned on or before the last date
stamped below.

WITHDRAWN

31. MAR 04		

C11384

Mulready

By Marcia Pointon

A book with catalogue,
published to accompany the exhibition
William Mulready: 1786–1863
organised to celebrate the bicentenary
of the artist's birth, at the
Victoria and Albert Museum, London,
1 July–12 October 1986,
continuing at the National Gallery of Ireland, Dublin,
and at the Ulster Museum, Belfast,
Autumn/Winter 1986/87

Victoria and Albert Museum

For Ray Watkinson

FRONT COVER Detail from Plate XXXVI BROTHER AND SISTER 1835–6
Victoria and Albert Museum (cat. 114)

Published by the Victoria and Albert Museum, 1986
Copyright © Marcia Pointon, 1986

ISBN 1 85177 057 7

Photography by Ian Jones

Designed by Tim Harvey

Typeset in Monophoto Van Dijck 203
and printed by Jolly & Barber Ltd, Rugby, Warwickshire

Contents

FOREWORD

I am delighted that the Victoria and Albert Museum has organised the most important exhibition yet of the work of William Mulready, and published this major study and catalogue by Dr Marcia Pointon of the University of Sussex. For several reasons: the V&A holds the most comprehensive collection of this Irish painter's work, due to the generosity of his great friend, John Sheepshanks; Mulready lived within walking distance of the V & A and was a friend of the Museum's founder Director, Sir Henry Cole. It is also the bicentenary of William Mulready's birth.

But above all this book, and the exhibition it accompanies, follows an increasing tendency within the V&A to examine the role and purpose of the artist, to look not only at his painterly or decorative brilliance, but the view of his times and the prevailing social attitudes that the artist reflects. Mulready's paintings speak volumes for his prejudices, about women, rural life and childhood, and Dr Marcia Pointon, in examining anew these attitudes, reveals the social and historical context in which Mulready's oeuvre must be set to be fully understood. But Mulready's art can be appreciated simply for the charm and originality of his images of childhood, of his romantic genre scenes. The paintings in the exhibition and the illustrations in this book show a master of composition, a painter who has conquered the problems of presenting the everyday, the quizzical. His arrangements of figures in landscape are sometimes mysterious, sometimes perverse, always arresting.

If this book and exhibition lead to a new generation of victims of Mulready's charm and enchanting rural world it will have succeeded, and succeeded magnificently. Dr Marcia Pointon deserves our gratitude for her painstaking insight that opens our eyes to a once neglected genius.

SIR ROY STRONG
DIRECTOR, VICTORIA AND ALBERT MUSEUM

ACKNOWLEDGEMENTS

Brighton 1986

I first began to be interested in Mulready when I was a Research Fellow at the Barber Institute of Fine Arts in the University of Birmingham in 1973. I owe a great debt to Professor Hamish Miles for his encouragement at that time and on many occasions since; to my former colleagues at Birmingham and to my family. Without the generous cooperation of Mulready's descendants and the descendants of his immediate associates and patrons I could not have advanced with my researches. I am especially grateful to Mr John Harrison, Mrs Everel Wood, Mr Brian Stone, Mr John Stone, Mr Tim Stone, Mrs W.L. Townsend, Mr Peter Mulready, Mrs Joan Browne-Swinburne, Mrs Joan Linnell-Ivimy, Lord Lambton and the Earl of Dartmouth. I have had fruitful and extremely helpful discussions with John Barrell, David Blayney Brown, Katherine Crouan, Peter Cunningham, Celina Fox, Joany Hichberger, Ben Johnson and with my graduate students Paul Barlow, Lewis Johnson and Colin Trodd. John Gage kindly gave advice while John Murdoch's extensive knowledge of the period and his unstintingly generous disposal of his time in reading the whole of this text in manuscript have been of inestimable value to me. The book is dedicated to Ray Watkinson who, over many years, has not only generously made available to me his library, but has (whilst not always agreeing with me) unfailingly been willing to talk about nineteenth-century art with which he has a long, extensive and intimate acquaintance. What is written in the following text is, however, my responsibility alone.

In gathering together the material for this book and in preparing the exhibition, I have received assistance from the following individuals and institutions to whom I would like to address my warm thanks: Eric Adams; Marjorie Allthorpe-Guyton; the Artists' General Benevolent Institution; Anthony Acheson; J.A. Avery; the Ashmolean Museum; Professor Ivor Batchelor; Baring Brothers & Co. Ltd; the late Sir John Betjeman; Bristol City Art Gallery; Ulster Museum, Belfast; the late Walter A. Brandt; the British Museum; the Hon. Mrs Bull; Duncan Bull; the Public Library, Art Gallery and Museum, Bury; Susan Casteras; Cheltenham Art Gallery and Museum; P. and D. Colnaghi & Co. Ltd.; Christie's; Father Stephen Dessain; the Fitzwilliam Museum; Patrick Flynn; Forbes Magazine Collection; Sarah Fox-Pitt; David Erdman; Lindsay Errington; Mireille Galinou; Mrs Edward Gibbons; Glasgow Museums and Art Galleries; R.F. Brooks Grundy; Charles Gosford; Francis Greenacre; Halina Grubert; Robin Hamlyn; Kathryn M. Heleniak; Simon R. Houfe; Graham Hutton; Mrs Charity Hodge; the National Gallery of Ireland, Dublin; Wendy Jacobsen; Michael Kauffmann; Michael Kitson; Kensington Public Library; Kenneth Lohf; Jules Lubbock; the Lady Lever Art Gallery; Limerick Art Gallery and Museum; Richard Lockett; Jeremy Maas; Kenneth McConkey; Manchester City Art Galleries; the Paul Mellon Centre for Studies in British Art; Sir Oliver Millar; the late Capt. Hugh Moore; the National Postal Museum and Archive; the National Maritime Museum; Miss Gabriel Naughton; Lord Northbrook; Northumberland County Record Office; National Portrait Gallery; Marshall Newman Ltd; Anthony Mould Ltd; the Museum of London; the Old Hall Gallery; Leslie Parris; Sir Richard Proby; Eric W. Phipps; Anne Rorimer; Sotheby's; Charles Sparrow; Staffordshire County Record Office; Royal Academy; Royal Astronomical Society; Royal Horticultural Society; Tate Gallery; H. Cornish Torbock; the Yale Center for British Art; Duke of Westminster; Whitworth Art Gallery; Wolverhampton Art Gallery and Museums.

I would especially like to thank all those individuals and institutions named above who generously lent works to the exhibition of Mulready's work at the Victoria and Albert Museum. The staff of the Department of Paintings, Prints and Drawings and Design and of the Library of the Victoria and Albert Museum have been both patient and helpful to me. My special thanks go to Julian Litten, to Mark Goodwin and to my editor, Nicky Bird, for their willingness to shoulder a burden of work at short notice and to offer me continuous encouragement and support.

ABBREVIATIONS

Catalogue 1864 — South Kensington Museum, *A Catalogue of the Pictures, Drawings, Sketches, etc. of the late William Mulready, Esq., R.A.*, 1864.

Catalogue 1848 — *A Catalogue of the Pictures, Drawings, sketches etc. of William Mulready, R.A. Selected for Exhibition at the Society of Arts, Adelphi, London: in aid of the formation of a National Gallery of British Art*, 1848

annotated copies of both catalogues and a draft list of works for the 1848 exhibition are to be found in the Victoria and Albert Museum Library.

FD — *The Diary of Joseph Farington*, eds. K. Garlick, A. Macintyre, K. Cave, New Haven and London, 1978–84

FGS — F.G. Stephens, *Masterpieces of Mulready*, 1867

KH — K. Heleniak, *William Mulready*, New Haven and London, 1980

Mulready's Account Book — William Mulready's account book, MS. Victoria and Albert Museum Library, 86 NN 1

Roget — J.L. Roget, *A History of the Old Watercolour Society*, 1891

Rorimer — A. Rorimer, *Drawings by William Mulready*, Victoria and Albert Museum, London, 1972

Studio sale — Christie, Manson & Woods, *Catalogue of the whole of the remaining Drawings, Sketches in Oil, Chalks, and Pen and Ink of William Mulready, R.A., deceased . . .*, April 28, 29, 30, 1864.

LIST OF ILLUSTRATIONS

17
A.W. CALLCOTT
COW BOYS
Oil on canvas, $49\frac{1}{4} \times 40\frac{1}{8}$ in
Herbert Art Gallery, Coventry

18
JOHN CROME
VIEW ON MOUSEHOLD HEATH NEAR
NORWICH
Oil on canvas, $16\frac{1}{8} \times 20\frac{1}{2}$ in
Victoria and Albert Museum (cat. 10)

19
HORSES BAITING
Oil on panel, $15\frac{3}{4} \times 19\frac{3}{4}$ in
Whitworth Art Gallery, Manchester (cat. 151)

20
STUDY FOR HORSES BAITING
Pen and ink, $2\frac{7}{8} \times 4\frac{1}{8}$ in
Victoria and Albert Museum

21
STUDY FOR THE MALL
Pen and ink, $3 \times 4\frac{1}{4}$ in
Victoria and Albert Museum

22
CARTOON FOR PUNCH
Chalks, pen and ink and wash, $21\frac{3}{4} \times 15\frac{1}{4}$ in
Victoria and Albert Museum (cat. 32)

23
SKETCH FOR PUNCH
Oil on canvas laid on panel, $8 \times 12\frac{1}{2}$ in
Victoria and Albert Museum (cat. 31)

24
MOUNCES KNOWE
Black and white chalk on grey-green paper,
$10\frac{1}{8} \times 14\frac{1}{2}$ in
Victoria and Albert Museum (cat. 6)

25
INTERIOR OF A HERD'S HOUSE, MOUNCES
Pencil, $10\frac{3}{4} \times 15$ in
Trustees of the British Museum (cat. 155)

26
CAPHEATON, A WOOD AT SUNSET
Pastel, ca. $3\frac{1}{2} \times 5\frac{1}{2}$ in
National Gallery of Ireland, Dublin (cat. 7 ii)

27
BOYS FISHING
Oil on canvas, $30\frac{1}{2} \times 26$ in
His Grace the Duke of Westminster, DL
(cat. 156)

28
STUDY FOR BOYS FISHING
Pen and ink, $3\frac{5}{8} \times 5$ in
Victoria and Albert Museum

29
PAUL SANDBY
AN OLD PUBLIC HOUSE, BAYSWATER
Victoria and Albert Museum

30
PLAN FROM A CONVEYANCE
Dated 5 October, 1849
Location unknown, photo: Mansell Collection

31
ANON
VIEW OF MULREADY'S HOUSE IN LINDEN
GROVE
Location unknown, photo: Mansell Collection

32 A AND B
TWO SKETCHES FOR A HOUSE
Pen and ink
Victoria and Albert Museum (cat. 35)

33
CHATELAIN AND ROBERTS
THE SOUTH VIEW OF KENSINGTON
Engraving, $27\frac{3}{8} \times 19\frac{3}{4}$ in
Museum of London (cat. 14)

34
J. WELLS
ONE TREE FIELD NEAR KENSINGTON
Watercolour, $8\frac{1}{2} \times 12\frac{7}{8}$ in
Museum of London (cat. 15)

35
ANON
THE THREE HORSESHOES INN NEAR
KENSINGTON GRAVEL PITS
Aquatint, $5\frac{1}{2} \times 7\frac{3}{8}$ in
Museum of London (cat. 16)

36
J. OR R. SCHNEBBELIE
KENSINGTON PALACE
Engraving, $3\frac{7}{8} \times 6\frac{1}{4}$ in
Museum of London (cat. 17)

37
ATTRIB. PAUL SANDBY
BAYSWATER, GENERAL LYING IN HOSPITAL
Watercolour, $7\frac{1}{2} \times 10\frac{3}{8}$ in
Museum of London (cat. 18)

38
J. OR R. SCHNEBBELIE
BAYSWATER, ST. PETERSBURG COTTAGE
Watercolour, $3 \times 4\frac{1}{2}$ in
Museum of London (cat. 19)

39
C. VARLEY
BAYSWATER
Pencil, $4\frac{7}{8} \times 2\frac{1}{2}$ in
Museum of London (cat. 20)

40
FREDERICK BACON BARWELL
PORTRAIT OF MULREADY
Oil on canvas, $39\frac{3}{4} \times 60$ in
Victoria and Albert Museum

41
PORTRAIT OF JOHN VARLEY
Oil on panel, $3\frac{1}{2} \times 3$ in
National Portrait Gallery (cat. 49)

42
A MUSIC LESSON
Oil on canvas stuck on panel, $15\frac{1}{4} \times 12$ in
Brian Stone, Esq. (cat. 39)

69
STUDY FOR THE WOLF AND THE LAMB
Pen and brown ink, $4\frac{5}{8} \times 3\frac{5}{8}$ in
Whitworth Art Gallery, Manchester (cat. 104)

70
STUDY FOR THE WOLF AND THE LAMB
Pen and brown ink, $11\frac{3}{8} \times 5\frac{3}{8}$ in
Whitworth Art Gallery, Manchester (cat. 105)

71
WILLIAM HENRY KNIGHT
THE BROKEN WINDOW: WHO THREW
THE STONE?
Oil on canvas, 29×38 in
Wolverhampton Art Gallery (cat. 103)

72
STUDY FOR THE ORIGIN OF A PAINTER
Black and white chalk on brown paper,
$7\frac{1}{2} \times 6$ in
Victoria and Albert Museum

73
STUDY FOR THE CANNON
Black and white chalk, $6 \times 7\frac{1}{4}$ in
Victoria and Albert Museum

74
DRAWINGS ON ZINC FOR THE MOTHER'S
PRIMER
$3\frac{3}{8} \times 3\frac{3}{8}$ in; $1\frac{5}{8} \times 3\frac{3}{8}$ in
Victoria and Albert Museum (cat. 118)

75
THE WEDDING MORNING
Oil on panel, $6\frac{5}{8} \times 7\frac{5}{8}$ in
Lady Lever Art Gallery, Port Sunlight

76
LENDING A BITE
Oil on panel, 30×26 in
Private collection (cat. 130)

77
STUDY FOR THE TRAVELLING DRUGGIST
Pen and sepia and sepia wash, $4\frac{5}{8} \times 3\frac{5}{8}$ in
Trustees of the British Museum (cat. 10)

78
POOR CRAZY SAMUEL AND THE
MISCHIEVOUS BOYS
Illustration by John Bewick to A. Berquin,
The Looking Glass for the Mind, 1814
Victoria and Albert Museum

79
E. BALDWIN
Fables Ancient and Modern, 1805, vol. I
Victoria and Albert Museum (cat. 120)

80
E. BALDWIN
Fables Ancient and Modern, 1805, vol. II
Victoria and Albert Museum (cat. 120)

81
FRONTISPIECE TO *The Child's True Friend*,
1808
Victoria and Albert Museum (cat. 120)

82
TRUSLER'S *Proverbs exemplified and illustrated
by pictures from real life*, 1790
Victoria and Albert Museum (cat. 122)

83
Lamb's Tales from Shakespeare, 4th edn., vol I,
1822
Victoria and Albert Museum (cat. 123)

84
'WILL WATERPROOF'S MONOLOGUE'
Moxon's *Tennyson*, 1857
Victoria and Albert Museum (cat. 167)

85
THE SEVEN AGES OF MAN
Oil on canvas, $35\frac{1}{2} \times 45$ in
Victoria and Albert Museum (cat. 118)

86
THE CHEMIST'S SHOP
Pencil and white chalk on thick beige paper,
$6\frac{1}{4} \times 5\frac{5}{8}$ in
Whitworth Art Gallery, Manchester

87
THE INTERCEPTED BILLET
Oil on panel, $10 \times 8\frac{1}{4}$ in
Victoria and Albert Museum (cat. 82)

88
DUCKS AND GEESE
Pen and ink, $4\frac{1}{4} \times 3\frac{3}{8}$ in
Victoria and Albert Museum

89
A MARKET GIRL
Watercolour, $9\frac{1}{2} \times 6\frac{7}{8}$ in
Private collection (cat. 146)

90
CROSSING THE FORD
Oil on panel, $23\frac{7}{8} \times 19\frac{3}{4}$ in
Trustees of the Tate Gallery (cat. 162)

91
A SHEPHERD BOY AND DOG
Watercolour, $9\frac{3}{4} \times 6\frac{3}{4}$ in
Location unknown

92
THE KITCHEN FIRE
Oil on panel, $7\frac{7}{10} \times 6\frac{4}{10}$ in
Private collection (cat. 154)

93
INTERIOR OF AN ENGLISH COTTAGE
Oil on panel, $3\frac{1}{4} \times 2\frac{3}{4}$ in
Trustees of the Tate Gallery (cat. 157)

94
INTERIOR OF AN ENGLISH COTTAGE
Chalk, $24 \times 19\frac{1}{2}$ in
Victoria and Albert Museum (cat. 158)

95
AN INTERIOR: AN ARTIST'S STUDY
Red chalk, $15\frac{1}{2} \times 13\frac{3}{4}$ in
Manchester City Art Galleries (cat. 159)

96
BATHERS SURPRISED
Oil on panel, $23\frac{1}{4} \times 17\frac{1}{4}$ in
National Gallery of Ireland (cat. 145)

ILLUSTRATIONS

INTRODUCTION

It is time to take a fresh look at Mulready's art. We come to this exhibition in the bicentenary of the artist's birth well equipped to address the problems, historical and aesthetic, that his art poses for a modern audience. The exhibition of Mulready's drawings at the Victoria and Albert Museum in 1972[1] aroused considerable interest and helped to establish the reputation that Mulready has enjoyed during the past two decades as an exceptionally determined, well-organised and highly motivated craftsman, a serious artist, indeed a classical artist. Kathryn Heleniak's book of 1980[2] with its full-length catalogue succeeded in establishing the oeuvre, gave a fuller account of Mulready's life than we had enjoyed through the agency of his protective contemporary biographers, F.G. Stephens and James Dafforne[3] and signalled some of the contradictions that threaten on close examination to burst from the carefully tooled surface both of Mulready's life-account and of his paintings. The late 'seventies and early 'eighties have seen a succession of serious explorations (often in journals and articles rather than in books) of the subject matter of nineteenth-century painting; we do now recognise that these paintings are often immensely more complex than their sometimes bland and invariably everyday subject matter would suggest. Questions have been asked about iconography and about the audiences for whom these objects were produced. Moreover, there has been a great deal of research during the last decade on Landscape as a genre which has sociological implications as well as aesthetic; this work has also provided a framework for the further understanding of Mulready's oeuvre.

There are also dangers in the recognition that Mulready, as well as creating vividly attractive objects, was responsible for an imagery that produced meanings in its own time and continues to produce meanings in ours. That these are not the same meanings is important to bear in mind. Regency and Victorian biography is an agreeable proposition; enthusiastic pursuit of the 'other Victorians', as Stephen Marcus named them,[4] can result in too great an emphasis being laid on the private life behind the public figure. In the case of Mulready, the irregularities of his private life have now been recovered and should take their place alongside the official biographical account from which they were eradicated. We should not, however, take those facts as suggesting either that Mulready was particularly unusual in his difficulties or that he was in some way typical of a Victorian stereotype.

Born in 1786, Mulready's education and upbringing were eighteenth century and Georgian, not Victorian. He was fifty-one at the time of Queen Victoria's accession and his training was in an Academy dominated by eighteenth-century worthies: Fuseli, Northcote, West, Opie, Hopner and Lawrence. He entered the Royal Academy Schools at the age of fourteen in 1800 and was an exhibitor by 1803. But he was not elected an Associate until 1815 or a full Academician until 1816. His father was part of the first wave of Irish immigrant labour that resulted, by 1841, in an Irish workforce in Britain of around 400,000.[5] The Irish were the cheapest labour in Western Europe and endured here, as well as in the homeland they had fled, the most appalling conditions.[6] It is impossible to believe that Mulready was ignorant of these facts; whilst he established for himself a bourgeois lifestyle, his own living conditions as a young man are known to have been crowded and impoverished.

Mulready the artist was the first generation of his family brought up in England. He was born in Ennis, County Clare but the family is said to have been settled in the Bayswater area of London by 1792. It is important not to make ahistorical judgements about Mulready's early life and his domestic circumstances. What is remark-

[1] A. Rorimer, *Drawings by William Mulready*, Victoria and Albert Museum, London, 1972
[2] K.M. Heleniak, *William Mulready*, 1980
[3] F.G. Stephens, *Masterpieces of Mulready*, 1867; F.G. Stephens, *Memorials of William Mulready*, 1890; J. Dafforne, *Pictures by William Mulready*, 1872
[4] S. Marcus, *The Other Victorians*, 1974
[5] J.F.C. Harrison, *Early Victorian Britain 1832–1851*, 1979, p. 70
[6] See E.P. Thompson, *The Making of the English Working Class*, 1963, 1968, p. 472

able is that the documentation of that life has survived allowing a vivid, entertaining and often painful view of the personal life of a struggling young artist, his friends and family during the early years of the century. That these documents have survived is due to the fact – and this is extraordinary – of Mulready's transition from the class of the artisan and craftsman to what we would now call the upper middle class, no mean feat in an age in which mobility within the social stratification was virtually nil. For a skilled worker (and we can assume that as a leather breeches maker, Mulready's father came into this category) to retain his position distinct from and above that of his relatives was one thing. For him or any of his relatives to move up the social scale was quite another.

Paintings are not documents that relate unproblematically to the social situation; we need to resist the temptation to move from accepting that Mulready's paintings mean nothing to arguing that they mean everything. The images Mulready presents us with do not provide an open window onto Regency or early Victorian society. Nor do they provide us with a readily recognisable correlative with Mulready's psyche. Society and the artist's psychological make-up are certainly the domain wherein the visual language of the painting is produced but the paintings do not straightforwardly illustrate either. Whilst it is useful to draw attention to the relationship between *The Rattle* of 1808 (XIII) and *A Music Lesson* of 1809 (42) as signalling a very deliberate shift from a Genre, Dutch style style motif to a bourgeois subject (a shift that may be seen to reflect Mulready's own social aspirations of this time), it is to the complex imagery of paintings like *Train up a child . . .* (XXI) that we need to turn to explore the precise intersection of the personal with the political in a painting constructed for a particular patron and connoting meanings possibly at variance with the narrative denoted. We know little about Mulready's Irish background but Irish artisans (weavers, leather workers, shoe-makers) had a well-founded reputation for radical revolt which was sustained well into the century. Indeed the agricultural Swing riots in the south of England in 1830 were often shown to have been led by craftsmen rather than by labourers and the Irish were often blamed.[7] Endeavouring to establish himself as a respectable bourgeois in

the years when revolution from across the water was perceived as a massive and continuous danger, William Mulready faced problems as an outsider on at least five counts. He was an Irish immigrant and the son of a worker. It is worth noting that the trade in which Mulready's father was employed was precisely that in which the radical artisan, Francis Place, began his adult life. He was an artist and here the status achieved by some High Victorian artists should not be allowed to obscure the essentially marginal position of artists as a category within society. He was a man who lived for most of his adult life estranged from his wife and, one might add, he chose to work on Landscape and Genre subjects rather than on the more marketable commodity of portraiture or the more officially esteemed class of History paintings.

Unlike his friend Wilkie, Mulready was in no position to exploit his ethnic origins. Scottishness could be turned into a distinct asset in London during the early years of the nineteenth century where the popularity of Scott's poetry and novels was germane to the development of a fashion that swept through the age carrying Queen Victoria to Balmoral and Landseer into the Highland glens. Ireland, on the other hand, connoted not heroism and romance but dirt, ignorance, poverty and unresolvable problems for British demographers. Irish writers like Maria Edgeworth, while presenting the Irish rural problem for a literate English audience, did so in the light of Tory paternalism and a writer like Lady Morgan thrived from a London base on a reputation for Irish eccentricity that could only underline what was perceived to be difference in national identity and character. The best-known Irish artist, James Barry was not a role model for an aspiring young Royal Academician having died in squalor in 1806 after a life distinguished for its contribution to the Fine Arts but dogged by controversy and dissent. It is significant that it was Wilkie, not Mulready, who painted *The Irish Whisky Still*. Such a subject for Mulready would have constituted a declaration of affiliation that he evidently strove to disavow even to the extent of leaving instructions that his funeral should be conducted according to Anglican rites.

[7] See E.J. Hobsbawm and G. Rude, *Captain Swing*, 1969. 1985

The incipient hostility towards the Irish which is absent from official discourse (the nineteenth-century biographies, the Royal Academy reviews, the obituaries in the national press) is blatantly present on the surface in satirical discourse occasioned by the publication of the Mulready postal envelope (97). Caricatures of Mulready's design feature blarney stones, an artist called Moll Rooney (100), anti Papal narratives and a host of other overtly anti-Irish propaganda (99). Mulready's sensitivity on the subject of his Irish background was well-known; he was extremely anxious about the effects of re-publication of Godwin's early Life in 1843[8] and only agreed to the project in 1847. He has been described as having an obsession with privacy.[9] Nevertheless it is clear that at one level of national consciousness it was the Irish identity of the highly successful Royal Academician that was notable and all the artist's efforts to neutralise his origins were proven in 1840 to have been of no avail.

Such problems facing a young man might quite reasonably be thought to have been if not insuperable at least very discouraging. Mulready struggled to overcome them and his main weapon seems to have been, in one word, vigilance. He maintained as rigorous a control over his personal affairs (no easy task for an evidently hot-tempered man) as he did over the immensely refined and durable surfaces of his canvases. Whilst it is tempting to view his images of children as in some way compensatory both for his own childhood and for that of his four sons, the artist's inate and carefully regulated conservatism is more significantly the basis for his art.

The characters participating in Mulready's dramas do not labour. One would not, of course, expect to find squalor and hardship in paintings produced for a patrician and middle class audience. But Mulready's exhibited paintings often promote a timeless and archaising view of the world, a pastoral mode in which labour does not exist and the sun always shines. To be sure that view of the world is sometimes disturbed by elements within the paintings themselves and by an examination of the drawings. But the publicly presented view is one in which Nature is confined to a precisely glimpsed vista or a framed view through a window [as in *The Last In* (XVII) and *An Artist's Study* (95)]. Young girls in eroticised ver-sions of rustic dress reveal unblemished white shoulders. Cottage scenes confer unity upon phenomena explored as multifarious. Scenes of love and courtship often removed from anything that might associate them with actuality affirm gender difference with an insistence that defies challenge. The moments of crisis [in *The Fight Interrupted* (XVI) or *The Wolf and the Lamb* (XVIII)] are slight hiatuses which serve to reinforce rather than to undermine the timelessness of the social order that is an inherent feature of Mulready's imagery.

The element of control was recognised in Mulready's own age and accounted for aesthetically by Francis Turner Palgrave who also confirms that Mulready was never a popular artist. Reviewing the retrospective of his work that had been planned immediately following Mulready's death in 1863, Palgrave says:

> His compositions dwell on the mind amidst a thousand which we have admired, and dimly remembered, like some of the airs of Mozart or Beethoven compared with other men's sonatas. To use an old scholastic phrase, they are 'essential forms' of grace. Perhaps this is why, in the widest sense, Mulready has never been a popular artist. We do not expect that this exhibition, complete as it is, will make him such. For this fine point of grace so very rarely shown in English art is in itself a matter calling for so much attention from the spectator, that it is not likely to meet with common appreciation. The fit audience for such an artist will be inevitably few, at any rate in the modern world. An Athenian tribunal is required for men like Mulready, Flaxman, and Ingres.[10]

[8] K.H., p. 228 quoting Henry Cole's diary
[9] Ibid, ch. I, n. 38
[10] F.T. Palgrave, *Essays on Art*, 1866, p. 47

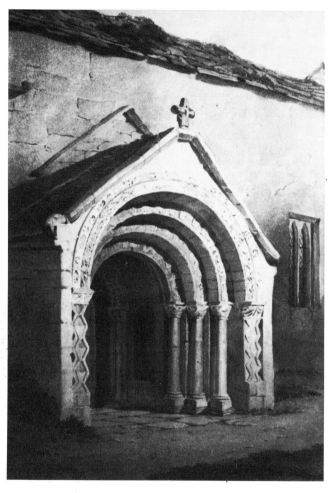

I. THE PORCH OF ST. MARGARET'S, YORK, *collection of Brian Stone* (cat. 3)

CHAPTER I
LOCATIONS FOR LIVING: PLACES FOR PAINTING

PART I

By the end of the nineteenth century, Kensington had become a favoured residential area with successful artists; among those who lived there and built themselves substantial homes were G.F. Watts, Frank Dicksee, Albert Moore, Luke Fildes, Sir John Everett Millais, Val Prinsep, Lord Leighton and Sir Edward Burne-Jones. But during the early years of the century Kensington and Bayswater were predominantly rural; aspiring and successful artists made their homes in the West End not on the fringes of London. In 1815 when John Landseer took his sons to B.R. Haydon's studio as pupils, Landseer was living in Foley Street, Newman Street 'thronged with painters and sculptors' including West, Stothard and Banks (Mulready's first mentor in artistic matters). A.E. Chalon lived in Great Titchfield Street, Shee in Cavendish Square, Collins in Great Portland Street, Daniell, Thompson, James Ward, George Dawe and Henry Howard all lived in Cleveland Street and Hilton and De Wint lived in Percy Street.[1] In the West End clients could attend portrait sittings, Somerset House (then the home of the Royal Academy) was close at hand and colour merchants, frame-makers and all those services that made up the infrastructure of the artistic economy of the capital were nearby.

Kensington with its gravel walks and unpolluted air (34, 39) was regarded as a resort for health and holidays and as an ideal place for children to be educated. As well as the Kensington Free School endowed by George I in 1786 and having in 1806 fifty boys and the same number of girls as boarding pupils, there were many genteel establishments for the education of the young such as Mrs Stewart's and Mrs Denham's boarding school for young ladies in Campden House.[2] The pleasure gardens were open from Spring until Autumn in 1804 though later they opened all the year round (36). The economic basis of the area was also visible; from at least the early seventeenth century gravel was dug from pits, some of which survived as ponds well into the nineteenth century

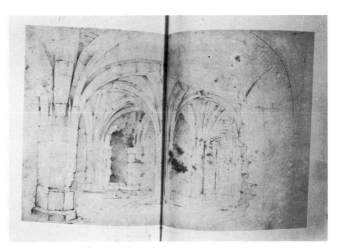

2. THE CRYPT OF KIRKSTALL ABBEY, *Royal Academy*, *Jupp Catalogue*

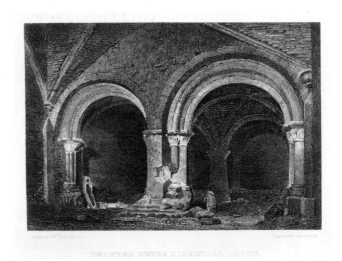

3. AN HISTORICAL, ANTIQUARIAN AND PICTURESQUE ACCOUNT OF KIRKSTALL ABBEY, 1827 (cat. 4)

(VI, 12, 13). The district now known as Notting Hill Gate, which includes not only the road but the area on either side of it, was called Kensington Gravel Pits in the nineteenth century (35).[3] The location is prominent in

[1] *Memoirs of Sir Edwin Landseer*, 1874, pp. 43–4
[2] D. Lysons, *Environs of London*, 1795–1811, II, 506, 530–1

21

the early work of Mulready and his friends (IV, V); Augustus Wall Callcott, who was born in the Gravel Pits, the grandson of a bricklayer,[4] painted his first view of the area in 1803 (R.A. 164, cf 16, 17), Mulready's first view dates from 1807–8 and Linnell's from around the same time.

When Mulready first exhibited at the Royal Academy in 1804 he was living with John Varley, his teacher and a man only eight years older than himself at 15, Broad Street, Golden Square in the heart of the West End. Varley also owned a cottage at Twickenham to which he sent his pupils: Mulready, Linnell and William Henry Hunt so that they might sketch along the banks of the Thames.[5] The rural fringes of London were becoming as popular as far-off picturesque Wales and Yorkshire. Lambeth, Millbank (not then bound in but 'irregular with a garniture of mud banks'),[6] Richmond, Twickenham, Teddington to the South-East and Brentford, Heston, Hendon and St. Albans to the North are names which frequently recur in the exhibition catalogues and sketch books at the beginning of the century.

In 1808 Mulready moved, with Linnell, into No. 30 Francis Street, Bedford Square; Mulready and his family occupied two rooms on the first floor and Linnell had the top floor. Conditions must have been very cramped. Mulready's youngest son was born in Holland Street on 27 June 1809[7] but Mulready was still using the Francis Street address. The couple appear to have separated about this time, possibly prior to John's birth. By 1811 Mulready's address appears in the Royal Academy catalogues as 'Kensington Gravel Pits'. Linnell indicates that he shared accommodation there with Mulready's parents. Other artists resident in the area at this time were Callcott, Collins and Wilkie who lived in Phillimore Gardens just south of the Gravel Pits.

Mulready never returned to central London. At first he occupied a cottage (presumably the one he shared with his parents) in Robinson's Row or Robinson's Rents just off the Gravel Pits. It does not appear on contemporary maps of the district and must have been extremely humble. In 1826 he was living in Moscow Cottages, Bayswater, situated just behind Moscow Road which still exists today. Thomas Allason began building on the Ladbroke

4. COTTAGE AND FIGURES, *Trustees of the Tate Gallery* (cat. 1)

Estate in 1828 and Mulready moved into the first of the substantial villas constructed in Linden Grove (now renamed Linden Gardens), at right angles to Notting Hill Gate (30, 31). He lived here for the rest of his life with his son Michael, having been formally separated from his wife since 1810. Thomas Creswick lived at no. 42 until his house was affected by the building of the Metropolitan railway in 1877 when he moved into Mulready's former home. At about the same time a Hungarian immigrant named Augustin Rischgitz affirmed the identity of the street as a location of artistic production by setting up his photographic studios (cat. 36 ii). His house, still occupied by a descendant, is one of only two of Allason's original houses, and gives an interesting indication of Mulready's environment.[8]

[3] E.W. Walford, *Old and New London*, 1892, V, 134, 154; *The Survey of London*, XXXVIII, 1975, p. 38

[4] D. Blayney Brown, *Augustus Wall Callcott*, The Tate Gallery, 1981, p. 9

[5] Roget, I, 86; A.T. Storey, *The Life of John Linell*, 1892, II, 44

[6] Roget, I, 86

[7] Inscription in family photograph album, collection Jeremy Maas, Esq.

5. A SEA SHORE, *Trustees of the Tate Gallery* (cat. 150)

Kensington was an ideal place for the landscape painter when Mulready moved there. Access to central London was easy but Kensington Gardens and the large parks around Campden House and Holland House ensured a good northern light. Although two of the largest land-owners in northern Kensington, Lord Holland and J.W. Ladbroke began to develop their estates in the 1820s, the financial crash of 1825 hit them hard and no new enterprises were undertaken until 1839. The area retained, therefore, its cottages and its village atmosphere well into the nineteenth century[9] (33, 35, 37). But during Mulready's lifetime the area was to evolve from a rural community to a busy mass of streets and houses, roads and railway developments to become by 1860 what has been named 'the very citadel of Victorian London'.[10] It also rapidly became an area of notorious slums. Life expectancy in the area of Kensington brick kilns in the 1840s was eleven years and although Linden Grove remained salubrious, Mulready can scarcely have failed to be aware of the tremendous changes taking place around

[8] Lease of no. 1, Linden Grove, 7 March 1828, MS. Tate gallery, 72–16/26; the rent from 1828 to 1849 was thirty-five pounds per annum
[9] *The Survey of London*, XXXVII, general introduction, 39; 268–9
[10] Ibid

23

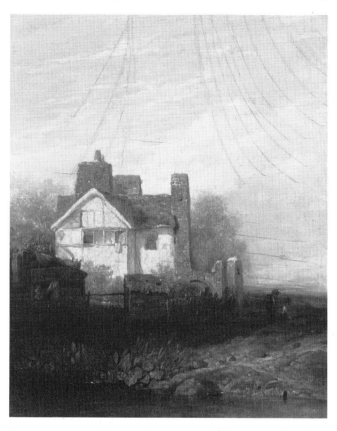

6. LANDSCAPE WITH COTTAGE, *Victoria and Albert Museum* (cat. 29)

him in a parish which, when he first moved there, had been little more than a country village renowned for its pastoral calm and fresh air. Indeed, Mulready's eldest son, William, lived during the 1840s with his young wife on the twelve shillings a week allowed him by his father (which did not keep him out of debt)[11] (cat. 89, 96) opposite the Gas Works at Kensal Green,[12] an area 'not just shabby but extraordinarily poor'.[13] It has been pointed out that Mulready began his career when patronage of English art was at a low ebb.[14] He met his first important patron in 1811 and from that time was able to count on a steady income. He continued to support his wife after their separation and took his responsibilities as head of the family extremely seriously (see cat. 96). He left over £3,900 in his will, a very considerable sum for the period.

The Mall, Near the Mall and *A Gravel Pit* (IV, V, VI) were all painted between 1808 and 1812 in the Kensington, Notting Hill area. They remained unsold by Mulready

until 1844. Whilst they evidently represent an essentially selective view of this particular locality the connotations (rather than the precise definition of place) rendered them unsaleable until such time as the area had changed in appearance and economy. By 1844 the old inns like that depicted by Paul Sandby in *An Old Public House, Bayswater* (29) at the beginning of the century had gone. The Gravel Pits Alms Houses had been demolished in 1821. Some of the parks and gardens remained but the predominantly rural character had been eliminated and the open views recorded by Sandby, Cornelius Varley, Linnell (37, 39, 12, 13) and the others had been replaced by an essentially urban view.

In Linden Grove, Mulready aspired to create a genteel environment for himself. Many drawings survive recording plans for the furnishing of his house and the arrangement of his garden (31, 32, and cat. 35). Conrad Loddiges, the Hackney horticulturalist was a friend and patron and would have supplied Mulready with shrubs and flowers to plant out the terrain according to the artist's own very detailed designs. One such drawing shows shrubs arranged elegantly in urns and a kennel provided for the dog who annoyed the neighbours by chasing cats up the trees.[15] Mulready's arrival in the neighbourhood accompanied by four boisterous boys and their guns was evidently not to everyone's liking in the street.

Unlike Turner and many of his contemporaries, Mulready was not a traveller. Like Constable he never went abroad and his journeys away from London and its surrounding districts seem to have been mainly confined to visits to Capheaton, the Northumberland seat of his patron, Sir John Swinburne (24, 25, 26). Preparing in March 1848 for the Society of Arts exhibition of his work, Mulready wrote from Northumberland to his ward:

'I have had a regular fag at painting without an atom of exercise, so I am fat, but not blooming. My left shoulder has been close to the open air, but without at all enjoying it, and I must put this shoulder to the same work for ten weeks longer'.[16]

[11] K.H., p. 15
[12] Correspondence Linnell/Mulready June 1844–6, MSS. Linnell Trust
[13] P. Malcolmson, *The London Journal*, I, May 1975, p. 28
[14] K.H. 161
[15] Draft letter in reply to a neighbour's complaint, MS. Tate Gallery 7216.7 16 June 1826

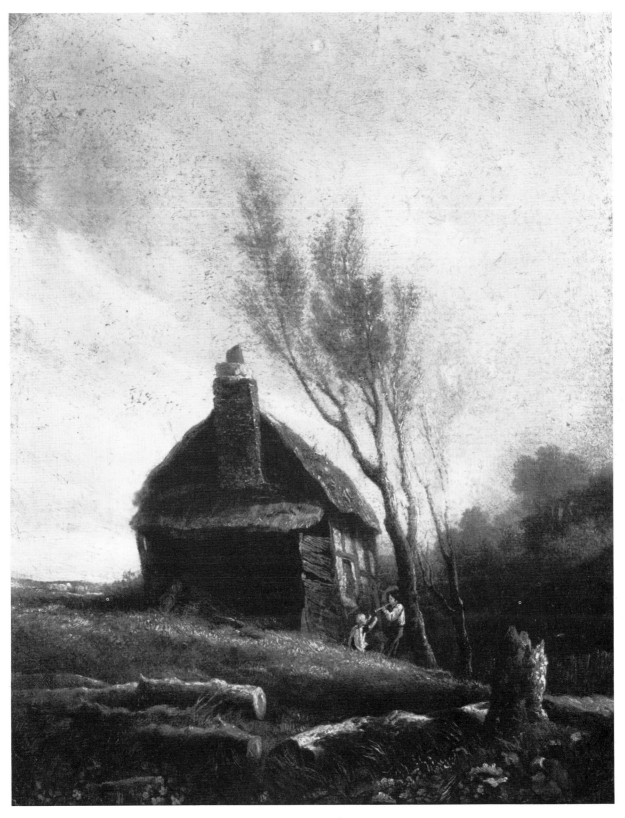

7. LANDSCAPE WITH COTTAGE, TREES AND CHILDREN, *Victoria and Albert Museum* (cat. 33)

Mulready, confined to the house, had just sent five pictures to London and was preparing to send another seven plus numerous sketches and drawings. He must have been also finalising *The Butt* (XXV, XXVI) which he exhibited at the Royal Academy in May that year. A great deal of space would have been needed for all this work and it seems probable, therefore, that Sir John Swinburne provided Mulready with the sort of accommodation at Capheaton that Turner enjoyed at Petworth under the Earl of Egremont's patronage.

Mulready's earliest recorded work at Capheaton is dated 1814 (cat. 125).[17] He seems to have visited Sir John's house almost every summer from then on as a friend ('a great favourite with everybody')[18] and as drawing teacher to the Swinburne family (see 50–54, cat. 55–63).[19] A drawing of a young woman wrapped in a shawl and sketching in a beech wood may be a portrait sketch of one of the Swinburne girls. It suggests that the artist encouraged his pupils to draw out of doors.[20]

Mounces Knowe, where the Swinburne family took up temporary residence for the shooting season, was a marvellous location for landscape study (26, cat. 7). One visitor described the place as 'that valley of Nature's tears' and, having endured a day of continuous deluging rain there, 'never wished to see the place again.'[21] But the family loved Mounces and young Algernon Charles Swinburne remembered it when, writing to his mother from Weisbaden in 1855 and wishing to convey to her the impression he had received of Robber Lutweis's cave, he described walking 'to the most lovely place on earth — a sort of mixture of the prettiest parts of Mounces and Capheaton.'[22]

Mulready executed many sketches at Mounces Knowe including several in 1814 of the rickety bridge seen from different angles all of which have the precision of his and Linnell's early Kensington studies (24).[23] One drawing, very roughly blocked in with areas of light and shade shows children, adults and dogs clambering over a rocky Northumbrian outcrop.[24] Capheaton was always a place where Mulready felt relaxed and able to work. On 6 September 1860, having just arrived at Capheaton, he wrote to Mary Mulready Stone:

'This is the first visit to Capheaton that my getting to work has been delayed for more than twenty hours. Some of my coming work is fixed upon, and perhaps a beginning may be made this afternoon.'

It is clear that, despite his complaint in 1848 (see p. 24), Mulready didn't spend his entire time at Capheaton incarcerated in the house. The series of studies of Capheaton at different times of the day (26, cat. 7) is an interesting example of a concern with *plein-airism*, an interest in the dynamics of light in the landscape and the progress of effect. These impressions are recorded in an easily transportable medium (pastel) and are reiterated in Mulready's drawings but find little expression in his oil paintings after 1815. Although he is known to have accompanied Sir John Swinburne to St. Leonards on Sea in April 1845 there are no landscapes or seascapes relating to this visit. A series of annotated drawings of waves executed on black-edged mourning paper[26] and dated Jan. 1845 may be the result of a similar visit earlier the same year.[27]

The Toy Seller (58, cat. 117), on which Mulready was working at the time of his death includes, as its background, a landscape view with the extraordinary brilliance of what is based academically on the colouristic juxtapositions of Poussin set against the Titianesque glazes on the toy-seller's smock. Such Old Master connotations are never accidental or exclusively aesthetic. Here the Renaissance associations endow the black man with the intrinsic dignity of the Magus and the classical tonal

[16] W. Mulready to Mary Mulready Stone, 10 March 1848, MS. Collection of Mr. Brian Stone
[17] Mulready's studio sale, Christie's 28 April 1864, lots 209, 210, 213, 216, 217. See also *Interior of a herd's house, Mounces,* drawing, 1814, British Museum. But it should also be noted that the portrait of Sir John Swinburne's servant, Harry Sumpter, was given the date of 1809 in the exhibition catalogue (annotated) of the South Kensington exhibition immediately following Mulready's death
[18] FD. 13 Oct 1815
[19] See items in the Browne Swinburne family collection and K.H. ch. VI
[20] British Museum 1914–8–10–1
[21] B. Charlton, *The Recollections of a Northumbrian Lady 1815–1866,* ed. L.E.O. Charlton, 1949, pp. 152–3
[22] D. Leith, *The Boyhood of Algernon Charles Swinburne: Personal Recollections by his cousin,* 1917, p. 46
[23] Rorimer, 141, 142; K.H. pl. 38
[24] Dublin, National Gallery of Ireland, 7005
[25] William Mulready to Mary Mulready Stone, collection of Mr Brian Stone
[26] Whitworth Art Gallery, University of Manchester D57 1895; D58 1895
[27] K.H. cat. 172
[28] K.H. cat. 92

contrasts reinforce the disavowal both of genre subject matter and Victorian actuality. When Mulready turned from recording his immediate environment to become a master of the Georgian and early Victorian subject painting (a transition that coincides roughly with his election to associate membership of the Royal Academy with *Idle Boys* (cat. 99) in 1815)[28] he abandoned his practice of re-constituting his environment in a favour of a refined rural construct signifying the rustic and manifest (with the exception of *The Convalescent . . .* of 1822, 66) in depictions characterised by mature trees and well-stocked meadows, a fertile and well-watered landscape that supports but never intrudes upon or is a part of the narrative events depicted. It is the ideal fruitful landscape and it functions as part of the cult of elevated paternalism.

PART II

There were signs, at the time when Mulready became a student in the Royal Academy schools in 1800, that Landscape painting might gradually receive the sort of approbation that Gainsborough had desired for it fifty years earlier. History painting in the Grand Style remained the prime objective of students ambitious for worldly success. Nevertheless a number of factors contributed towards the creation of an atmosphere more generally favourable towards landscape painting than had ever before prevailed in this country. The steady output of water-colour painters during the eighteenth century, the spontaneous and non literary approach to nature adopted by Thomas Jones in his oil sketches of Rome in the 1780s

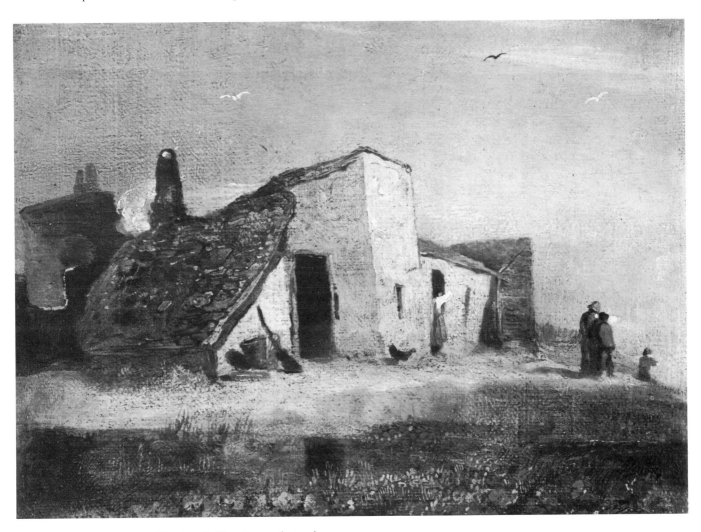

8. COTTAGES ON THE COAST, *Victoria and Albert Museum* (cat. 34)

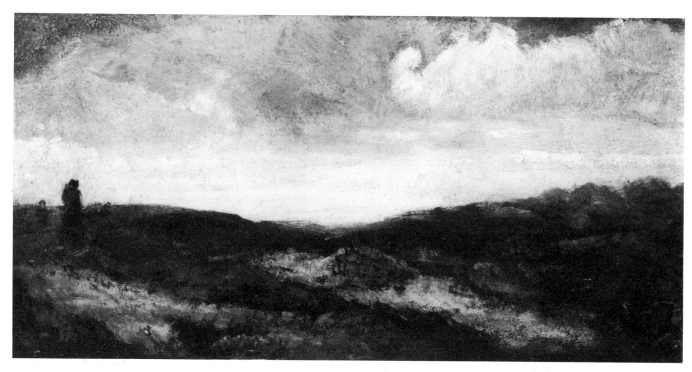

9. HAMPSTEAD HEATH, *Victoria and Albert Museum* (cat. 26)

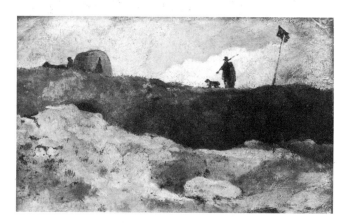

10. HAMPSTEAD HEATH, *Victoria and Albert Museum* (cat. 28)

and the fact that Benjamin West, President of the Royal Academy, occasionally applied himself to the painting of views all played their part.

The authority of Claude remained unchallenged; his serene classical landscapes would be a vital influence on the development of Turner and Constable but, increasingly, the Dutch and Flemish painters and in particular Rubens were also attracting attention. Reynolds had recognised the achievement of Gainsborough in his *Discourses*

and, with this example before them both artists and patrons were looking at a wider range of Dutch art. But this period of optimism for English landscape was shortlived. By 1813 West was telling Sir Richard Payne Knight that however agreeable the English countryside might be, such scenes and colours would not do in Landscape painting.[1] When Mulready came to try to sell his Gravel Pits scenes in 1812 (IV, V, cat. 22, 23) the mood of sympathy had given way to an entrenched insistence on moral content, drawing on High Renaissance modes of composition. All the old values, in fact, were reasserted.

The popularity of Landscape among London artists from the 1780s on was a cause for concern. In the 1780s some thirty per cent of Royal Academy exhibits were in this genre. Plein-air sketching around the turn of the century was to become a craze and even Benjamin Robert Haydon, who devoted his life to the ideal of a national school of History painting, was studying landscape in 1811.[2] An ambivalence that is typical of the period is displayed by Sir George Beaumont, owner of an important collection

[1] Farington Diary, 13 July 1813
[2] FD 15 Jan 1811

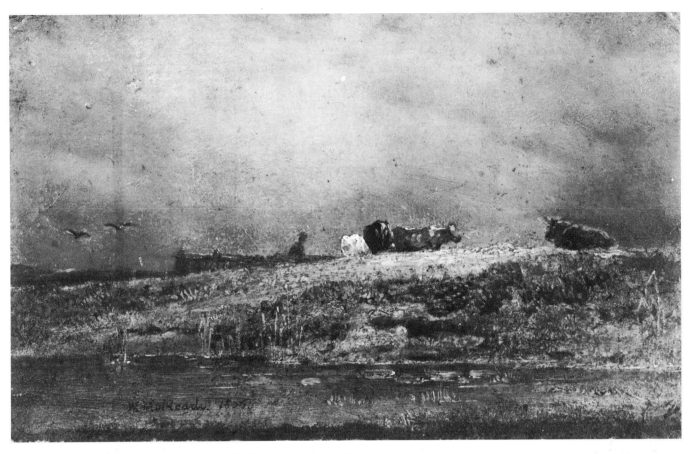

11. HAMPSTEAD HEATH WITH COWS, *Victoria and Albert Museum* (cat. 27)

of paintings by Claude and by artists of the Dutch and Flemish schools and, himself, an amateur Landscape artist. John Burnet, writing in the middle of the century, but recalling a much earlier period when the young and promising Scottish artist David Wilkie arrived in London to study, describes delightful afternoons spent in the company of Wilkie, Etty and Nasmyth at the London homes of Sir George Beaumont, Lord Grosvenor and others.[3] But in 1808 Sir George was expressing grave anxiety about 'the rage for watercolour drawing' which was, undoubtedly, another manifestation of the delight in Landscape and in cottage scenes that propelled Wilkie and his friends to Sir George's own house.[4] Watercolour was the most efficient and popular medium in the first half of the nineteenth century for recording the changing effects and varied textures of the external world. We no longer remember Wilkie for his watercolours or, indeed,

for Landscape painting at all. In 1808, however, he accompanied Mulready and Linnell on a sketching trip to Chatham.[5] They became members of the informal group of Kensington based artists whose environment and origins have already been discussed.

The Kensington artists enjoyed easy access to Dutch painting in private collections; works by Cuyp, Berghem, Potter, Ostade, Wynants and others were to be found in private collections. Mr. Ridley Colborne, for example, owned works by Ostade and Teniers which he was prepared to lend to Wilkie and Mulready in 1808–9.[6] As the century advanced the Dutch School came increasingly before the public as paintings passed through the sale rooms

[3] J. Burnet, *The Progress of a Painter*, 1854, pp. 64–5
[4] FD 1 June 1808
[5] Mulready's Account Book, July 1808
[6] A. Cunningham, *Life of Sir David Wilkie*, 1843, I, 172, 451; Mulready's Account Book, 1808; KH, pp. 50–2

albeit at very insignificant prices. Robert Peel, for example, started collecting after his marriage in 1820 and systematically built up a remarkable collection of Dutch and Flemish works including Rubens's *Chapeau de Paille* and two Hobbemas, *The Château de Brederode* and *Avenue Middleharnis*.[7] Sir George Beaumont owned Rubens's *Autumn, the Château de Steen* which he made accessible to Constable and others at his home and to a wider audience by lending it to the British Institution in 1815 and, eleven years later, presenting it to the infant National Gallery.

William Henry Pyne's *Microcosm . . .* of 1806 offers a verbal account of some of the concerns manifest in the

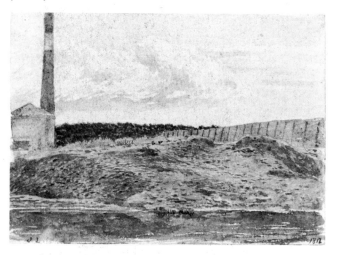

12. JOHN LINNELL, KENSINGTON BRICK KILN, *Mrs Joan Linnell Ivimy* (cat. 12)

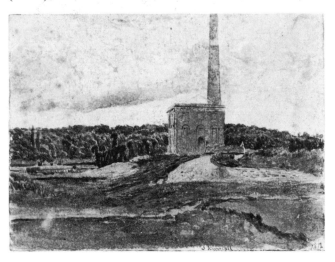

13. JOHN LINNELL, KENSINGTON BRICK KILN, *Mrs Joan Linnell Ivimy* (cat. 12)

paintings of the Kensington artists. Although intended as a kind of storehouse for amateur painters to raid when in need of figures for their Landscapes, the *Microcosm . . .* was an encyclopaedic collection of occupations and trades which offered an analytical approach to the contemporary scene. Pyne's introduction expresses the notion of realism and contemporaneity in no uncertain terms: 'The poet, the painter or the dramatist, who makes an imaginary nature his model, or any other nature, but the nature of common life, if he lives long, will himself live to see his attempts consigned to oblivion.'[8]

The Kensington artists shared with Pyne a respect for the working, everyday landscape of the labourer. We are told how Mulready's friend and teacher, John Varley, on his way to work in the office of the architect to whom he was apprenticed as a young man, would linger in the High Street to sketch the humanised urban scene. Whether or not this is true it is significant that by the time the Redgraves came to write their study of British art (one of the first serious assessments of the art of their own age) such events had entered into the mythology of artistic production of the early years of the century.[9] Linnell in a rare and monumental early exercise actually depicted gravel diggers at work (Tate Gallery). Mulready on the other hand produced a host of sketches defining labour of different categories (cat. 138). These drawings do not, however, lead to paintings of labour. Nevertheless, he created an imagery of the vernacular and the unspectacular in his cottage and gravel pits scenes that was so vivid and startling in its rendering that it attracted admirers as diverse as Samuel Palmer and Ruskin. In view of his drawings and notes Mulready's positivism seems undeniable. Yet the human element in his early vernacular subjects is always distant and controlled in its relations to the environment (see cat. 29). It might be said that such work constitutes a compromise between Godwinian empiricism and the paternalism of eighteenth-century writers like Crabbe.

[7] N. Gash, *Peel*, 1976, p. 57.
[8] W.H. Pyne, *Microcosm or, a picturesque Delineation of the Arts, Agriculture and Manufactures of Great Britain in a series of above a Thousand Groups of small figures for the embellishment of Landscape*, 1806
[9] R. and S. Redgrave, *A Century of British Painters* (1866), ed. R. Todd, 1946, p. 199

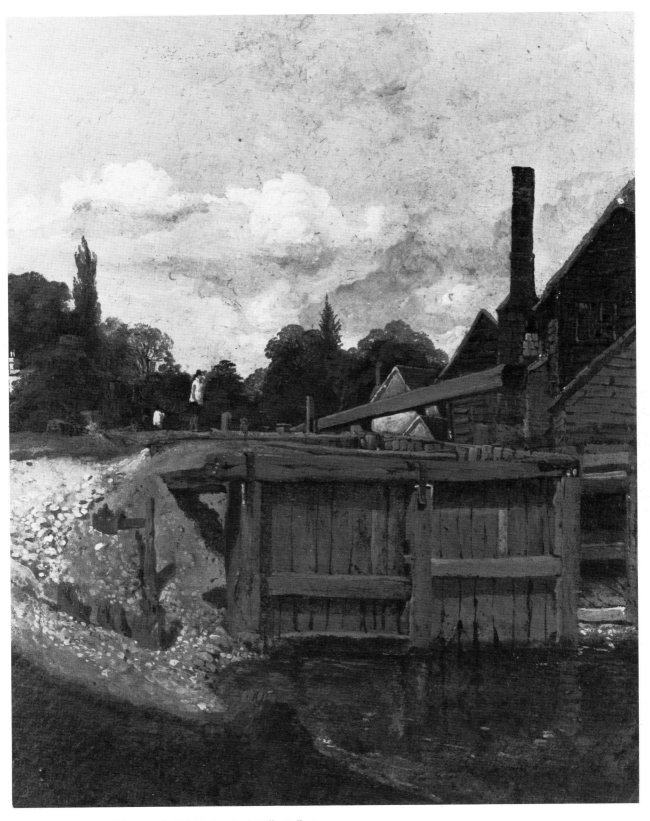

14. THE LOCK GATE, *Yale Center for British Art, Paul Mellon Collection*

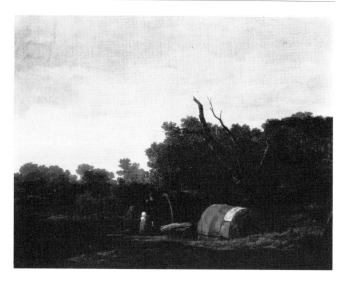

15. GIPSY ENCAMPMENT, *National Gallery of Ireland, Dublin* (cat. 153)

16. A. W. CALLCOTT, MORNING *Royal Academy*

The Norwich School had also gone a long way towards gaining acceptance for the visual vernacular of familiar and local landscape. The Norwich Society was founded in 1803 and, for the next few years, there were close connections established between Kensington and Norwich. Cotman was in London until 1806 but Crome also made regular journeys to London and was impressed by Turner's Landscapes which he saw in Royal Academy exhibitions. Crome's *View on Mousehold Heath near Norwich* (18) is a prototype for Linnell's, Callcott's and Mulready's early landscapes, both in style and content (17, VI). Cotman's

art of this period is very different and, although he must have provided a human contact, there seems little doubt that it was Crome rather than Cotman who provided the inspiration at this period. It is, however, necessary to bear in mind that both groups of artists were drawing on the same Dutch sources and the similarity between paintings like Crome's *The Blacksmith's Shop, Hingham* (1807–8) (Norwich) and Mulready's St. Albans views executed c.1806–8 may simply derive from a common source. However, Cotman is known to have gone round London exhibitions sketching other artists work and on several occasions exhibited in Norwich subjects that were virtually identical with subjects exhibited by Kensington artists in London at an earlier date.[10] (See cat. 25.)

Just as important as any painter or publication was the sympathetic support of one or two patrons and collectors. The role played by Dr. Monro in the development of British Landscape in the first part of the nineteenth century has long been acknowledged. Mulready's name is not mentioned by those, like Roget, who have written about Dr. Monro's 'Academy'. It does, however, seem likely that Mulready who enjoyed the friendship of the Varleys and of William Henry Hunt from 1800 and whose work was admired and emulated by Cotman, was also acquainted with the doctor. Moreover, the fact that Michael Mulready recorded in 1864 that two pencil sketches by his father of cottage subjects had been sold to Thomas Monro would support the supposition.[11]

Among Mulready's early successes were *A View in St. Albans* (1806) purchased from the Royal Academy by Thomas Hope. An ardent classicist, Hope perhaps detected in Mulready's cottage subjects those formal aspects of design that are striking to a modern audience. The following year John Henderson, a friend and neighbour of Dr. Monro and himself an artist whose watercolours were subsumed into the products of the Monro 'Academy' paid Mulready nine pounds for a view of Eton and eight pounds for a drawing or painting of a cottage in Caernarvon.[12] Probably

[10] S.D. Kitson, *The Life of John Sell Cotman*, 1937, p. 168; KH pp. 66–9 suggests that both Crome and Cotman were influenced by Mulready and draws attention to the fact that Mulready was commanding higher prices than either by 1807
[11] Cat. 1864, p. 27
[12] See M. Pointon, *Bonington, Francia and Wyld*, 1985, p. 56, p. 63 n. 71; KH cat. 22, 23, 21 but the identity of Henderson given here seems improbable

I A COTTAGE IN ST. ALBANS, *Victoria and Albert Museum* (cat. 25)

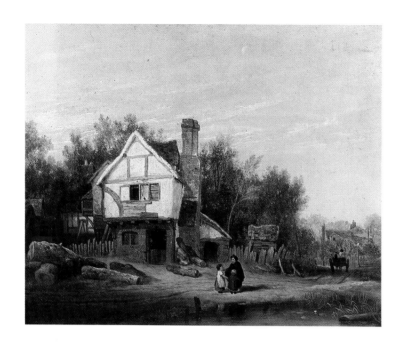

II LANDSCAPE WITH COTTAGES,
Victoria and Albert Museum (cat. 30)

III LANDSCAPE: THE FORGE, *Syndics of the Fitzwilliam Museum, Cambridge* (cat. 11)

34

IV THE MALL, KENSINGTON GRAVEL PITS, *Victoria and Albert Museum* (cat. 22)

V NEAR THE MALL, KENSINGTON GRAVEL PITS, *Victoria and Albert Museum* (cat. 23)

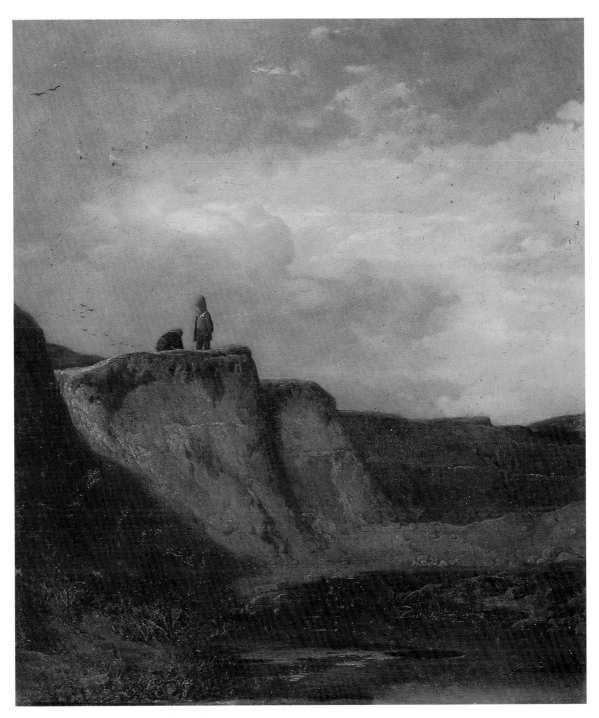

VI A GRAVEL PIT, *Lord Northbrook* (cat. 9)

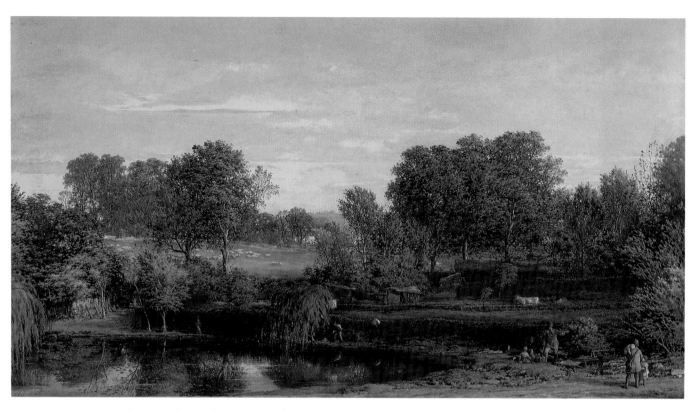

VII BLACKHEATH PARK, *Victoria and Albert Museum* (cat. 24)

VIII SELF PORTRAIT, *Mrs Everel Wood*
(cat. 65)

IX MISS ELIZABETH SWINBURNE, *private collection* (cat. 56)

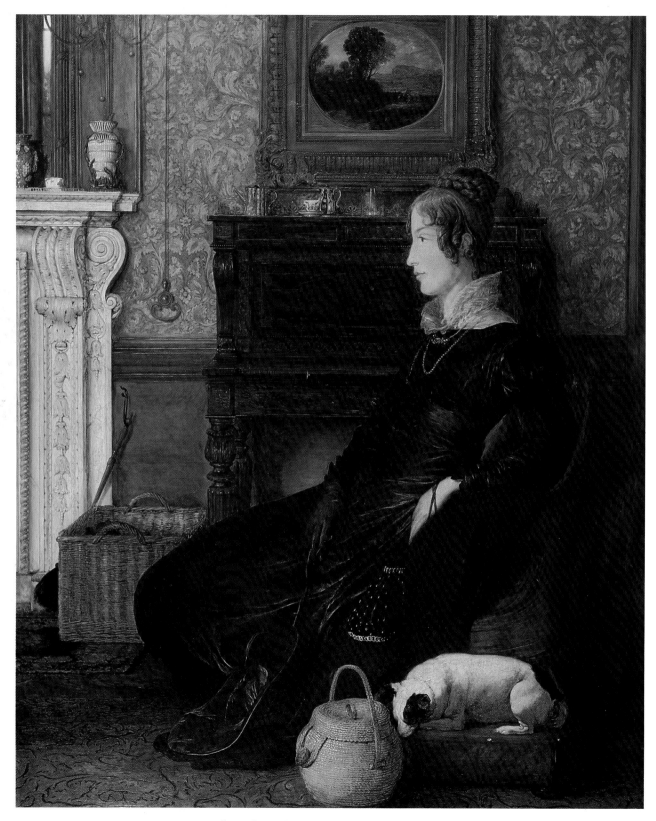

X THE COUNTESS OF DARTMOUTH, *private collection* (cat. 67)

in emulation of Monro, Henderson gave Girtin and Turner the opportunity of copying works in his collection including examples of the work of Canaletto.[13] The engagement with the varied patterns and colour of ageing masonry that characterises paintings like Mulready's St Albans view as well as many works of the Varleys and Linnell of the same period may well have originated in a sympathetic study of Canaletto. If John Henderson purchased works from Mulready, then the artist may have had access to his house and his collection.

The Kensington school did not survive long. Augustus Wall Callcott who had produced some remarkably direct genre scenes between 1807 and 1811 went on to paint for a market in large-scale European port and marine subjects. At an unspecified date he rationalized this move when he wrote:

> 'the perfection of a painter's eye is to reverse the common orders of observing nature, it is to acquire from habit the power of perceiving variety in what is generally considered as unity and unity in what to others appears a collection of individual things'[14]

Linnell opted for success through the depiction of generalised pastoral scenery, William Henry Hunt – whose serious physical disability had always made it difficult for him to go out sketching – concentrated on a microscopic view of a tiny area of nature earning for himself the title of 'Bird's Nest Hunt' and painted exquisite interiors in watercolour. Mulready, for his part, followed Wilkie's example and took up subject painting and in addition developed his own form of refined of pastoral.

Constable's oft quoted remark on his contemporaries suggests that despite the brevity of the Kensington artists' practice as producers of Landscape portraying their immediate environment, their work had made an impact. Writing to C.R. Leslie in 1832 Constable groaned: 'What must I feel when I knock my head against the clouds and waves of poor Callcott – or breathe the stagnant sulphur of Turner – or smell the . . . of a publick house skittle ground by Collins – or be smothered in a privy by Linnell or Mulready – but let them alone, is best of all.'[15]

A younger generation was, however, ready to learn to look at the details of everyday landscape. Samuel Palmer's sketchbook of 1819 reveals a searching, analytical approach

17. A. W. CALLCOTT, COW BOYS, *Herbert Art Gallery, Coventry*

to his surroundings. In 1874 Palmer recalled Mulready as a 'disciple of exactness': 'Mulready recommended the copying sometimes objects which were not beautiful, to cut away the adventitious aid of association. A very inaccurate imitation of a bunch of grapes will be pleasing in virtue of the subject; but when I have gone to school to a potato in black and white chalk, I have found it difficult to make it unmistakeably like.'[16] The Kensington environment during the first two decades of the century provided the opportunity for Mulready's experiment life-size. Samuel Palmer also remembered Mulready having said: 'We cannot proceed a step without anatomy; and in landscape what is analogous to it. We cannot rightly see or imitate what is before us without understanding structure.'[17]

[13] Roget, I 86–7
[14] Augustus Wall Callcott, Notes on Landsc. MS. Whitelegge coll. nd F.35, on deposit, Ashmolean Museum, Oxford
[15] *John Constable's Correspondence*, Ipswich, Suffolk Rec. Soc. III, 1965, 17 Dec. 1832
[16] *The Letters of Samuel Palmer*, ed. R. Lister, Oxford, 1974, S. Palmer to P.G. Hamerton, Feb. 1874
[17] Ibid, S. Palmer to L.R. Valpy, May 1875

18. JOHN CROME, VIEW ON MOUSEHOLD HEATH NEAR NORWICH, *Victoria and Albert Museum* (cat. 10)

The Kensington artists left their mark on the younger generation. Yet their failure to continue in the practice they had established requires some explanation. One reason must be that patrons prepared to pay good prices for cottage subjects and vernacular landscapes were not forthcoming. Wilkie's overnight success with *The Blind Fiddler* (1807) opened the eyes of artists and patrons alike to the possibilities of a new genre, the British subject piece. This was an ideal compromise for the collector who admired Dutch art but wanted something with a more pronounced moral overtone than he could find in De Hoogh or Teniers, who felt that Landscape – associated as it was with Topography – was an inferior branch of art, but that History painting was too grand for him. Wilkie who went sketching with Linnell and Mulready, was the link between the landscape artists and the new

subject painting. The old buildings which the Varleys, Linnell and Mulready were painting for their own sake, were used by Wilkie as background for his pictures. The study of crumbling plaster and lath cost him much effort and he was wont to say after working away at an old projecting house in Jew's Row for the background of his *Chelsea Pensioners*: 'I am awkward and slow at anything like landscape'.[18] But Wilkie could command higher prices for his subject paintings with cottage backgrounds than ever Mulready could for his cottage subjects with landscape backgrounds. Wilkie was paid fifty guineas for *The Blind Fiddler* whereas Mulready received on average ten pounds for his cottage scenes.

A further reason for the changing practices of the Kensington based artists must lie in the fact that London,

[18] A. Cunningham, op. cit. II, 53

from around 1820, became the centre of the European art market.[19] With the arrival of the Elgin marbles in 1808, protagonists of High Art like Benjamin Robert Haydon were determined to re-vitalize the Reynoldsian struggle to establish an English school of History painting founded upon classical principles. At the same time Constable's project was the re-vitalization of a Landscape tradition going back to Claude, Poussin and Rubens. Now, just as a group of young artists inclined to naturalism and open air sketching were beginning to consolidate and extend their practice,[20] just as the Society of Painters in Water-colours and the British Institution were established im-plicitly challenging the pre-eminence of the Royal Academy by providing alternative exhibition space, a vast influx of old master paintings asserted an influence towards tra-ditional values and genres in the execution of painting and the collection of works of art. The British Institution reinforced this by the practice, after 1815, of arranging exhibitions of old masters. The possibility of closely study-ing the surfaces of old master paintings was beneficial to the young artist attempting to learn technique for no tuition was provided in painting in a formal sense in the Royal Academy schools. The intensification of colour that is evident in Mulready's work from the mid 'twenties may well be due to his having studied paintings in exhibitions and in the sale rooms for he never went abroad.

PART III

In the summer of 1803, John Varley made a sketching tour of Yorkshire. It was a year of intense activity and ferment among Landscape artists; Cornelius Varley was in Wales, Cristall and Hills were both on sketching tours. It seems more than likely that Varley took his seventeen-year-old pupil with him. Mulready's earliest dated Landscape drawings are slight and tentative pencil sketches of a cottage at Kirkstall dated 22 July 1803 and executed in the dot-and-dash outline manner reminiscent of that which Girtin had perfected by 1799[1] and a sketch of the porch of St. Margaret's, York also dated 1803 (I).[2]

A watercolour of the same subject dated 1804 derives from this drawing and suggests that Mulready had by this date acquired considerable mastery over his medium (cat. 2–4). The purpose of such sketching tours was to provide the basis for works subsequently painted in his studio. Mulready accordingly in 1804 sent a view of the crypt at Kirkstall to the Academy (cf 2)[3] and the follow-ing year he exhibited the watercolour view of St. Mar-garet's already mentioned.[4] It must have been during this 1803 tour that Mulready also drew the Chapter House of Kirkstall, a view that was engraved and pub-lished in 1827[5] as well as several other Yorkshire views that are on record (3).[6]

From 1803 for the next few years we find Mulready sketching on the Isle of Wight, at Windsor, Eton and many of the places popular with watercolour painters of the time.[7] At the same time as he was sketching out of doors, perfecting his technique, Mulready was attempting to establish himself as a History painter. In 1804 he painted *The Disobedient Prophet* and *Ulysses*; both works are lost but a number of sketches suggest that he may have been attempting to execute the kind of epic and historical landscape subject advocated by the sketching club that

[19] F. Haskell, *Rediscoveries in Art: Some aspects of Taste, Fashion and Collecting in England and France*, 1976, pp. 25–6
[20] Mulready and Linnell took William Godwin's son to Hampstead Heath to sketch in 1808

[1] Jupp cat. Royal Academy Library
[2] British Museum
[3] KH, cat. 2
[4] Ex KH
[5] J. Cousen, *An Historical, Antiquarian and Picturesque Account of Kirkstall Abbey*, 1827
[6] KH infers more than one tour
[7] FGS, 1867 gives list of locations visited at this time

had been established by Francia, Girtin and others in 1799.[8]

He seems to have soon abandoned the attempt. Apart from *Endymion* of 1808 and *The Supper at Emmaeus* of 1809 there is no further record of paintings within this genre apart from an isolated *The Flight into Egypt* in 1838 (also lost). Genre subjects and studies for the class of figures that was to become a focus of Mulready's art first appear around 1804. Two watercolours of market women reminiscent in manner of Joshua Cristall, one of which is dated 1804, provide some indication of figure style at this time (89, cat. 146, 147). *Old Kaspar* of 1806 (and another version of 1808) are lost as is *The Girl at work* also of 1808 but *The Rattle* (XIII, cat. 101) establishes Mulready's high degree of technical accomplishment at this date. The fact that Mulready sent nothing to the Academy in 1805 was probably due to the fact that he was extensively employed by William Godwin on the illustration of children's books that year (79, 80, cat. 120). A series of energetic oil studies of the sandy banks of Hampstead Heath seen from a low view-point with bright skies against which cattle, herdsmen or horses and carts are silhouetted reveal a debt to Cuyp (9–11) but also testify to Mulready's rapidly gaining confidence in the free handling of oil. Working on a small scale,[9] Mulready builds up a surface with the bold use of dry white and heavy impasto.

A further series of paintings dating from 1806–7 and executed in oil on board can loosely be described as cottage subjects; here Mulready scrutinizes the structure and the texture of humble domestic buildings without embellishment, foliage and with very little in the way of human ornament. Figures, when they occur, are small. They relate to the tubby, short-legged children who inhabit Mulready's book illustrations for Godwin and do not challenge the powerful display of buildings and other inanimate structures that dominate the picture field. *The Lock Gate* (14)[10] and Mulready's two known paintings of gravel pits were also painted between 1806 and 1808 though none was sold until later. *A Gravel Pit* (VI),[11] finally bought in 1848 by Thomas Baring, the discerning collector of Dutch painting, is a strikingly simple composition reducing the pictorial conventions of Ruisdael and Wouwermans, conventions that were contempor-

aneously being re-worked also by Crome, to the most basic framework within which to transcribe a fragment of worked over, and abandoned, landscape. The scarred face of the escarpment where the gravel has been dug is rendered with less attention to finish than one might expect in the work of a young artist emulating the Dutch masters but with great sensitivity to rich earth colours. Ruskin, bewailing what he saw as the affectation of Mulready's later landscape details, invoked the power of this painting of a piece of Kensington wasteland: 'that simplest, that deepest of all secrets, which gives such majesty to the ragged leaves about the edges of the pond . . . and imparts a strange interest to the ragged urchins disappearing behind the bank, that bank so low, so familiar, so sublime!'[12]

Paintings of this period that did find purchasers were Mulready's views of old cottages in and near St. Albans.[13] In these works he abandons architectural and geographical exactitude in favour of a preoccupation with variations of light and of texture, and with the pattern produced by uneven, assymetrical buildings set one against the other in close proximity. The nature of the subject is precisely that which appealed to seekers after picturesque views; Heleniak has described *A Cottage in St. Albans* (I) as a painting in which 'a black hooded woman, dark air-born birds, and a somber threatening sky cast a morbidly Romantic mood over the scene.'[14] These views are certainly disconcerting and compelling but the features listed by Heleniak do not in themselves, as objective correlatives, produce mood; they are merely the readily identifiable components in a complex structure of which the affect is anxiety. The visual vocabulary is familiar from Dutch seventeenth-century paintings and from late eighteenth-century theories of the Picturesque. Mulready has taken that vocabulary and employed it, concentrated it, and reconstructed it. It is in the relationship between com-

[8] For sketches see Rorimer
[9] KH assumes these are *plein-air* studies but there is no evidence for this KH p. 39, p. 45
[10] Unaccepted by KH
[11] KH cat. 34
[12] J Ruskin, *Modern Painters*, II, 336–7, Library ed. 1903, IV
[13] KH, cat. 23, 24, 25, 35, 68
[14] KH p. 56

ponents and in the absence of those components that mood is produced. We can see how this happens by looking closely at some of these works.

In several views of this period [*Landscape with cottage*, (6); *Cottage and Figures* (4); *A Cottage in St. Albans* (1)] the immediate foreground is occupied by water. The middle ground prominently contains the motif of the cottage and the human figures. The distance echoes the middle ground in so far as it contains an equivalent structure and a highlit area which correlates with the figures and the cottage. The distance and the foreground present inchoate, unconstructed, incomplete forms in contrast with the highly wrought construction occupying the centre ground. The uneven posts, the vague blur of St. Albans Abbey tower, a woodland and a flock of sheep and especially, the dark uncertainty of water in the foreground, impel the viewer to the middle ground. The presence of humanity outside the cottages provides a scale against which the architecture can be measured. But it is a false scale. In so far as can be assessed, the figures are too small to function convincingly within the construct of Reality created in the field of the painting.

Imagine the doorway of a 'Medieval' cottage, place two adults some yards in front of it and you would not have figures of the scale of those in *An Old Cottage in St. Albans*. Moreover, the separation of the human beings from the houses, a separation that is reinforced by violent contrasts of light and shade, by the careful sculpting of the architectural profile and by touches like the bright vertical of the old man's stick, concentrates attention upon the monumentalised cottage. In *Landscape with Cottages* (11) and *Landscape with Cottage, trees and Children* (7)[15] gigantic sawn logs have to be traversed before the eye can examine the dominating structure of the cottage.

In narrative terms the trees, the water, the sandy bank and the human beings are all the components out of which cottages are produced. But the structure of the cottages invites enquiry, establishes within the domain of the visible, a terrain of knowledge concerning material substance, a terrain with distinct and clearly signalled boundaries. To take the Tate Gallery *Cottage and Figures* (4), plaster and lath, doorways and shutters, display themselves with an openness and a formal harmony. But those

very displayed surfaces also deny the three dimensionality of 'house' as we know it. Chimney stacks, doorways and the adjacent building at the left all signal 'house' but the surface confounds that expectation. For all its clarity, we know no more of this structure than we know of St. Albans Abbey Tower in the misty distance. The pressing question: What can be on the other side poses itself urgently in relation to *A Cottage, St. Albans* (1).[16] The assymetry of its structure defies comprehension of the cottage as complete and apprehensible object. What can be known is clearly indicated: brick and tile, plaster, wood, glass, window openings. The very tactile quality of these items provokes anxiety at the impossibility of 'reading' the remainder. It is interesting to observe that Mulready's drawings of cottages, the basic recording from which the paintings were constructed, seldom possess the same tension, being much more in the way of regular topographical depictions or suggestive picturesque views.

[15] KH, cat. 68, 35
[16] KH, cat. 13

45

PART IV

From 1809–12, Mulready became increasingly interested in the human narrative enacted within landscape. *The Rattle*, painted in 1807 (XIII)[1] and *The Carpenter's Shop* (1808) (67)[2] are extensions of the St. Albans and Kensington Cottage scenes in so far as they open up for inspection the interior of the vernacular buildings which had been the object of examination from outside. And this is particularly true of *The Rattle* with its uncluttered surfaces and its magic vista through beams and struts to the warmly lit hay-loft. *Gipsy Encampment* (15, cat. 153), *An Old Gable* (cat. 148), *Horses Baiting* (19, cat. 151) and *Landscape the Forge* (III, cat. 11) are all examples of Mulready's treatment of rural themes at this period.[3]

In the last of these paintings, variations of light and the suggestion of changes in the weather are, as with the earlier cottage scenes, of great importance but they are less dramatic: the relationship between the figures and the solid structures has become one of difused narrative rather than intense event. The heavy shadow cast by the window shutters, the mysterious still depth of the wood on the right, as well as the straight line of smoke from the forge chimney, all suggest imminent rain and a time of day in the late afternoon. The figures in the painting are abruptly staccato, disconnected focal points; to the right an old man with a bundle over his shoulder wends his way home down a lane, a woman feeds hens, a man wheels a barrow and a dog loiters in the bottom right corner marking the extreme boundary of the pictorial field. The central episode of shoeing the horse is given no more attention than the two men who sharpen a knife at a millstone. Marks on the left hand side of the shed indicate where someone has recently removed a poster. All this desultory activity takes place in a landscape distanced from the viewer, open in format and rising to the centre of the picture at the point where the lop-sided roof of the forge marks the summit of the elevation of land. The huge beech tree to the right reinforces the lack of congruity in the human activity and the effect of realism that derives from the deliberated lack of organisation in the foreground area. The overall effect is one in which labour is presented as an isolating and fragmented

19. HORSES BAITING, *Whitworth Art Gallery, Manchester* (cat. 151)

experience in landscape, distanced from the viewer and spread across the pictorial field. It is testimony to Mulready's deliberate and careful control over his subject-matter, a control which allowed him to protect his own acquired identity as an inhabitant of the city and an artist disassociated from an Irish background. On another level the painting suggests a sophisticated exploration of the tension between landscape space and human narrative of the kind that finds a more profound rendering in Constable's *Boat Building at Flatford Mill* of 1815 where, as John Barrell has pointed out, the figures that throng the sketch have been absorbed into the landscape and moved away from the foreground.[4]

[1] KH cat. 36
[2] KH cat. 42
[3] KH cat. 67, 53, 61, 200; KH disallows the last of these but see M. Pointon, *Times Literary Supplement*, 24 Oct. 1980 for a defence
[4] J. Barrell, The Dark Side of the Landscape: the Rural Poor in English Painting 1730–1840, Cambridge, 1980, p. 133

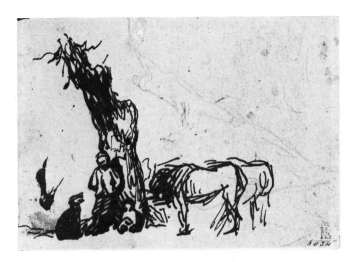

20. STUDY FOR HORSES BAITING, *Victoria and Albert Museum*

21. STUDY FOR THE MALL, *Victoria and Albert Museum*

The culmination of this series were two landscapes, *The Mall* and *Near the Mall* (IV and V, cat. 22 and 23).[5] Both represent the Kensington Gravel Pits close to Mulready's home. In both works there is considerable narrative interest; the children with their cart in *The Mall* are matched by the tinker and his donkey in the pendant. Motifs such as these were developed for their own sake in paintings after 1812. Painted between 1811 and 1812 these two works were evidently treated by Mulready as particularly important; the loving attention to detail and location is rendered on canvas instead of on the panels which the artist customarily employed at this period, perhaps suggesting an aspiration to eighteenth-century

academic practice. But Mulready was also clearly working within a convention for the depiction of street scenes. Topographical views of the area such as the watercolour dated 1811, and probably by J. or R. Schnebbelie, showing St. Petersburg cottages, Bayswater (within yards of Mulready's home and the location of the Gravel Pits, 38, cat. 19) and Paul Sandby's views of c.1800 (29) continue a tradition clearly established with Chatelain and Roberts's views of 1750 that were frequently reproduced and replicated (33, cat. 14). A straight passage, flanked by walls and punctuated by human figures was a standard form for urban depictions. The quality of recession in the street scenes that Mulready later developed may owe something to the popularity at this period of perspective views designed to be looked at in special mechanical devices.[6]

It may have been as much this kind of association as the remainder of the Dutch school (which was, after all, beginning to be in favour) that rendered the paintings unacceptable to the patron who had commissioned them via Augustus Wall Callcott. They were also rejected by the Royal Academy. F.G. Stephens suggests that the gentlemen concerned were insufficiently educated to admit, still less to admire, anything so literal.[7] Yet comparison with Mulready's preparatory sketches suggests that they were far from literal. The influence of Crome's mellow landscape tints and the careful symmetry of composition apparent in the finished canvases is absent from the preparatory work. In the canvases, moreover, the houses are higher and the shapes of the trees modified, the fences and walls adjusted. By 1844 when the two pictures were, finally, exhibited at the Royal Academy in 1844 they were described in the *Art Union* as 'gems of rare value.'[8] After Mulready's death a writer in *The Art Journal* recognised the promise of *The Mall* and *Near the Mall* saying 'He must have been within a little of devoting himself to landscape and street scenery, and it is difficult to understand how he escaped this, considering the mastery of such works . . . and others of the same kind.'[9]

[5] KH cat. 78, 79
[6] See C.J. Kaldenbach, 'Perspective Views', *Print Quarterly*, vol II, no. 2, June 1985
[7] FGS 1867, p. 67
[8] *Art Union*, 1844, p. 161
[9] *Art Journal*, 1864, p. 130

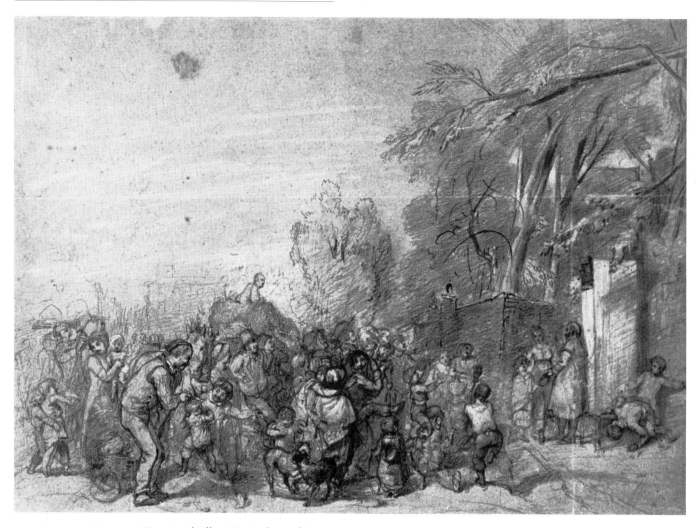

22. CARTOON FOR PUNCH, *Victoria and Albert Museum* (cat. 32)

The ambivalence of an observation that recognises mastery but nevertheless sees Mulready's departure as an 'escape' is typical of the criticism of realisms in the nineteenth century.

Mulready's defection from landscape and street scenes to subject paintings was not, however, a sudden one. The decisive incident may have been the rejection of *The Mall* and *Near the Mall* but there is actually no great difference between these two paintings and *Punch* of 1813 (in so far as it can be reconstituted from sketches, 22, 23, cat. 31 and 32) or *Boys Fishing* of 1814 (27) although the titles of these works suggest that they are less landscape than subject paintings.[10] The setting for *Punch* is Kensington Church Street and, like *The Mall* and *Near the Mall*

features townscape and park wall (the wall around Campden House), mature trees and distant houses. The only real difference seems to be that in *Punch* Mulready introduces far more figures, probably in an attempt to capitalize on Wilkie's success. Though the figures are more numerous than in the Mall paintings they are not depicted on a larger scale nor in a closer relationship to the spectator than those in the earlier Gravel Pits paintings.

As early as 1806 in *A View in St. Albans*[11] the first ideas for a townscape had taken the form of dark and light areas massed roughly in chalk on paper. The chiaroscuro drawing became one of the artist's most important

[10] KH cat. 85, 81
[11] Rorimer, cat. 50

48

23. OIL STUDY FOR PUNCH, *Victoria and Albert Museum* (cat. 31)

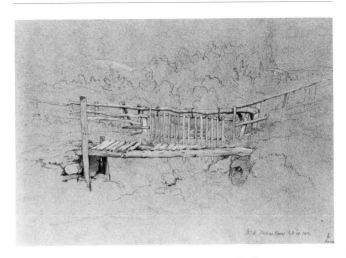

24. DRAWING OF MOUNCES KNOWE, *Victoria and Albert Museum* (cat. 6)

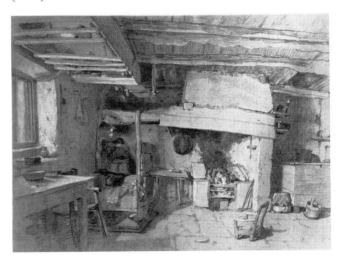

25. INTERIOR OF A HERD'S HOUSE, MOUNCES, *Trustees of the British Museum* (cat. 155)

ways of working. It is significant that *Near the Mall*, in which owing to the trees and the hillside at the back the genre element appears much less prominent than in its pendant, is less effective of the pair. There are other indications too that Mulready was at this time grappling with problems not essentially linked with landscape when he painted *The Mall* in 1811–12. The child picked out in a patch of light against the bright house wall at the far end of the alley, and the figure of the old man seiving by the water butt in the left foreground are not there for exclusively narrative purposes. The relationship between figure and object: bending man and seive, barrel and seive, barrel and man, continued to intrigue Mulready all his life and led him to include highly-wrought still-life studies in paintings which publicly proclaim themselves to be portraits or subject paintings. The most notable examples are, perhaps, the surroundings of the Countess of Dartmouth (X, cat. 67) and the interior of Sheepshanks' house (XII, cat. 78).[12] Also notable are the basket of lavendar in the background to *The Butt* (XXVI, cat. 142, 143)[13] and the objects on the mantelpiece in *Father and Child* (XIV, cat. 109).[14] In works such as these the attention to the object attains the level of fetishization; a process whereby the vitality of the subject is displaced upon the surrounding objects which become a focus for desire. This is particularly interesting in the Dartmouth portrait which was painted posthumously.

The poignant effect that could be produced by isolat-ing a figure in a splash of light was learned by Mulready from De Hoogh and used consistently to great effect in his paintings from this time on. The stillness of the single figure against a high wall contrasting with the busy foreground movement evokes a sense of varying experiences of the passage of time. The remote figure, isolated in light in *The Mall* (IV) is an image that Mulready repeated in *The Village Buffoon*, 1815–16 (XXIII) and in *The Careless Messenger*, 1821 (XX).[15] In both these paint-

[12] KH, cat. 114, 133
[13] KH, cat. 166
[14] KH, cat. 117
[15] KH, cat. 94, 102

26. CAPHEATON, A WOOD AT SUNSET, *National Gallery of Ireland, Dublin* (cat. 7 ii)

28. STUDY FOR BOYS FISHING, *Victoria and Albert Museum*

ings, the violent movements of the foreground figures are offset by a moment of tranquil, timeless beauty in the distance, separated from us by bands of shadow and endowed thus with lyricism and nostalgia. Sometimes it is the motionless figure of an old man, sometimes it is a mother and child walking under shady trees or a gentleman stopping to talk with a waterseller. Mulready's preference for doors opening into other rooms or receding vistas flanked by brick walls can thus be seen as not only allusive to fashionable Dutch images but also a calculated compositional choice in the creation of pictorial equivalents of the intervals of time and space, an evocation of what is other, outside of the time and place of the representation. The formal origin of the motif of the figure counterpoised against a wall would seem to owe as much to Mulready's

acquaintance with late eighteenth-century Fable illustrations as to Dutch painting. John Bewick's engravings to Trusler's *Proverbs exemplified and illustrated by pictures from real life*, 1790 (82) provide the precise equivalent for this psychological use of space and more will be said of this in a later chapter. The 'real life' context of Mulready's subject matter (the streets of Kensington, Notting Hill and Bayswater) is transformed by the dual frame of reference provided by the Dutch painting and the child's book illustration both of which serve to distance and render timeless the representation of place. The reparation is experienced on the level of geography and psychology; the viewer need no longer be an adult in an area of London that was, at least in parts, extremely poor, but can be a child in a fantasy environment that has retained its 'realism' and hence its feel of home – familiarity.

Boys Fishing of 1813 (27)[16] is, despite its title, virtually uninterrupted landscape and is extremely classical in composition. This is a lush, green riverside scene with a vista through and beyond a bridge over which horses and waggons are passing. Mulready's account book reveals that he began work on this subject in 1812 though it was not exhibited at the Academy until 1814. Constable showed his *Boys Fishing* in 1813, and, judging by the appearance of the work that has been identified with this exhibit, it is reasonable to raise questions about the priority of influence between Constable and Mulready.[17] Mulready was at this period painting with the sort of attention to technical finish that Constable was advised to attempt in order to achieve success. The features of Mulready's *Boys Fishing* (the farmhouse, the bridge, the boys, the still water overhung with trees) are also components in Constable's work.

Although there are no further completed and exhibited landscapes until *Blackheath Park* of 1852 (VII), landscape remains prominent in paintings like *A Sailing Match* (XIX), *The Sonnet* (XXXIV), *The Convalescent from Waterloo* (XXVII), *Brother and Sister* (XXXVI) and *Train up a Child* (XII). Redgrave suggests that Mulready painted his landscape backgrounds from memory and F.G. Stephens views them as weak; presumably he found them lacking the

[16] KH, cat. 81
[17] National Trust, Anglesey Abbey

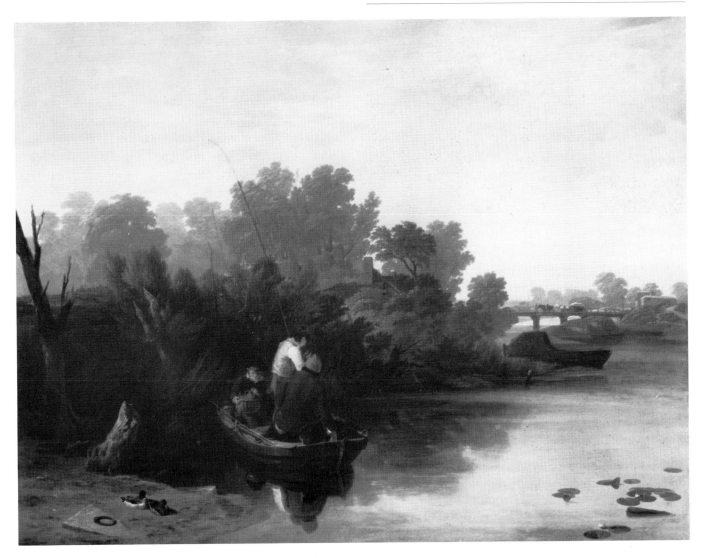

27. BOYS FISHING, *His Grace the Duke of Westminster*, DL (cat. 156)

Pre-Raphaelite plenitude and attention to observed detail.[18] A series of photographs of landscapes were in the artist's possession at the time of his death.[19] These may account for the mannered treatment of trees which Ruskin so disliked[20] and the thinly painted generalised, panoramic backgrounds that are a feature of some of these paintings. But the use of photographs is a symptom, not a cause, of Mulready's evident need to distance himself from the actual; the process is complicated for, on the one hand he continued to draw from nature at least until 1845 but on the other hand the procedure for producing paintings resulted in unindividualised backgrounds like that to *The*

First Voyage or *Brother and Sister*. The act of painting (picture-making) had become divorced from the process of observing.

Blackheath Park, Mulready's last recorded landscape, begun in 1832 but not finished until 1852, was a view from John Sheepshanks's house (VII, cat. 24).[21] It is a synthesis of the preoccupations, problematics and constraints that we have been discussing in this chapter. Mulready here has distanced himself both from his Kensington environ-

[18] FGS, 1867, p. 118
[19] Mulready's sale, Christie's 28 April 1864 (lot 65)
[20] J. Ruskin, *Modern Painters*, II, *Works*, IV Library edn. 1903, 336–7
[21] KH, cat. 168

ment and from the everyday iconography of the street scene. The subject is the grounds of a gentleman's country residence south of London. Mulready completed the view in minute detail and brilliant colour which inspired *The Athenaeum*, in a tone of apparently condescending but coded approbation, to describe it as a 'refreshing little *green* bit of nature.'[22] *The Art Journal*, similarly, pronounced it to be a 'pre-Raffaellesque eccentricity . . . scarcely expected . . . under this name . . . a minute transcription from a locality of no pictorial quality'. . . . The writer goes on to say, however, that 'in the whole there is an attractive softness and sweetness of execution, which we presume is proposed as a lesson to those youths who "babble of green fields" '[23]

Although the colour of *Blackheath Park* is bright and the artist had certainly by this date met members of the Brotherhood in his capacity as teacher in the Royal Academy Schools and as a member of the Hanging Committee, it is important to realize that detail of execution and brilliance of colour need not, at this date, necessarily derive from Pre-Raphaelite innovations. J.F. Lewis, Francis Danby and Samuel Palmer were all painting in bright, if not strident, colours before 1852. In the early 'fifties Linnell (to whose work *Blackheath Park* is not dissimilar) was painting minutely detailed landscapes peopled with small-scale rustics and children.

It was presumably on account of the presence of labourers digging a trench in *Blackheath Park* that the *Art Journal* dismissed the location as 'of no pictorial quality'. Yet the view is extremely pictorial; with the artifice of its wide panoramic view and the pastoral quality that the *Art Journal* also picked up, it lacks the 'slice of life' quality of Jacques Louis David's view of the Luxembourg Gardens from his prison window or Constable's view of his father's garden seen from an upstairs window. Indeed the workaday figures translated into this highly wrought landscape with its crystalline reflective pool lose all Georgic associations before the pressure of the Arcadian. Far from Mulready having been influenced by the Pre-Raphaelites, it seems much more likely that Ford Madox Brown, who began *An English Autumn Afternoon* in the early Autumn of 1852 was influenced by Mulready, whose *Blackheath Park* was exhibited in the summer of that year.

Viewing *Blackheath Park* at the Exposition Universelle of 1855, Gautier was reminded of 'ces paysages si prodigieusement finis de Buttura, ou l'on pouvait compter jusqu'au dernier plan les feuilles, d'arbres et les brins d'herbe'.[24] E.F. Buttura was a recently deceased miscrocopist. Mulready's interest in Botany extended beyond questions of representation; he numbered among his friends and patrons George Loddiges, the Hackney horticulturalist (1784–1846) and his brother Conrad who collaborated in producing the *Botanical Cabinet* between 1813 and 1833.[25] In 1821, Mulready took Sir John Swinburne to visit George Cooke, the engraver responsible for the plates in *The Botanical Cabinet*. Cooke lived in Loddiges Row, Hackney and after calling on him, Mulready took Sir John to look at Loddiges' nursery.[26] Mulready had ambitious plans to stock his own garden with specimens from the nursery and made many designs for the lay-out of flower beds and shrubberies.[27] He cultivated his garden with enthusiasm at first but soon lost interest and neglected it. Ultimately the garden of his friend and patron, John Sheepshanks, re-produced on canvas, was to prove a more lasting testimony.

[22] *Athenaeum*, no. 1280, 8 May 1852, 519
[23] *Art Journal*. 1852, p. 167
[24] T. Gautier, *Les Beaux Arts en Europe*, Paris, 1855, p. 19 passim
[25] Conrad bought *Returning from the Hustings*; for details of the family see W. Blunt, *The Art of Botanical Illustration*, 1950 and H.R. Fletcher, *The Story of the Royal Horticultural Society, 1804–1968*, Oxford, 1969
[26] W. Mulready to George Cooke, 19?, 1821, MS. coll. K. Lohf, NY
[27] Rorimer, 468–74

SECTION I
LOCATIONS FOR LIVING: PLACES FOR PAINTING

'So low, so familiar, so sublime!' John Ruskin on Mulready's A GRAVEL PIT

1

COTTAGE AND FIGURES, c.1806–7
Oil on board, $15\frac{5}{8} \times 13\frac{1}{8}$in.
Trustees of the Tate Gallery, London (4)

Mulready's treatment of Picturesque motifs at this period reveals, in common with that of Linnell, Cornelius Varley and William Henry Hunt, a powerful predilection for formal analysis of structure. Notice the varied and broken outline of the building against the sky and the way in which contradictory textures are piled vertically – water, sand, plaster, lath – in a pattern that, in its abstract quality, challenges the narrative in the foreground and the identifiable feature of St. Albans Abbey tower in the distance.

2

PORCH OF ST. MARGARET'S, YORK
Signed and dated 1803
Ink and watercolour, $12\frac{3}{4} \times 6\frac{1}{2}$in.
Trustees of the British Museum, London

Mulready is known to have toured Yorkshire in 1803; dated drawings of Kirkstall Abbey and a cottage in Kirkstall survive in the Royal Academy, Jupp catalogue (1803). John Varley, Mulready's early mentor and his father-in-law, went on a tour of Yorkshire in 1803 and it is likely that the two men were companions. A version of this view by Varley but slightly more extensive is in the Museum; VAM, 780–1870. St. Margaret's was of considerable antiquarian interest and was a standard tourist site in the eighteenth century.

3

PORCH OF ST. MARGARET'S, YORK
Signed and dated 1804
Watercolour on grey paper, $13 \times 9\frac{1}{8}$in.
Private collection (1)

A replica or alternative version of number 2; both drawings reveal Mulready as a very competent antiquarian draughtsman by the age of eighteen.

4

AN HISTORICAL, ANTIQUARIAN AND PICTURESQUE ACCOUNT OF KIRKSTALL ABBEY, 1827
Victoria and Albert Museum Library (3)

Mulready is known to have executed an oil of the crypt of Kirkstall Abbey: 1804, formerly C.W. Cope collection, now unlocated. A drawing of the West front by Mulready is in the Museum: VAM P49–1936. Kirkstall was one of the most popular Yorkshire sites for the Picturesque traveller and was written about by Edward Dayes in *Excursion through*

29. PAUL SANDBY, AN OLD PUBLIC HOUSE, BAYSWATER, *Victoria and Albert Museum*

the Principal Parts of Derbyshire and Yorkshire – published posthumously in 1805 – as well as depicted by numerous artists including Girtin. A drawing of the same subject is in the Royal Academy, Jupp catalogue (2).

5

C. VARLEY

HOLLAND STREET, BLACKFRIARS, c.1808

Pencil, $12\frac{1}{8} \times 8\frac{7}{8}$in.

Trustees of the British Museum, London

Mulready was closely associated with John and Cornelius Varley and married their sister, Elizabeth. The Varleys, Mulready and Linnell in the early years of the century explored the city and the environs of London, sketching objects that were picturesque in their dilapidation and decay. Mulready's interest in decrepit cottage structures can be compared with Cornelius Varley's analytic eye as manifest in this drawing. The motif, typically detached from its context and devoid of function, is treated to a detailed examination of its parts and their relation to a now incomplete whole. See also 87.

6

MOUNCES KNOWE

Black & white chalk on grey-green paper, $10\frac{1}{8} \times 14\frac{1}{2}$in.

Victoria and Albert Museum (6089) (24)

Mounces Knowe was a beauty spot in Northumberland and a picnic site greatly favoured by the Swinburne family with whom Mulready spent many summers from 1814 onwards. The Museum owns a second drawing of the bridge, VAM 6090, and a third showing the bridge from the other side and dated 1814 is in a private collection. See also 155.

30. PLAN FROM A CONVEYANCE DATED 5 OCTOBER, 1849, location unknown, *Mansell Collection*

7

THREE STUDIES OF MORNING AND EVENING SKIES AT CAPHEATON, 1845–6 (26)

Pastel, all c. $3\frac{1}{2} \times 5\frac{1}{2}$in.

National Gallery of Ireland, Dublin

(i) STORMY CLOUDS AT SUNRISE (7005)

(ii) A WOOD AT SUNSET (7004)

(iii) FIGURES AMONG ROCKS AT SUNSET (7006)

These drawings belong to a series of nine executed in the winter of 1845–6 in the vicinity of Capheaton, the Northumberland home of Mulready's patron, Sir John Swinburne. They reveal a confidence with a medium that Mulready did not employ frequently though he used chalk to great effect in his Life studies. Works such as these as well as a number of annotated ink drawings of weather conditions indicate that Mulready came to share the concern of contemporaries like Constable and Turner with landscape under different light and weather conditions.

8

WILLIAM HENRY HUNT

LANDSCAPE WITH A COTTAGE

Watercolour, $13\frac{1}{8} \times 16\frac{3}{4}$in.

The Visitors of the Ashmolean Museum, Oxford

Like Mulready, Linnell and Varley, Hunt executed many studies of cottages in which varied textures and irregular forms are explored.

9

A GRAVEL PIT, 1807 or 1808

Oil on canvas, $15 \times 12\frac{1}{2}$in.

Lord Northbrook (VI)

This strikingly simple composition reduces the pictorial conventions of Ruisdael and Wouwerman to the most basic framework within which to transcribe a fragment of worked-over and abandoned landscape. The site is typical of the artist's Kensington environment where gravel digging, for supply to the West End building trade, was a staple industry.

10

JOHN CROME

VIEW ON MOUSEHOLD HEATH

Oil on canvas, $21\frac{1}{2} \times 32$in.

Victoria and Albert Museum (18)

Crome, Cotman and Mulready shared an interest in gravel pits and heath scenes, quarries and rough ground. Who initiated such motifs is difficult to ascertain but Crome, whilst working on a larger scale, offers the low view-point and the same concern with texture and the idiom of the worked landscape as we see in Mulready's Gravel Pit painting 9.

31. ANON, VIEW OF MULREADY'S HOUSE IN LINDEN GROVE, location unknown, photo: *Mansell Collection*

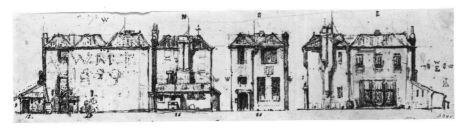

32 a and b TWO SKETCHES FOR A HOUSE, *Victoria and Albert Museum* (cat. 35)

I I

LANDSCAPE, THE FORGE, c.1811

Oil on canvas, $16\frac{1}{8} \times 20\frac{1}{2}$ in.

Syndics of the Fitzwilliam Museum, Cambridge (III)

Here Mulready can be seen to have moved from the intense concentration on structure exemplified in no.1 to an interest in a diffuse narrative event in a landscape within which are evident the effects of weather and time of day. The figures are abrupt and staccato, and the desultory activity in and around the forge takes place in a landscape distanced from the viewer, open in format and rising to the centre.

I2

JOHN LINNELL

TWO STUDIES OF KENSINGTON BRICK KILNS, 1812

Watercolour, ca. $5\frac{1}{8} \times 5\frac{3}{4}$ in.

Mrs Joan Linnell Ivimy (12, 13)

Kensington, Bayswater and Notting Hill Gate, where Mulready and his friends – among whom Linnell was probably the closest – sketched and painted was an area characterised by gravel pits and brick kilns. The unembroidered literal quality of these works is remarkable though it needs to be stressed that such depictions were private studies and were never intended by the artist for public display.

I3

WILLIAM MULREADY JUNIOR

NOTTING HILL FARM

Oil on canvas, $15 \times 18\frac{1}{2}$ in

Kensington Public Library

Notting Hill, or Kensington Gravel Pits as the area was known in the nineteenth century, retained its semi-rural character well into the nineteenth century. All Mulready's sons painted and William, the third son, attempted to earn a precarious livelihood by his art. See also 89.

14

CHATELAIN AND ROBERTS

THE SOUTH VIEW OF KENSINGTON,
c.1750

Engraving, $27\frac{3}{8} \times 19\frac{3}{4}$ in

Museum of London (33)

The village quality of Kensington recorded in this eighteenth-century view survived until the building boom of the 1830s. Perspective views like this were designed for use in a special optical machine; they often featured streets where all the horizontal lines in the buildings appear as lines converging at the same vanishing point. It is interesting to note that the strongly recessive street view was often employed by Mulready to great effect in his subject paintings, see, for example, 126.

15

J. WELLS

ONE TREE FIELD NEAR KENSINGTON,
1790

Watercolour, $8\frac{1}{2} \times 12\frac{7}{8}$ in

Museum of London (34)

This view by an amateur or semi-professional artist indicates the essentially rural character of Kensington which made it such an attractive location for schools and for leisure. It was regarded in the early years of the nineteenth century as a healthy resort; as it became built up from the 1830s those seeking open space close to London moved out to Hamspstead.

16

ANON

THE THREE HORSE SHOES NEAR
KENSINGTON GRAVEL PITS, 1795

Aquatint, $5\frac{1}{2} \times 7\frac{3}{8}$ in.

Museum of London (35)

The area abounded in picturesque inns and other ancient buildings which provided Mulready and his friends with objects of study and also supplied the cottage backgrounds to paintings like *Lending a Bite* 130 and *Fair Time* 149.

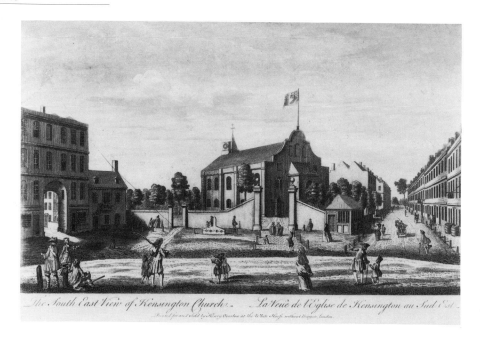

33. CHATELAIN AND ROBERTS, THE SOUTH VIEW OF KENSINGTON,
Museum of London (cat. 14)

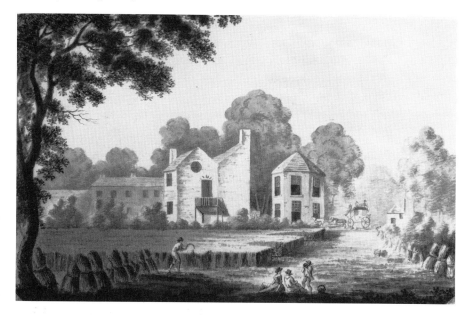

34. J. WELLS, ONE TREE FIELD NEAR KENSINGTON, *Museum of London* (cat. 15)

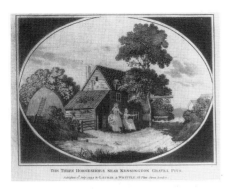

35. ANON. THE THREE HORSESHOES INN
NEAR KENSINGTON GRAVEL PITS,
Museum of London (cat. 16)

17

J. OR R. SCHNEBBELIE

PUB. J. STRATFORD,

KENSINGTON PALACE, 1805

Engraving, $3\frac{7}{8} \times 6\frac{1}{4}$ in.

Museum of London (36)

Mulready rented a house within easy reach
of the grounds of Kensington Palace which
were open to the public. The walls around
Kensington Gardens, Holland House and
Campden House with their gateways opening
onto parkland vistas provided the locations
for paintings such as *Punch, The Village Buffoon*
and *The Careless Messenger Detected*, 31, 126,
106.

18

ATTRIB. PAUL SANDBY,

BAYSWATER GENERAL LYING IN

HOSPITAL, c.1791

Watercolour, $7\frac{1}{2} \times 10\frac{3}{8}$ in.

Museum of London (37)

The area adjoining Notting Hill, or Kensing-
ton Gravel Pits as it was known, was Bays-
water whose chief landmark was the famous
turnpike. Mulready lived on the border be-
tween Bayswater and Notting Hill though
his postal address was Bayswater. The area
began to become built up after 1828, see
map 21.

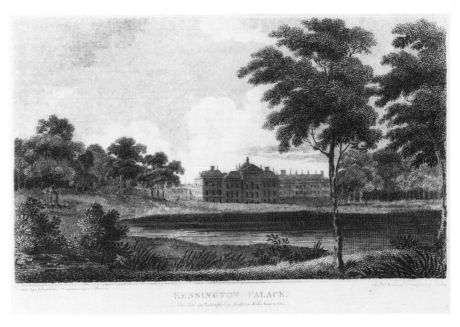

36. J. OR R. SCHNEBBELIE, KENSINGTON PALACE, *Museum of London* (cat. 19)

37. ATTRIB. PAUL SANDBY, BAYSWATER GENERAL LYING IN HOSPITAL,
Museum of London (cat. 18)

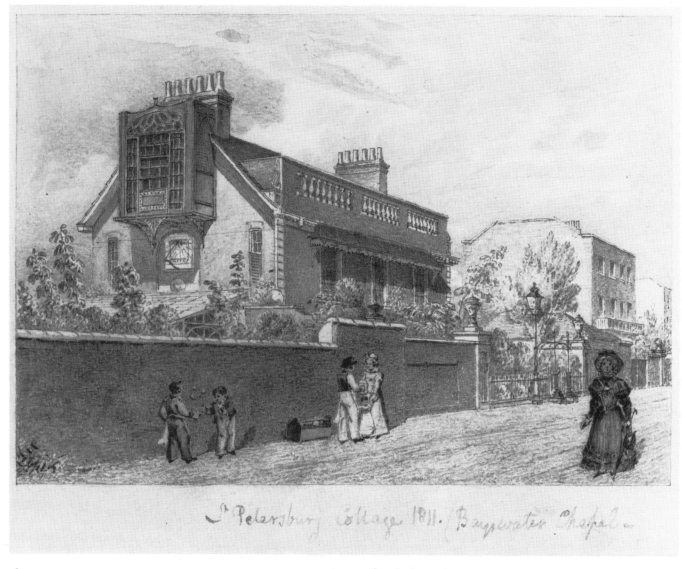

38. J. OR R. SCHNEBBELIE, BAYSWATER, ST. PETERSBURG COTTAGE, *Museum of London* (cat. 19)

19

J. OR R. SCHNEBBELIE
BAYSWATER, ST. PETERSBURG
COTTAGE, 1811
Watercolour, 3 × 4½ in.
Museum of London (38)

When he first moved out of the West End where he had shared accommodation with Linnell, Mulready lived with his parents in Robinson's Rents. The year was 1811 and the dwellings were evidently very humble and do not appear on Cruchley's map 21. He soon moved to Moscow Cottages, which were situated at right angles to St. Petersburg Place depicted in this watercolour. It is interesting to notice the ingredients of Mulready's subject paintings present in this early nineteenth-century view: the long receding wall and the groups of children and adults articulated against it.

20

C. VARLEY
BAYSWATER
Pencil, $4\frac{7}{8}$ × $2\frac{1}{2}$ in.
Museum of London (39)

Cornelius Varley also responded to the semi-rural character of the area.

39. C. VARLEY, BAYSWATER, *Museum of London* (cat. 20)

21

CRUCHLEY'S LONDON AND
ENVIRONS, 1828

*Museum of London, photograph of section
showing relationship of Kensington to the
West End.*

In 1811 Mulready moved from the West
End to Robinson's Rents, Kensington which
do not appear on the map; in 1826 he was
living in Moscow Cottages behind Moscow
Road and then in 1828 he moved into the
first of the substantial villas constructed by
Thomas Allason in Linden Grove, now re-
named Linden Gardens.

22

THE MALL, KENSINGTON GRAVEL
PITS, 1811–12

Oil on canvas, 14 × 19$\frac{1}{4}$in.

Victoria and Albert Museum (IV)

This is the first of two views of what is now
Notting Hill Gate painted for a patron who
declined to accept them on their completion.
Mulready finally exhibited them in 1844.
Together they represent the synthesis of the
artist's early studies of the area and owe
much not only to Dutch art – particularly in
their colour range – but also to a British
tradition of townscape as represented in nos.
14 and 16.

23

NEAR THE MALL, KENSINGTON
GRAVEL PITS, 1812–13

Oil on canvas, 13$\frac{1}{2}$ × 18$\frac{3}{4}$in.

Victoria and Albert Museum, London (V)

These two paintings charmed visitors to the
Royal Academy in 1844 but undoubtedly
appeared much too literal and vernacular in
1812 to find a purchaser. By the time they
entered the Sheepshanks collection the lo-
cation upon which these two compositions
were based had changed beyond all recog-
nition and these views offered a nostalgic
experience.

24

BLACKHEATH PARK, 1851–2
Oil on panel, $13\frac{1}{2} \times 24$in.
Victoria and Albert Museum (VII)

This shows the garden of John Sheepshanks's house at Blackheath. Sheepshanks, whose fortune derived from the Yorkshire woollen industry, was an enthusiastic patron of contemporary British art and, like Mulready, a keen gardener. The high degree of elaboration and finish in this work provides, as it were, a terminal point of reference in Mulready's development as a landscape artist and can be contrasted with the broad treatment of his earlier views.

25

A COTTAGE IN ST. ALBANS, 1805–6
Oil on canvas, 14×10in.
Victoria and Albert Museum (I)

It was with cottage scenes such as this that Mulready earned his living in the early years of the century prior to enjoying the patronage of men like Sheepshanks. This cottage scene is very close to certain works by Cotman who is known to have executed a free copy of the composition.

26

HAMPSTEAD HEATH
Signed and dated WM 1806
Oil on board, $6\frac{1}{2} \times 10\frac{1}{4}$in.
Victoria and Albert Museum (9)

Constable did not admire Mulready's work but these studies with their feel of plein-air freshness evoke not only Dutch counterparts but Constable's own later studies of the heath and its industries.

27

HAMPSTEAD HEATH WITH COWS
Signed and dated W Mulready 1806
Oil on board, $6 \times 10\frac{1}{4}$in.
Victoria and Albert Museum (11)

28

HAMPSTEAD HEATH
Signed and dated WM 1806
Oil on board, $5\frac{1}{2} \times 10$in.
Victoria and Albert Museum (10)

29

LANDSCAPE WITH A COTTAGE, c.1810
Oil on panel, $8\frac{3}{4} \times 7\frac{1}{2}$in.
Victoria and Albert Museum (6)

This somewhat unresolved composition shows Mulready again working with components of irregular architecture, water and the human figure, see also 1 and 30. The woman seen opening a window, a motif from Dutch painting which Mulready tried out in the oil sketch for *The Rattle*, no.101, introduces a note of engagement unusual in these works. The figures are more often grouped outside the cottage as in no. 30. There is a strange hiatus where the line of the building breaks to allow maximum view of the substantial house that lies behind the shed. Mulready appears here to have been working towards a more complex composition than customary in his cottage subjects in which differing architectural structures and, by implication, differing social conditions, are being contrasted.

30

LANDSCAPE WITH COTTAGES, 1810–12
Oil on panel, $14 \times 17\frac{1}{2}$in.
Victoria and Albert Museum (11)

This is a more extensive cottage scene than those of 1805–6 and shows Mulready moving towards the narrative content of *The Mall* and *Near the Mall*, 22 and 23.

31

SKETCH FOR PUNCH, c.1811–12
Canvas on panel, $8 \times 12\frac{1}{2}$in.
Victoria and Albert Museum (23)

The present whereabouts of the painting for which this is a preparatory study is not known. It was purchased from the Royal Academy by Sir John Swinburne in 1813 and Mulready regarded it as a gem. A letter from the artist to Mary Mulready Stone dated 29 May 1861 reads: 'As John, Mary's husband, appears to be interested in the knocking down of my pictures tell him that about the second week in June my picture of Punch will be knocked down by Christie. . . . He is not recommended to buy it unless he could get it for five hundred or six hundred pounds that none of you know what to do with – it would not much injure a man that got it for that sum. I should be very glad to get it for the sum named as a good profit might be made on it but there is little chance of my ardent admirers being caught napping. So we must be content with letting the gem go for more than it is worth, MS. collection of Brian Stone, Esq. A further letter also to Mary indicates that Mulready signed the painting, cleaned it and varnished it himself in 1862, MS. 14 April 1862, collection of Brian Stone, Esq. The painting was bought at the sale by Pennell for £1,002–15–0, an indication of the extraordinarily high prices that Mulready's works were fetching before his death. See also 32.

32

CARTOON FOR PUNCH, 1811–12
Chalks, pen & ink and wash,
$21\frac{3}{4} \times 15\frac{1}{4}$in.
Victoria and Albert Museum
(E1859–1910) (22)

Annotations to the 1864 South Kensington exhibition catalogue indicate that the location is the park wall of Campden House and that the scene is laid in Church Place, Kensington. A child comes rushing out of a door in the wall with a servant and 'by its astonished face we may guess that this is the first Exhi-

bition of Punch the child has seen.' The choice of subject and the disposition of the figures suggest that Mulready was inspired by Wilkie's success at this period.

33

LANDSCAPE, A COTTAGE WITH TREES AND TWO CHILDREN, 1807−10
Oil on board, 13 × 10½in.
Victoria and Albert Museum (7)

The diagonal sweep, the feathery trees, the lyrical scene outside the cottage where a boy blows a horn, and the prominent tree stump marking the bottom right extremity of one of the intersecting diagonals of which the composition is constructed all suggest the influence of Gainsborough.

34

COTTAGES ON THE COAST, 1806
Oil on board, 6½ × 8½in.
Victoria and Albert Museum (8)

A sketch which suggests Mulready's interest at an early date in recessive lines of buildings and a Cuyp like approach to the horizon.

35

TWO SKETCHES OF MULREADY'S HOUSE AND GARDEN
Pen & ink, thumb nail drawings
Victoria and Albert Museum
(6340, 6371) (32)

The elaborate design for a neo-Tudor house which appears to incorporate not only a weather vane and a mosaic pattern comprising the artist's initials but also a three-light window worthy of William Burges or C.R. Ashbee is pure fantasy. A house survives in Linden Gardens identical to that which Mulready inhabited from 1828 until his death in 1863, see no.36. The urns that feature in his design for the garden do, however, appear to have been introduced at Linden Grove, as it was then called, perhaps on the inspiration of Mulready's friend the Hackney horticulturalist, Conrad Loddiges. At least one of these urns survives today in the garden of the last remaining Allason villa in the street, 36 ii.

36

THREE PHOTOGRAPHS OF LINDEN GROVE
Miss Louie Boutroy

(i) a sepia view looking down Linden Grove towards Notting Hill Gate, c.1890.
(ii) No.42, Linden Gardens, formerly Linden Grove, showing the photographer, Augustin Rischgitz's studios, dated on the reverse 1899.
(iii) The garden of no. 42 Linden Grove.

37

A SERIES OF PHOTOGRAPHS SHOWING MULREADY'S TOMB, DESIGNED BY GODFREY SYKES AND ERECTED AT KENSAL GREEN CEMETERY; PAID FOR BY MEMBERS OF THE ROYAL ACADEMY.
Photographs: Ian Jones

Mulready's tomb is a splendid example of High Victorian neo-Renaissance tomb sculpture. It is made from Dalton stone and the head of the artist appears to have been modelled from a death mask. Around the base are incised in outline the artist's best-known works including *The Dog of Two Minds, The Careless Messenger Detected, The Wolf and the Lamb, Haymaking* and *The Last In.*

40. FREDERICK BACON BARWELL,
PORTRAIT OF MULREADY,
Victoria and Albert Museum (cat. 168)

CHAPTER II
PEOPLE BOTH PUBLIC AND PRIVATE

In comparison with many figures of the nineteenth century art world, Mulready led a simple life. He never travelled abroad and in London his leisure and relaxation consisted of visits to the theatre or to concerts in the company of friends like John Varley and David Wilkie. Although he was entertained by members of the aristocracy and the fashionable artistic establishment, he does not seem to have established close relationships with any except perhaps Henry Cole. Reading the two biographical studies of Mulready produced shortly after his death,[1] we are left with the impression of a reasonable, placid personality and an uneventful life. 'It is useless to seek in the biographies of his contemporaries for any information about him . . . his world could hardly have stretched beyond his studio' wrote Dafforne.[2] Hodgson and Eaton do not put up quite such a barrier but even they say that 'of Mulready's private life very little is known, for he was a man who throughout his long life kept himself very much to himself'.[3] Our efforts to catch even a glimpse of what William Mulready was really like are defeated by the bland and pious utterances of his biographers who succeeded in inventing an unassailable reputation for posterity.

Yet plenty of people did talk about Mulready; Mrs. C.R. Leslie, wife of one of Mulready's artist friends, entertaining William Mulready and his son to tea one Sunday in 1838, thought the artist 'very handsome and agreeable'.[4] Holman Hunt, who was one of Mulready's students in the Royal Academy Life class, remembered his teacher at the gold medal presentation of 1843. He was, Holman Hunt recalled, 'then of perfect build and beautiful face'.[5] When dining with Sir Charles and Lady Eastlake at Fitzroy Square in January 1851, Mulready amused his hostess by his droll and lively conversation with Landseer and impressed her with his 'gentlemanly, animated and prepossessing' demeanour.[6] 'Tall, manly in form, and handsome – in his old age no less than when in the prime of life' is how contemporaries described him.[7] In short he seems to have been regarded by both men and women as a remarkably

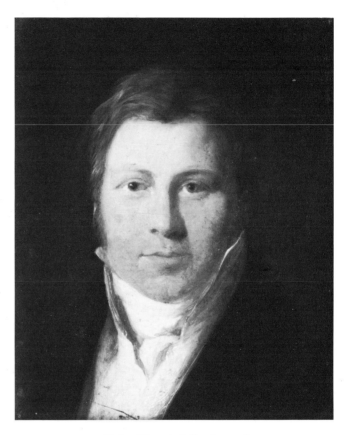

41. JOHN VARLEY, *National Portrait Gallery* (cat. 49)

attractive looking man. Access to the – until recently – unpublished diaries of the period tends to confirm the accounts of Mulready's personal attraction while offering a view of the artist somewhat at variance with Stephens's and Dafforne's official line. Ford Madox Brown recorded in his diary a conversation in which Holman Hunt 'dillated

[1] J. Dafforne, *Pictures by William Mulready* R.A., n.d.; F.G. Stephens, *Masterpieces of Mulready*, 1867, reprinted with revisions as *Memorials of William Mulready*, 1879
[2] Op. cit. p. 4
[3] J.E. Hodgson and F.A. Eaton, *The Royal Academy and its Members 1768–1830*, 1905, p. 279
[4] Mrs. C.R. Leslie's diary, 5 August 1838, MS. private collection
[5] W. Holman Hunt, *Pre-Raphaelitism and the Pre-Raphaelite Brotherhood*, 1905, I, 32
[6] Lady Eastlake, *Journals and Correspondence*, edited by her nephew Charles Eastlake Smith, London 1895, I, 265–6
[7] J. Dafforne, op. cit., p. 53, reiterated by S.C. Hall in *Retrospect of a Long Life*, 1883, II, 218

much on the RAs want of virtue & principle. M——y at 70 has seduced a young model who sits for the head & has a child by her, or rather she by him.'[8]

A series of self portraits, a portrait by Linnell, a photograph and a posthumous effigy provide a visual counterpoint to the verbal evocations. In an early miniature self portrait (VIII), Mulready appears, like some Renaissance lover, with limpid eyes, delicate nostrils, hair which softly curls around his temples, his lips very slightly parted. In middle age the solid image of reliability is established through the depiction of the broad forehead, prominent chin and aquiline nose (40). Such portraits seem to project Mulready as the man of sentiment who broke hearts, wrote love sonnets in middle age and painted pictorial idylls like *First Love* and *The Sonnet*[9] and as the fiercely disciplined Academician remembered for his 'sarcastic expression' and 'terrible frown'.[10]

Mulready lived and worked in an age when biography was a literary medium with a major social and political function, when the public record of a life commenced even before death and with the subject as one of its collaborators. Having had a personal experience of the medium from an early age[11] Mulready is likely to have had an awareness of the possibilities of colluding in the construction of an image. Episodes and incidents from his life-history are highlighted and enshrined in texts where they became narratives in their own right, contributing to the creation of a construct William Mulready R.A.[12]

Many of these accounts thematise an event into a narrative of the just and the wise man; Mulready who had allegedly been instructed in boxing by Mendoza when set upon by a thief taking his assailant home with him and enquiring into his needs,[13] Mulready rescuing John Sheepshanks from an attacker[14] Mulready interceding to establish the cause of right in a quarrel between Collins and Linnell.[15] In fact his work for the Artist's Benevolent Fund and individual acts of charity like the provision of bail for the composer John Hatton in Lancaster Jail for debt[16] were an essential aspiration of the professional middle class that Mulready had joined.

Mulready presented a public face of professional integrity, honesty and forthrightness; his record is beyond reproach. His private life on the other hand was fraught with difficulties. In 1804 Mulready, then aged only seventeen, married Elizabeth Varley who was about a year and a half older. She was the sister of John and Cornelius Varley and also an artist. Between 1811 and 1819 Elizabeth Mulready exhibited thirteen landscapes at the Royal Academy, five at the British Institution, and eleven at the Old Watercolour Society. She returned to the Royal Academy in 1828 with one further landscape but none of these works has been identified.

42. A MUSIC LESSON, *Brian Stone, Esq.* (cat. 39)

[8] V. Surtees, *The Diary of Ford Madox Brown*, 1981, p.189, 23 Sept. 1856. I am grateful to Jeremy Maas for drawing my attention to this passage
[9] The draft of a sonnet in Mulready's hand is in the Tate Gallery archive, MS. 72—16/6
[10] J. Dafforne and S.C. Hall, ops cit. locs. cit
[11] Mulready was the subject of a biography by William Godwin, see ch. III
[12] K.H. p. 12 sees Mulready's visits to Farington as careful strategies to protect his reputation but it has to be said that Mulready, in soliciting support from Farington was only acting as did the majority of his peer group
[13] F.G.S., 1867. p. 72
[14] A.T. Story, *The Life of John Linnell*, 1892, I, 263—4
[15] *John Constable's Correspondence*, ed. R.B. Beckett, Ipswich: Suffolk Records Society, IV, pp. 292—3, ed. notes
[16] MSS. Victoria and Albert Museum, 86 NN 1; British Library, MS. 41312 f. 287

43. MARY WRIGHT THE DAUGHTER OF A CARPENTER, *Victoria and Albert Museum* (cat. 83)

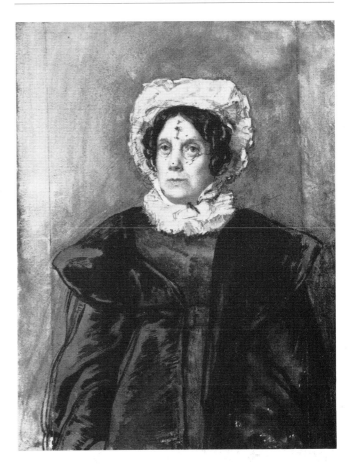

44. FRANCES FINCH, DOWAGER COUNTESS OF DARTMOUTH, *private collection* (cat. 67)

Competitiveness may not have been the only factor in the break-down of the Mulready marriage in 1810 but it was probably a major one. It certainly seems significant that Elizabeth Mulready was so productive immediately following the separation. While Mulready paid maintenance until his death and provided for her in his will, Elizabeth Mulready may at this time have needed both to earn and to demonstrate her own independent professional status. Images of Elizabeth Robinson Mulready, nee Varley, in old age suggest a fine but formidable looking woman (cat. 88, 89). Reference books tell us nothing about her; she has no entry in works like E.C. Clayton, *English Female Artists* (1867) and neither she nor her work is given any acknowledgement in the biographies of her husband. The only fragment comes from Varley's biographer who states that the Mulreadys' final quarrel was precipitated by Elizabeth's habit of going into her husband's studio in his absence and working on his pictures (see cat. 39). She is alleged, when in a bad humour, to have painted out the eyes of his figures.[17] Just as William Mulready was constructed as 'good' his wife, it would seem, was categorized as 'bad'; while Mulready embodied physical strength and justice, she embodied 'bad humour'. The account of her having painted out the eyes of the figures in her husband's paintings may, of course, be apocryphal but it suggests a profound level of hostility and disturbance that sought to mutilate and blind those representations of humanity that resulted from the love and devotion to an art that Mulready could not or did not direct towards his wife. Two letters written by Elizabeth Mulready many years after the separation, one to Mulready congratulating him on being awarded the Legion d'Honneur and the other to

[17] A.T. Story, *James Holmes and John Varley*, 1894, pp. 240–1

her Grand-child, William Henry, suggest a sensitive and warm personality (cat. 94 and 97).

In 1816 Mulready expressed to Farington his fear that reports were being circulated 'to the prejudice of his moral character' and his belief that he suffered from disadvantage, doubt and suspicion.[18] This was the year in which Mulready had failed to be elected to the Royal Academy and he must have feared that rumours about his domestic problems (which had not been solved by the separation of 1810) had cost him the coveted place. His fears were by no means groundless; Francis Danby, A.R.A. would be compelled to break with the Academy and leave the country after a scandal concerning his domestic arrangements and artists like Turner who had common law wives conducted their private lives secretly and remote from their professional environments. Early on in the marriage Mulready learned to be discreet about the irregularities in his domestic life; he also adopted strategies to ensure that he would be acceptable in every other way. He acquired at least some semblance of the serious learning that he needed to feel at home in the Athenaeum Club and to frequent the circles of men like Eastlake and Henry Cole. If F.G. Stephens can be believed he had a reading knowledge of French, Latin and Greek[19] and in 1812 he was arranging to exchange drawing lessons for instruction in German.[20]

Financial worry and overcrowding must have put a strain on the Mulreadys' relationship; in Linnell's diary for these years Mulready's name appears frequently as a borrower and as a repayer.[21] In later years Mulready told an old friend at a meeting of the Artists' Benevolent Fund that 'out of the profession, few people can comprehend the toils and difficulties of an artist' and that he remembered a time when he had 'a wife, four children, nothing to do, and was six hundred pounds in debt.'[22] By the end of his life Mulready had acquired a reputation for being 'the very genius of prudence'[23] and certainly his account book recording his income from teaching and

[18] FD, 12 February 1816
[19] FGS, 1867, pp. 126–7
[20] Victoria and Albert Museum, MS. 86 NN 1, letter dated 12 February 1812
[21] A.T. Story, *The Life of John Linnell*, I, 54–5
[22] F.G. S., 1867, p. 56
[23] *The Letters of Samuel Palmer*, ed. R. Lister, Oxford, 1974, S. Palmer to G. Gurney, October 1880

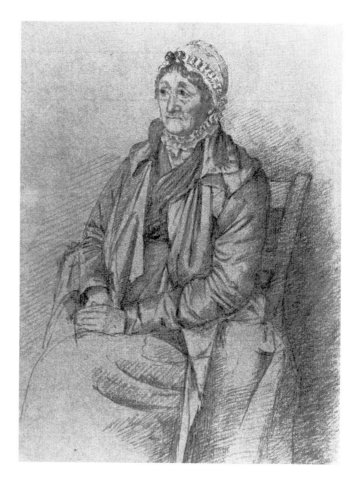

45. CHARLOTTE LEGGE, HANNAH MASON, *Staffordshire County Record Office* (cat. 71)

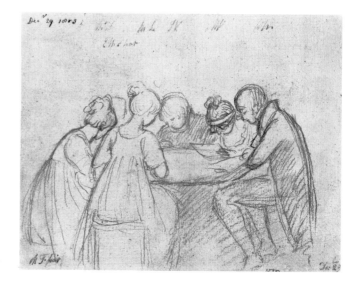

46. MARY ANN FLAXMAN, VARLEY, MULREADY AND FRIENDS DRAWING, *Victoria and Albert Museum* (cat. 51)

painting from 1805 and also his expenditure for the years 1826–8 suggests a very careful attempt to keep a firm control over his financial affairs. The account is very comprehensive, covering rent and taxes, table, utensils for house and as models in the studio, theatres and exhibitions, refreshments, subscriptions, maintenance (presumably payments to his wife), clothing and mending, bird (a pet, we may guess), William's painting (his son needed painting materials), lost or stolen, postage and carriage, common charity, repairs to clock, manure and gravel, books and newspaper, insurance, animals, boys pocket money, boys dancing (lessons had to be paid for), frames including re-gilding and silvering, medicine and haircutting.[24]

Careful management, learnt through bitter experience, may well have been the reason for the spartan austerity which people noticed as a characteristic of the Mulready house in later years.[25] A note on one of Mulready's many undated drawings relating to plans for his house and garden reads: 'What should be the rent of the house now. What would the improvements cost. What additional taxes & rates would they cause. What term of years & what yearly rent should I agree to, in condition of my money sunk in improvement.'[26] Financial difficulties were a commonplace for young artists and, in any case, Mulready was evidently a capable planner and a cautious spender. The root cause of the marital strife between the Mulreadys lay elsewhere. An incoherent and rambling letter from Elizabeth Mulready to her estranged husband, undated but written many years after separation, contains accusations of violence and infidelity (homosexual and heterosexual):

'On the afternoon of Thursday I shall call on you at Linden Grove I come in peace and it depends on yourself whether I return here or proceed to London to a Proctor. Repeated calumnies have rendered my feelings acute with agony. your visit here has sent me *wandering in my sleep with burning temples and a throbbing pulse* and if I have refrained from suicide the merit I fear is scarcely my own. I had four infant boys for whose sake I took blows and curses and suffered every indignity that cold blooded malice could invent. To whose welfare I devoted all the best years of my young life was a mother of a thousand to them and I live to find them in youth the scorn of everyone the mean associates of the wretch who supplanted their mother. I came here as I thought a strangeress, amongst strangers, but at every step, even in my passage down, have stumbled on persons who have lodged with or been imployed by Mrs. Lekie, who have had the confidence of Mrs. Murray, and as if starting form the dead, two individuals who twenty years back offered to prove on oath facts most vexatious to a wife. The servant who lived with us when we parted is resident here in this place and she told me amid a thousand impertinent things she still kept an eye upon Mrs. Linnell she should not forget the boy being locked in the bedroom with her master while her mistress and self were actually sitting up for them not knowing they were in the house. . . . And what cause could you shew for driving me and my children in 18[0]7 from hearth and home for Harriet who told me when you were at Rochester that you preferred her little finger to me and my four boys that you would not stay in Rochester and she in London, the event proved her statement correct, you alarmed me by your return at midnight and anounced it by the smashing of windows, we agreed to separate and from that hour Mulready I owed you no allegiance, have been accountable to none but heaven for my conduct. I had received little but blows and insults from you, and I ought not to have regretted you . . . I had loved you in youth as woman seldom loves, and in after years turn'd from the highly gifted in every profession, to the solitude of my own home, to brood over the desolation of all my hopes . . . you had taken a low boy to your bed, and turned me adrift at midnight, to seek one at the house of an unmarried man. What allegiance could I owe to such a husband? You placed this boy as a spy over me, between you loaded me with calumny, and a more formal parting ensued. I forgive you for a part of this, you were *yourself deceived* and I would not undeceive you at the expense of another. . . . Years elapsed and I felt pleasure when fame spoke of your talents . . . I never if I (chose to defend myself) was

[24] MS. Victoria and Albert Museum, 86 NN1
[25] MS. Victoria and Albert Museum 6356
[26] MS. Victoria and Albert Museum, 86 NN1

conscious of an action that ought to bring a blush on my cheeks. . . . If all the calumny is true your women have heaped upon me, and half is true the world insinuates of you; we are endeed [sic] a couple worthy of each other. Tell your sons I release them from all allegiance to me. . . . If you drive me to it; so help me God, I will do myself justice, though so little pleasure shall I reap from exposing the father of my children (my children now no more) but sons of the bondswoman, that the deed once done, my own hand may terminate life and suffering together. . . .'[27]

In the light of this account of physical violence, abuse and cruelty and considering the threats of legal action and of suicide, the painter of intimate scenes of domestic contentment appears as a very different character from that constructed by Biography. If the small oil painting in the possession of one of Michael Mulready's descendants which shows a woman weeping is, as has been proposed, a portrait of Elizabeth Mulready[28] then it suggests an ability on the part of the artist to externalise his feelings (cat. 42). His utterances on the matter are legalistic and self-protective (a draft containing articles of separation is the only indication of what his side of the story might have been[29] but the evidence demonstrates that he did provide for Elizabeth both in his lifetime and after his death (cat. 93).[30]

Unravelling the Balzacian relationships that are implied in Elizabeth's letter is a hard task. Heleniak has convincingly identified 'Harriet' as the young artist, Harriet Gouldsmith, who had been one of Mulready's pupils[31] and further evidence is provided by *The Music Lesson* (42, cat. 39). This painting, executed in 1809, has survived in the collection of a descendent of John Jefferies Stone who, as we shall see, had close connections with the artist. According to Mulready's biographers it features a portrait of Mulready[32] but annotations to the catalogue of the 1864 retrospective exhibition of Mulready's work[33] indicate that the model for the young woman who plays the piano was Harriet Gouldsmith. If this is the case we are dealing with an autobiographical painting in which the master-pupil relationship is affirmed but in the domain of music instead of painting. The sexual innuendo of the music lesson (the young man leaning solicitously over

the young woman's shoulder, a topos familiar in the English novel and signifying romance and sexuality within the social conventions of middle and upper class behaviour) is substituted for the professional and presumably competitive location of the studio. Thus the erotic is both displaced and confirmed, displaced from the studio where Mulready's real life drama took place but confirmed by reference to a familiar type connoting intimacy.

It has been suggested that the 'low boy' of Elizabeth Mulready's account is Linnell and that homosexual love was a cause of the Mulreadys' marital difficulties.[34] Certainly Linnell and Mulready were very much a partnership, revelling in all-male outings and boyish escapades away from the constraints and responsibilities of domestic life. A sketching trip to Gravesend and Chatham recounted by Linnell[35] concluded with the two young artists returning after midnight and entering the house by climbing up a drain pipe. Heleniak suggests that this is the event recalled by Elizabeth Mulready but it is likely that the artists visited the Thames estuary on more than one occasion and the mention of Rochester by Elizabeth is at variance with Linnell's statement that they stayed at Gravesend. Elizabeth Mulready is certainly accusing her husband of having one or more male lovers but whether or not Linnell is implicated is much less certain. Linnell seems to have been the 'bad' companion rather than the lover. Elizabeth's letter reveals a profound respect, indeed an almost abject deference, for authority in terms of class and professional achievement. It seems therefore unlikely that she would have referred to Linnell, who was by this time a much respected artist and who was known to have been the son of a frame-maker and nephew of a distinguished furniture-maker, as a 'low boy'.

One point raised by Elizabeth Mulready can now be verified to a certain degree. Mrs Leckie (or Lekie) was Elizabeth Forbes Leckie whose daughter, Mary Mulready

27 MS. Victoria and Albert Museum, 86 NN1
28 KH, cat. 6
29 Victoria and Albert Museum, MS. 86 NN 1
30 Account book entries for maintainance; a memorandum of a codicil to Mulready's will provides Elizabeth with £2,500, MS. Tate Gallery 72–16.32
31 KH, p. 12
32 F.G.S., p. 69; Dafforne, op. cit. p. 41
33 Victoria and Albert Museum Library
34 KH, p. 11
35 J. Linnell, MS. autobiographical notes, The Linnell Trust

Leckie, was the artist's ward and the recipient of a series of affectionate and paternal letters from Mulready (see family tree and cat. 40, 41, 44–47). A Miss Forbes appears as one of Mulready's pupils in his account book in 1803. She is known to have married James Leckie, an Irishman but may have been widowed or may never have actually abandoned a liaison with Mulready formed in youth. The painting *Father and Child* (XIV) is based upon a sketch labelled 'James Leckie and little Mary'. A very pregnant looking Mrs. Leckie was portrayed by Mulready in 1829; the portrait which survives in the collection of one of Mary's descendants bears a cryptic and partially illegible inscription which begins 'He who does not. . . .' (cat. 40) Important events in the artist's career were shared with Mrs Leckie; a proof of the postal envelope is inscribed 'To Elizabeth Forbes Leckie from W. Mulready 1840' (cat. 125d), Mulready advised Mrs Leckie about the insurance on and disposal of pictures in her collection and he witnessed her will in May 1856 after she had suffered a severe illness.[36] She was evidently known to Mulready's acquaintance as her name crops up in Henry Cole's diaries.[37] Equally it is clear that she and Mulready did not cohabit as they retained separate addresses but nevertheless Mrs Leckie appears to have been the 'wretch' cited by Elizabeth as supplanting her and a drawing depicting Mrs Leckie and Paul Mulready in an intimate composition testifies to this fact (cat. 41).

The big question is whether or not Mulready's ward, Mary Mulready Leckie was actually his daughter.[38] Mary was a gifted artist in her own right, producing portraits in pencil and red chalk in a manner similar to Mulready's and exhibiting at the Royal Academy under her maiden name between 1840 and 1844 and under her married name between 1845 and 1846 (cat. 44 and 46). She married John Jefferies Stone in 1843 at St. Mary Abbot's Church, Kensington and when her first child was born the following year he was christened Edward Mulready Stone with William Mulready as godfather.

Mary Mulready Leckie seems to have been brought up in close association with the Mulready boys and Mulready's letters to her contain messages for Michael and references to his other sons. The ramifications of this artistic family provide interesting evidence of the intermarriage among artists' families in London during the first half of the nineteenth century. The Mulready–Varley clan must have seemed to outsiders like a dynasty; all the Mulready sons became practising artists and one grandson is known to have trained in the School of Design at South Kensington.[39] One of Mulready's grandsons, an artist and restorer was still alive in 1950 aged about eighty-four.[40] One of Mary Mulready Stone's grandsons was Harold Mulready Stone, an artist and engraver and her great-grand-daughter is a professional portrait painter. Mrs Leckie had another daughter, Elizabeth, who married Albert Fleetwood Varley, John Varley's eldest son who was also a watercolourist and drawing teacher (see family tree). The friendship between Mulready and John Varley, a friendship that survived the estrangement between Mulready and his wife, was sustained through another generation. Albert Varley was Paul Mulready's boyhood friend; when Paul died in 1860 Albert became guardian to his son.[41]

William Mulready's position as patriarch in this extended artistic family is of more than genealogical interest. There are several recorded instances of confusion over authorship of works thought to be by William Mulready R.A. In March 1852 a would-be purchaser wrote to Mulready asking by what means he could distinguish a genuine painting of his.[42] In 1826 Mulready's *Punch*, executed in 1813, was returned to him for his signature[43] and a letter from the artist of the previous year highlights the problems of authenticity that were beginning to be apparent even before Mulready's death:

'Llewellyn, the dealer of Bristol had three pictures by me answering the description you give, the landscape very much [word illegible] it was once in the possession of Gilbert. The two little things of still life were

36 W. Mulready to Mrs. Leckie, Jan. 1846, MS. Mr. Brian Stone; statement headed 8, Sheffield Terrace, Kensington, dated 22 May 1856, MS. Mr. Tim Stone
37 For references see KH, p. 14
38 Muriel Frances Everington (née Stone), Mary's grand-daughter, when taxed by her daughter, Mrs. Everel Wood, about the relationship between Mary and the artist, admitted having heard rumours when she was young suggesting that Mary was Mulready's daughter. The subject was always hushed up
39 R. Redgrave, *A Memoir, compiled from his diary by E.M. Redgrave*, 1891, pp. 277–
40 Records, Victoria and Albert Museum, Dept. of Paintings, Prints and Drawings and Design
41 A.T. Story, *James Holmes and John Varley*, pp. 237–8, 239–40; see also KH ch. I for other information
42 Victoria and Albert Museum, MS. 86 NN 1
43 W. Mulready to John Jefferies Stone, 14 April 1862, MS. Mr. Brian Stone

Michael's who received 30 guineas for them from Llewellyn. They were touched upon by me while they were Michael's property. The touching was the only thing to hang the note upon about them progressing direct from me to their present owner – but this little liberty is not worth a counter note.'[44]

In 1827 Mulready received five hundred pounds from Sir Robert Peel as payment for his painting *The Cannon* (73), a work that had proved very popular at the Academy that year.[45] The price provoked Lord Egremont to complain angrily that people were talking of nothing but Mulready's 'little thing'.[46] When Mulready's *The Widow* (XXII) and C.R. Leslie's *Scene from the Vicar of Wakefield* were sold from George Knott's collection at Christie's in April 1845, Ruskin was amazed to learn that they fetched 400 and 650 guineas respectively 'compared with some old ones of great value next week – a Correggio valued at 4,00 going for 160.'[47] The high prices which even the slightest sketch fetched at Mulready's studio sale in 1864 were still remembered as extraordinary in 1877.[48] Mulready's financial success in maturity, his position as a leader of the modern British School and his evident ability to compete in a volatile market were instrumental in earning him his public reputation; much could be overlooked in this era in a person's private life if they were successful in business. Mulready demonstrated, moreover, an ability to attract sustained private patronage. In 1857 the Manchester Art Treasures exhibition became the focus of discussion about modern British art. There were those who felt that it was seriously lacking; A.H. Layard in the *Quarterly Review* blamed collectors for what he regarded as the mannerism of contemporary artists.[49] But in the same year the *Athenaeum* promised its readers that the Sheepshanks legacy to the South Kensington Museum would 'turn Brompton into a second Florence'.[50]

John Sheepshanks's gesture was in direct response to the dispute concerning the ancients versus the moderns and, as his collection was rich in works by Mulready, he helped to consolidate the reputation that Mulready had built up for himself through the 'forties. It may also help to explain the fact that after 1848 Mulready scarcely contributed a single new work to the Royal Academy annual exhibition. Replicas and re-workings appeared under his

name and he devoted a great deal of time to life drawing.

Mulready's relations with patrons were not free from difficulties. The price an artist could ask depended very much on what he had already managed to get for other pictures. This meant that unless he had achieved outstanding success and recognition with one picture it was difficult for an artist to push his prices up. In 1809 Mulready had asked 300 guineas for *The Carpenter's Shop* which was not bought until 1812 when it entered Miss Swinburne's collection for an unknown sum.[51]

Nine years later, by which time he was a Royal Academician, Mulready was offered only £100 for 'something humorous, an outdoor theme . . . the size to rest with yourself.'[52] He seems to have experienced a change in his fortunes between 1818 and 1822 possibly after selling *The Wolf and the Lamb* to King George IV from the Royal Academy in 1821 and *The Careless Messenger Detected* to the Earl of Durham the following year.

Henry McConnel, the middle-class patron of Turner, Eastlake and Wilkie, a highly original and determined collector offered Mulready in 1822 100 guineas for the drawing of a street preacher and 1,000 guineas for a painting of the same subject. No painting was ever executed though a drawing records some first ideas for the subject[53] and thirty-eight years later McConnel was still trying to acquire a painting by Mulready.[54] McConnel thought that Mulready lacked the courage to paint a provocative subject but this seems unlikely given the fact that he went on to paint *The Widow* (XXII) which Ruskin found improper. The apparent lack of concern with selling pictures after the early 'twenties is born out in other evidence; Major Thomas Birchall of Ribbleton Hall, Preston, wrote to Mulready in February 1849 that

44 W. Mulready to J.J. Stone, 7 March 1861, MS. Mr. Brian Stone
45 W. Whitley, *Art in England 1821–1837*, Cambridge, 1930, pp. 130–1
46 B.R. Haydon, *The Diary of B.R. Haydon*, W.B. Pope, ed. Cambridge, Mass., 1960, III, 1 June 1827
47 J. Ruskin to his father, 25 May 1845, H.I. Shapiro, ed., *Ruskin in Italy*, Oxford, 1972, p. 80
48 H. Ottley, *A Biographical Dictionary of Recent and Living Painters and Engravers* (a supplement to Bryan's *Dictionary*), 1877, p. 122
49 *Quarterly Review*, no. 203, July 1857, 195–7
50 *Athenaeum*, 1549, 4 July 1857, 857
51 Mulready's account book
52 A. Cooper to W. Mulready, 10 February 1818, MS. Victoria and Albert Museum 86 NN 1
53 Rorimer, 329
54 H. McConnel to W. Mulready, 7 September 1860

he was limited by the size of his rooms but was, nevertheless, anxious to obtain 'choice examples by the best masters'. By May 1852 he still had not managed to acquire what he desired so he invited the artist to dine with him in town in the hope of exerting pressure.[55] Finally in April 1853 he paid £262–10–0 for a highly finished cartoon for *Interior: an Artist's Study* (95), a study for the oil painting that Mrs Bacon had purchased in 1845 for £210.[56] Thomas Miller had a similar experience and, despite dining with W.P. Frith on the assurance that he would have the opportunity of meeting Mulready, failed to purchase anything from the artist until after his death.[57]

John Sheepshanks's name first appears in Mulready's account book in connection with a portrait. This must have been the small oval head in profile now in the Victoria and Albert Museum (cat. 79). By 9 May Sheepshanks's *Interior* (XII) was in progress. It was completed early in 1834 by which time Sheepshanks had acquired a replica of *The Boat Race* (*A Sailing Match*) from the original painted in 1831 and bought by John Gibbons (XIX). From now on Sheepshanks systematically bought up works by Mulready as they came onto the market and commissioned new works, paying the artist in instalments as the pictures progressed, often in very large sums as for *The Seven Ages* (Cat. 76 and 118, 85). He remained a good friend to Mulready until the time of his death which occurred, as did Mulready's, in 1863. Like other close friends and patrons, including Linnell and Sir John Swinburne, Sheepshanks became involved in Mulready's relationship with his eldest son, William (cat. 89) and a letter from Sheepshanks to Mulready of 1852 refers to a visit from the wayward young man who was told that 'any assistance he had from me was on the condition that you should be spared the amount of it under any circumstances'.[58] This suggests that Sheepshanks attempted the role of mediator and adviser that Linnell had abandoned as hopeless in the 'forties.

John Sheepshanks's income was derived from the family's woollen mill in Leeds.[59] Like Joseph Gillott, the Birmingham pen knib manufacturer and John Gibbons the Bristol iron-founder, both of whom patronised Mulready, Sheepshanks was actively engaged in trade. Although his

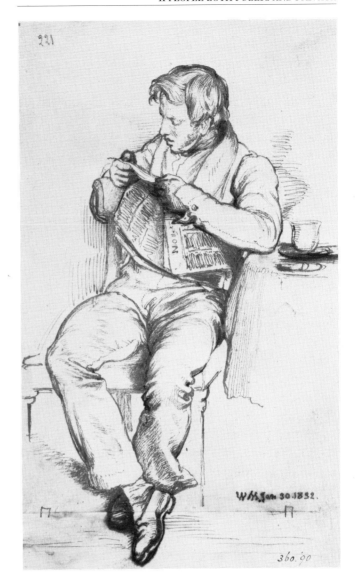

47. PORTRAIT OF JOHN SHEEPSHANKS READING, *Victoria and Albert Museum* (cat. 80)

commitment to art collection was intensified after his retirement from business and his move to London in 1833, he had begun collecting engravings and copies of Italian masters some years earlier. Constable was aggrieved

[55] Thomas Birchall to W. Mulready, 12 February 1849, 1 May 1852, MS. Victoria and Albert Museum 86 NN 1

[56] Mulready's account book

[57] W.P. Frith to W. Mulready, 25 April 1853, MS. Victoria and Albert Museum, 86 NN 1; Miller purchased *The First Voyage* after the artist's death

[58] J. Sheepshanks to W. Mulready, 27 April 1852, MS. Victoria and Albert Museum 86 NN 1

[59] See R.G. Wilson, *Gentleman Merchants: the Merchant Community in Leeds, 1700–1830*, Manchester 1971, p. 247; *Encyclopaedia Britannica*, 11th edn. 1810–11

48. SKETCH OF WALL FOR SHEEPSHANKS PORTRAIT, *Victoria and Albert Museum* (cat. 81)

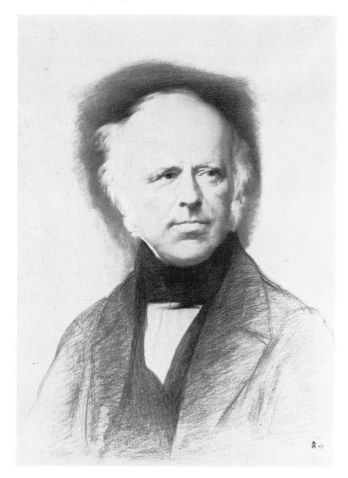

49. PORTRAIT OF THE REVD. RICHARD SHEEPSHANKS, *Victoria and Albert Museum*

at the twenty-four works by Mulready in Sheepshanks's collection, believing that he had been passed over but he failed to appreciate that Sheepshanks was unwilling to compete with Robert Vernon who possessed only one work by Mulready but many by Constable and whose collection was given to the nation in 1847.[60]

Sheepshanks's large income seems not to have made him oblivious to the disadvantages of the labouring classes and he requested that the South Kensington Museum should be open on Sundays after morning church hours so that his gift to the nation might be enjoyed by all. He was, alas, thwarted by 'a powerful sentiment that successfully opposed that wish.'[61]

The Sheepshanks story might well seem an archetypal nineteenth-century success story. John Sheepshanks is remembered for his splendid gift to the nation. His brother, Richard (1794–1855), also commemorated in a portrait by Mulready (49), was Fellow of the Royal Society and Fellow of Trinity College, Cambridge, and was equally distinguished in the world of science, bequeathing his collection of instruments to the Royal Astronomical Society. Yet John Sheepshanks died unmarried and childless and, with his reputation for ill-temper, shortness of stature and for being generally an odd character, a certain air of pathos surround his image. Frith remembered his being irritated by the importunity of strangers, whose requests to see his house and pictures were always refused. He is alleged to have said 'I have always paid my way, and paid for my pictures too' even though he had never possessed an income of more than fifteen hundred a year.[62] Nevertheless within his own circle Sheepshanks was evidently a hospitable man; Charles West Cope recalled the Wednesday dinners prepared for chosen guests (Robinson and Fox, the engravers, John Burnet, Mulready, Landseer and Leslie) who were expected without invitation, and the host's disappointment if his table were not filled.[63]

At Blackheath Sheepshanks devoted himself to his other great passion in life, horticulture. In his fine garden

[60] *John Constable's Correspondence*, Ipswich, Suffolk Records Society, 1965, III, ca. 29 Nov 1836, John Constable to C.R. Leslie
[61] R.V. Taylor, *The Biographia Leodiensis*, 1865–7, pp. 514–5
[62] W.P. Frith, *My Autobiography and Reminiscences*, 1887, 5th edn. 1888, I, 203
[63] C.W. Cope, *Reminiscences*, 1891, pp. 120–1

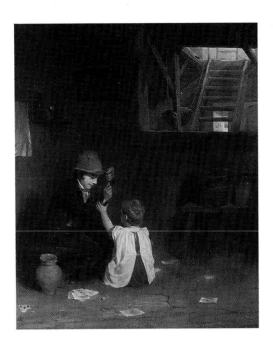

XIII THE RATTLE, *Trustees of the Tate Gallery* (cat. 100)

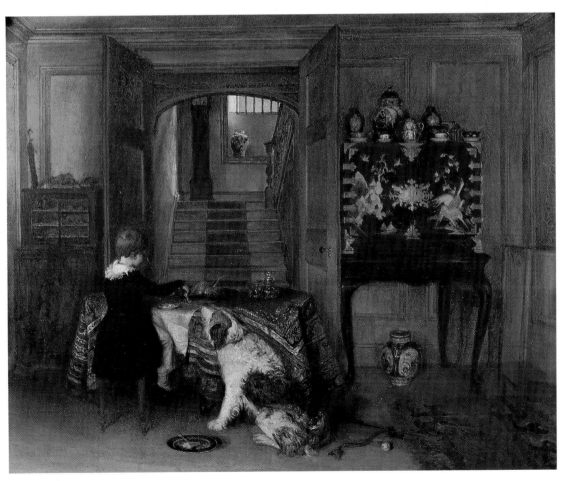

XI THE HON. WILLIAM WALTER LEGGE, *private collection* (cat. 69)

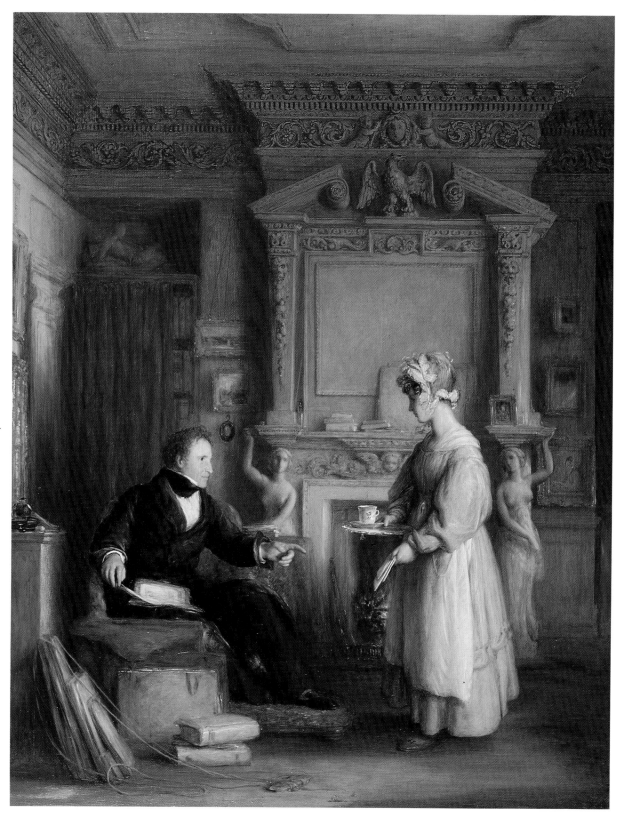

XII INTERIOR WITH A PORTRAIT OF JOHN SHEEPSHANKS, *Victoria and Albert Museum* (cat. 78)

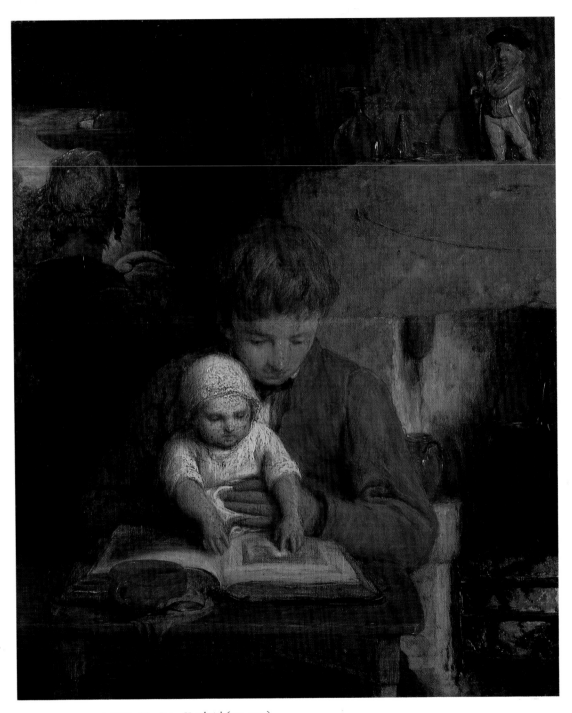

XIV FATHER AND CHILD, *Mrs Peter Hardwick* (cat. 109)

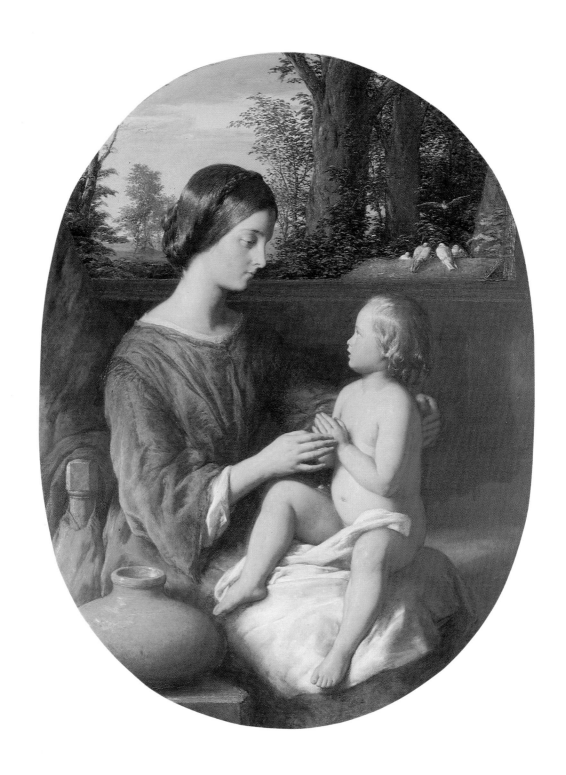

XV A MOTHER TEACHING HER SON, *Victoria and Albert Museum* (cat. 113)

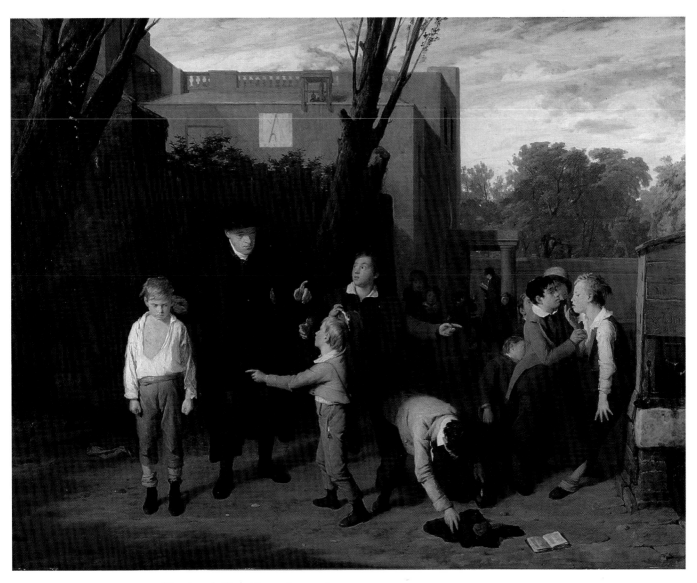

XVI THE FIGHT INTERRUPTED, *Victoria and Albert Museum* (cat. 102)

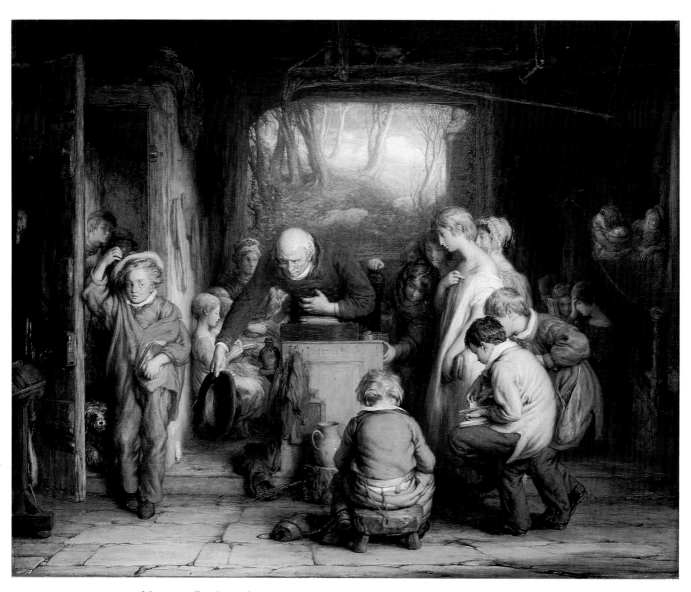

XVII THE LAST IN, *Trustees of the Tate Gallery* (cat. 98)

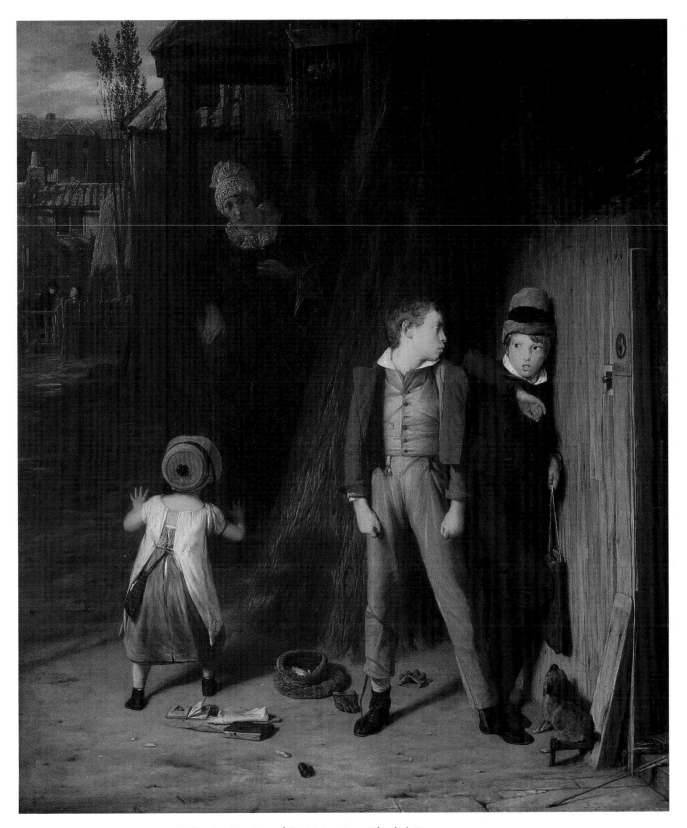

XVIII THE WOLF AND THE LAMB, *By Gracious Permission of Her Majesty Queen Elizabeth II*

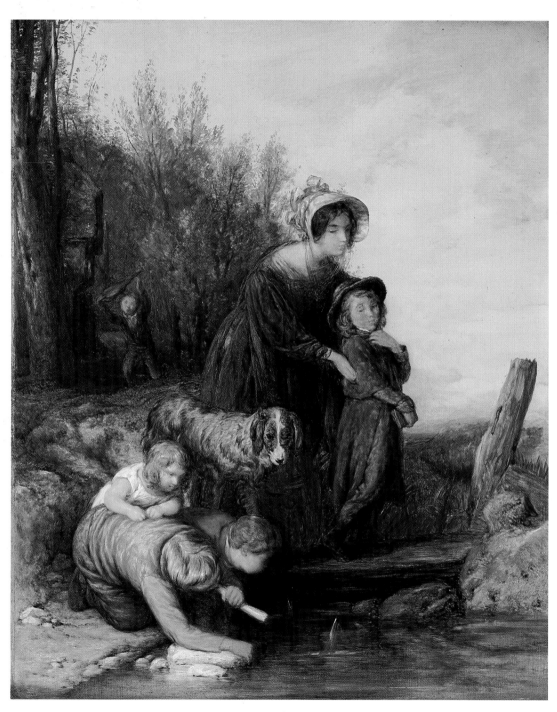

XIX A SAILING MATCH, *Victoria and Albert Museum* (cat. 111)

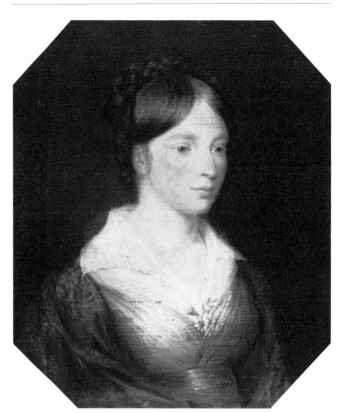

50. MISS ELIZABETH SWINBURNE, *private collection* (cat. 55)

51. MISS JULIA SWINBURNE, *private collection* (cat. 59)

depicted by Mulready in his landscape of Blackheath (VII), the former cloth manufacturer invented new geranium types (Sheepshanks and Grandiflora) and reared many prize-winning flowers.[64]

Sheepshanks kept rooms in Bond Street and it was in this setting that Mulready chose to portray him in *Interior with a Portrait of John Sheepshanks* (XII, cat. 78–81). The portrait of the patron among his works of art belongs in a long tradition; Daniel Mytens's portrait of the Earl of Arundel and Zoffany's portrait of Sir Lawrence Dundas are among works that might appropriately be cited as precedents. Mulready needed to translate this formula of aristocratic portraiture into an idiom appropriate to the ethos of the new middle-class patron. It is instructive, therefore, to compare the drawing of Sheepshanks in his bedroom slippers, reading the newspaper and leaning his elbow on the uncleared breakfast table (47) with the painting that was finally executed (XII). The domestic ambience is retained with Sheepshanks reaching forward to take his

letters and his tea from the maid but subtly Sheepshanks has ceased to be a tousled headed, unselfconscious, newspaper reader and become a dignified gentleman surrounded by signs of his wealth and his taste. The seated figure is not so readily endowed with authority as the standing but Sheepshanks was a short man and this would have been hard to disguise in a full length portrait. The problem is solved by the introduction of the fresh-faced maid who, with her gesture of subservience, provides a focus for Sheepshanks magisterial movement of the hand. Flanked on either side by caryatids that support the fireplace, the maid's presence accompanied by these emblems of artifice signifies a patron whose domain extends from art to nature. From her ribbons to her well-polished shoes the maid provides the measure for the full degree of Sheepshanks's wealth.

Teaching was a vital source of income to young artists; it could also lead to useful connections and to a pattern

[64] J.C. Horsley, *Recollections of a Royal Academician*, 1903, p. 49

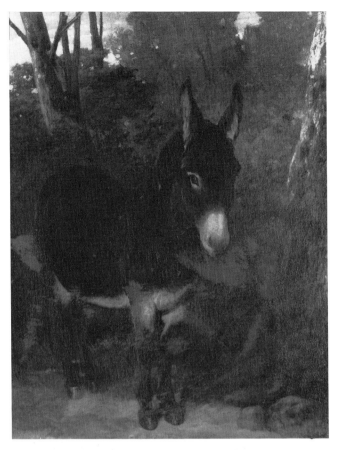

52. THE CAPHEATON ASS, *private collection* (cat. 60)

of patronage[65] Mulready taught the children of Sir John Swinburne from 1811[66] and a number of members of Lord Dartmouth's family from 1815. From both families he received a number of portrait commissions, moreover the Swinburnes were major purchasers of his subject paintings. Pupils could be useful to the artist in other ways too; one of Mulready's pupils in 1811 was Anne Isabella Milbanke who married Lord Byron in 1815 and, later the same year, having inherited the property of her maternal grandfather, took on her mother's name, Noel. She does not appear to have continued to take drawing lessons after her marriage. Nevertheless Mulready felt able to write to her in 1832 requesting a short-term loan.[67]

Between 1806 and 1827 Mulready's income from the sale of works of art gradually increased while his income from teaching declined. In 1806 teaching brought in £98–10–0 while painting and drawing brought in £82.

In 1827 Mulready earned £278–5–0 from teaching the members of fifteen families (the head of the family's name generally appears now and represents adult members of the family as well as children) and £685–10–0 from the sale of three pictures. It is impossible to know what Mulready charged for individual lessons as the sums paid vary from seven guineas to forty-nine pounds and there is no indication in the account book of the frequency of lessons.

By 1827 Mulready's accounts were much more complicated and it is interesting to note that of his income from painting that year, £525 was for one work, *The Cannon*, bought by Peel (location unknown, 73), and of the remainder, £10–10–0 was for a sketch for *The Gamekeeper's Wife* (subsequently named *Interior of an English Cottage*, XXXII) bought by Samuel Carter Hall and £150 was the balance owed Mulready for *The Origin of a Painter* (location unknown, 72) for which Lady Swinburne had paid two instalments in May and October 1826. This staggered payment reveals a special relationship between Mulready and the Swinburnes established with his engagement as drawing teacher to the family. Mulready was kept on a sort of retainer; sums of money were paid to him at intervals while he worked on a picture which may or may not have been earmarked beforehand. He enjoyed a similar relationship with Sheepshanks (who had no children in need of lessons) and with Sir Thomas Baring. Such relationships must have relieved him of much of the insecurity that had plagued his youthful career.

Sir John Swinburne had been nurtured on Voltaire and enjoyed the personal friendship of Mirabeau who was allegedly once tipped out of one of Sir John's carriages without, fortunately, sustaining any injury.[68] Mulready and Sir John became good friends; at the time of the murder trial of the boxing promoter, John Thurtell (cat. 84, 56), Mulready hastened to write to Sir John re-

[65] See M. Pointon, 'The Benefits of Patronage: A Study of the relationship between William Mulready R.A. and two of his Patrons', *Gazette des Beaux-Arts*, September 1980
[66] See KH ch. VI
[67] W. Mulready to Lady Noel Byron, 5 February 1832, MS. Dep. Lovelace Byron 74 f 6 b 7, Bodleian Library, Oxford; see also KH, p. 164
[68] A.C. Swinburne to E.C. Stedman, 20 February 1875, *The Swinburne Letters*, ed. Cecil Y. Lang, New Haven, Conn., 1960, pp.9–11; Sir Charles Tennyson and Hope Dyson, *The Tennysons: Background to Genius*, 1974, p. 205

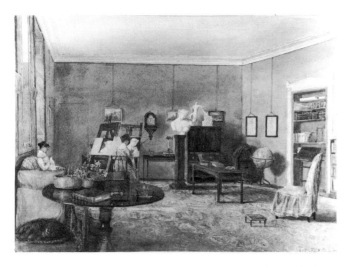

53. FRANCES SWINBURNE, INTERIOR CAPHEATON, *private collection* (cat. 61)

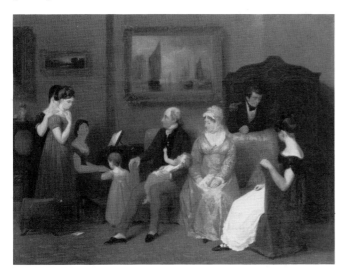

54. FRANCES SWINBURNE, CONVERSATION PIECE: THE MUSIC LESSON, *private collection* (cat. 63)

cording the appearance of the accused and describing the discomforts he himself had endured in endeavouring to get a good view at Hertford Assizes ('I stood for 15 hours without rest & without any refreshment except two biscuits and this I believe is the cause of a large boil that appeared the day after upon the inside of my left leg').[69] And in December 1858 Mulready was writing to Mary Mulready Stone telling her of the evening he had just spent with Sir John and his daughter, Julia, in London where the Swinburnes were resting on their way to the Isle of Wight. Sir John was recuperating from an illness

that had been 'very distressing' to the artist (cat. 91).[70]

Mulready's involvement with the Swinburne family, their lifestyle and their domestic practices are touched on elsewhere;[71] here it is, however, appropriate to point to the range of portraits of members of the Swinburne family both by Mulready and by the Swinburnes themselves under Mulready's tuition (cat. 55–63). Sir John's eldest son, Edward, was 'very intimate with Turner' and was himself an accomplished artist who 'devoted the whole of his long life to the brush'.[72] Frances, his sister, judging by her interior scenes at Capheaton (53, 54) was equally talented. Heleniak has suggested that Mulready was willing and able to encourage women pupils in particular;[73] he certainly had some success with the Swinburne daughters one of whom, Elizabeth, is portrayed by Mulready as a small child engrossed in her book, her red Swinburne hair falling over her face (IX).

The only surviving portrait of Sir John Swinburne appears as an engraved illustration after a portrait sketch by Mulready in John Pye's *Patronage of British Art* published in 1845. Sir John gave his protection in 1813 to the three-year-old Artist's Joint Stock Fund (subsequently to become the Artist's Benevolent Fund), an act which Pye recognised as 'the first mark of a dignified friendship which has materially advanced and consolidated its interests.'[74] In 1823, acknowledging Mulready's immense service as founder member and his dedication to the organisation, the members presented the artist with a cup inscribed with their names (cat. 73 and 74). The patronage of Sir John was on this occasion attributed entirely to Mulready's influence. The President, the engraver Charles Warren declared: 'To you, Sir, the institution is indebted for the powerful support it receives from one of the best men in existence, Sir John Swinburne Bart. You have', he

[69] W. Mulready to Sir John Swinburne, 11 January 1824, MS. Northumberland County record Office; the drawing made by Mulready at the trial are in the Victoria and Albert Museum, Rorimer, 199–202; for a full account see M. Pointon, 'Painters and Pugilism in early nineteenth-century England', *Gazette des Beaux-Arts*, Octobre, 1978

[70] W. Mulready to Mary Mulready Stone, 15 Dec. 1858, MS. collection of Mrs. Wood

[71] See chs. I and III; also see KH, ch. VI

[72] W. Thornbury, *The Life of J.M.W. Turner*, 1862, revised 1877, p. 227; Mrs. D. Leith, *The Boyhood of Algernon Charles Swinburne: Personal Recollections by his Cousin*, 1917, p. 245

[73] KH, p. 164

[74] J. Pye, *Patronage of British Art*, ch. VI

told Mulready and the assembled company, 'six times filled that office of trouble and expense [the Chair] with unabated ardour and advantage to the Fund, derived alike from your purse and your moral influence over your friends.'[75]

The Artist's Joint Stock Fund, as constituted in 1810, was divided into two distinct branches, a self-supporting Annuity Fund for the sickness and superannuation of its members, who were elected by ballot, and a Benevolent Fund for their widows and orphans which was raised by voluntary subscription. In 1827 a charter of incorporation was granted and the Fund became the Artist's Benevolent Fund. By this time, however, the Joint Stock Fund had suffered a series of financial and administrative disasters. It was John Pye, an engraver and 'consistent champion of the rights of his profession' who suggested in 1823 that engravers should capitalise on their own talents.[76] Mulready volunteered the rights of *The Wolf and the Lamb* (XVIII) if permission could be obtained from the king for it to be engraved by John Henry Robinson. Every member of the Royal Family was asked to subscribe and Mulready approached Sir Thomas Lawrence to obtain the patronage of the king and permission to dedicate it to him. Permission was granted and the engraved version of *The Wolf and the Lamb* became one of the most popular Victorian subject pictures. Many years later, just before the outbreak of the first world war, Mulready's god-son, Edward Mulready Stone, who had the engraving in his home, visited Buckingham Palace to see the original.[77] The final profit amounted to £1009–00–0 and the Fund, under the supervision of John Pye, went on to sponsor the engraving of other paintings but with greater complications and smaller profits.

Another patron who was connected with the Fund and with whom Mulready established a special relationship was Lord Dartmouth. But, unlike the Swinburne contact, little in the way of correspondence has survived from this relationship. From 1815 Lady Dartmouth's name and subsequently that of Lady Louisa and the Hón. Charles Legge appear regularly in Mulready's account book as pupils. Portrait drawings of family servants and landscape studies, evidently the work of these pupils, survive among the family papers and were probably executed at Sandwell, the Earl's country seat in Staffordshire (45).[78]

Household servants must frequently have been persuaded to sit as models to young amateur aristocratic artists; it is rare, however, for the results to have survived. A landscape drawing by Mulready 'accomplished during one morning's lesson' and still in Lady Caroline Legge's possession at the time of the 1864 exhibition of Mulready's work at South Kensington, suggests that the artist took advantage of the scenery of Sandwell Park and drew alongside his pupils.

The most interesting consequence of Mulready's relationship with the Earl of Dartmouth's family is two fine portraits. Lady Dartmouth, first wife of the fourth Earl, died in 1823 and was painted posthumously from a sketch in 1828 (X). Her only surviving child, William Walter, subsequently fifth Earl, was painted in the same year aged five (XI). Lord Dartmouth married again in 1828 and it was perhaps in connection with this event that the portrait of the first Lady Dartmouth was commissioned. Seventeen children were born of his second marriage, among whom were those already mentioned as Mulready's pupils. There is also a watercolour study of Frances Finch, the Dowager Countess of Dartmouth, painted about 1826 (44). Remarkable for its unembroidered directness, this portrait is further testimony to the close relationship between Mulready and the Dartmouth family.

Lady Dartmouth was, by all accounts, an extremely tall woman and it is perhaps on account of this that Mulready used the solution of the seated figure that would prove so useful with Sheepshanks's short figure. Clad in dark blue-grey silk in a room furnished warmly in crimson, Lady Dartmouth presents a wistful figure in this intimate interior filled with familiar objects: the work basket, the sleeping pug and the oval landscape above the fireplace.[79] The portrait of Lady Dartmouth's son is equally informal.[80] The child's size in relation to the dog who eagerly awaits a morsel of his dinner, the spaciousness of the surroundings,

75 Ibid, p. 352, n. 32
76 C. Fox, 'The engravers battle for professional recognition in early nineteenth-century London', *London Journal*, II, no. 1, June 1976, p. 9
77 Edward Mulready Stone's diary, MS. collection of Mr. Brian Stone; in fact there were many difficulties to be overcome before the publication could take place, some of which are recorded in a letter from Ramsay Richard Reinagle to Mulready, undated MS., Victoria and Albert Museum, 86 NN 1; see also C. Fox, op. cit.
78 Staffordshire County Record Office, mostly dated 1815–1825
79 Painted on copper, this was Claude's *The Dancing Dog*, given to a war charity sale by the seventh Earl and now in a private collection

the solitary nature of the meal and the vista up the stair-
case endow this portrait of a motherless only child in a
large house with great poignancy. This is the aristocratic
house in its essentially domestic aspect (toys and slippers
are scattered on the floor) but it insists nevertheless on a
hierarchy through the controlled relations between plain
panelled surfaces, the severe rise of the stairs, and the
beautifully painted rich patterning of the table covering,
the Chinese cabinet and the Oriental rug. A series of un-
dated sketches of Persian rugs laid over tables which may
be related to this portrait or to other paintings like *The
Widow* (XXII) in which Mulready used similar features, are
annotated in a way that reveals the extent to which the
artist pondered over visual effects of interior details in
his paintings:

'A fine persian rug on a table 4.2 by 2.3 and 2.4 high.
It hung at the side 15 at the end 23 metres and from
corner of table to corner of leg 2.3. a general idea to
compose. There are stubborn objects and this
characteristic of them must be respected and it may
be, with great beauty, if taken in true. The degree of
stubbornness may be taken advantage of by placing
objects so as to throw the corners into the distinctness
that the composition demands. A foot stool has a
power upon this stiff matter that it would not have
upon a more pliable material [diagram]. . . . Here
the corners form the best feature. One is quite
foreshortened. The other pressed out of feature by the
sofa. This is capable of forming a very beautiful corner
both in form and colour. . . . Here the corners are
marked in the outline which the mass presents. Very
little outline features & is therefore well calculated to
show the beauty of pattern'[81]

If, with advancing years, William Mulready ceased to be
the practical joker Linnell remembered and became precise
and punctilious in his ways,[82] we can still glimpse through
his letters to Mary Mulready Stone glimpses of the
acerbic wit, self-mockery and sense of humour which
must have been a source both of amusement and of irri-
tation to those closest to him. After a tedious journey to
St. Leonards on sea in April 1845 with Sir John Swinburne
and his family, Mulready wrote of carpet bags and travel
schedules and then, with heavy irony concludes:

'As I did not take leave of you upon the day of
departure, I will endeavour to show you that you are
not completely forgotten among the sirens and
mermaids of these parts. I will write a warm and
affectionate letter to my dear Mary . . . I then found
after arriving at St. Leonards that it was no use my
giving way to my feelings in a letter just then for that
there would not be any post to London from Hastings
till Sunday night. I began to think of what I should
say to those I love if it were any use. Now that
has made this communication of my emotions
comparatively easy. If you think that this will not be
too much for your mother you may let her see it, but
should you suspect that it may be too exciting you
will use a nice discretion in reading her such passages
as your sound discrimination will show that she can
safely bear. The same trouble need not be taken with
Michael, he is very strong – but this penmanship
may, perhaps, be too much for him, so perhaps the
substance might be conveyed to the Grove by some
intelligent person.'[83]

Like Turner, Mulready seems to have allowed a romantic
myth to evolve around his private life, through which he
appeared to his contemporaries a sad but benign, and
sensitive recluse. 'Alas, how hope is still in the future',
declared the Redgraves, describing Mulready's unfulfilled
plans for his children, his house and his garden. 'His ideal
of a painter's house was left incomplete. Yet he continued
to reside here for the remainder of his days, rarely leaving
home . . . his house bare of furniture and in it he led a sort
of half-hermit life. . . .'[84] Another writer describes Mulready
discovered in a drawing room 'where the somewhat sad
solemnities of a *soirée* were being celebrated'. 'What a
quaint, kindly hearted, slightly cynical, old fashioned

[80] K.H., cat. 202 doubts that this is Mulready's work and suggests the hand of a
pupil; I am of the view that an unevenness of handling and evidence of pentimenti,
the sensitivity of approach to the subject and the precision of the surroundings
indicate Mulready's hand whether as master or collaborator. As K.H. points out, the
only portrait mentioned in the account book is of a Charles Legge who cannot be
identified. The most likely explanation, therefore, is that Mulready entered the name
Charles by mistake or that Walter was called Charles within the family

[81] Victoria and Albert Museum, 6428, 6430, Rorimer, 303, 305

[82] A.T. Story, *The Life of John Linnell*, I, 300

[83] W. Mulready to Mary Mulready Stone, 20 April 1845, MS. Mrs. E. Wood

[84] R. and S. Redgrave, *A Century of Painters of the British School*, 1866, II, 323

figure was his. . . . The shadow of sorrow never altogether passed away from his face, it sometimes bore a sign of present pain; sometimes it seemed born of some old memory; but in the hour which he would always give to fitting audience the shadow never broke the sunniness which the occasion brought forth.'[85]

This view of Mulready has been challenged by Heleniak[86] who suggests that if Mulready was reclusive it can only have been during the very last years of his life and cites the Cole diaries as evidence for Mulready's regular if not busy social life. Reference to Mulready's correspondence with Mary Mulready Stone during the last years of his life demonstrates clearly, moreover, that despite the heart disease from which he was eventually to die, the artist was not the maudlin personality evoked by his biographers but a cheerful and fairly sociable being. In December 1857 Mulready's kitchen range is out of order but he enjoys, as a consequence, a joke at the expense of his housekeeper. In 1858 he describes himself as 'in the very thick of business', he has had visits from Miss Swinburne and from Mary and in December 1860, writing of his plans to spend Christmas with Mary and her 'little flock' he tells of visits from Etty and other friends.[87] The question is why did Mulready's biographers construct this pathetic 'Mulready'? Perhaps there is a sense in which, it having been well-known that Mulready's life had been on a personal level irregular, it was necessary for him to publicly atone for this through the biographical anecdote. Perhaps the discourse of artistic achievement can only find its closure in pathos. Perhaps people did genuinely feel sorry for the modest domestic scale on which Mulready lived.

Mulready died on 7 July 1863 and was buried, after an Anglican funeral according to his own wishes, quietly at Kensal Green. Although he had been brought up and educated as a boy in the Roman Catholic faith and one of his closest friends and most important patrons, Sir John Swinburne, was a Roman Catholic by birth, Mulready appears in adult life to have avoided affiliation to any religious sect. Only two Royal Academicians were present at this essentially private occasion and one mourner observed the curious contrast between this and the 'grand affair of Mr Turner and other ostentatious obsequies.'[88]

But if the funeral was modest the grave was splendid.

A grand Renaissance style tomb was erected at Kensal Green cemetery, carved by Godfrey Sykes and decorated around the base with outlines of Mulready's most famous compositions. Friends and fellow Academicians, including his patrons Thomas Baring, Thomas Miller, Sir Robert Peel, John Sheepshanks and Admiral Swinburne; artists like Creswick, Elmore, Horsley, William Henry Hunt, W. Holman Hunt, Landseer, Maclise, Redgrave and many others collected eighty pounds for the monument, one hundred and thirty pounds for a bust of the artist and a further sum for prizes in the Life School at the Academy.[89] Later Mulready was honoured as the only modern artist to be represented in the mosaic decorations at the South Kensington Museum (40). Undoubtedly his greatest memorial, however, was the huge exhibition of his work which Henry Cole was planning as early as 22 July 1863 and which opened at South Kensington the following year.[90]

85 Dr. Doran, *Athenaeum*, 2043, quoted by F.G. Stephens, *Memorials . . .* , p. 105
86 K.H., p. 16
87 MSS. Mr. Brian Stone and Mrs. E. Wood
88 Anderdon catalogue, MS. Royal Academy Library, XII, 23
89 Victoria and Albert Museum, MS. 86 NN 1
90 Minutes of the Science and Art Dept.; I am grateful to John Physick for drawing my attention to this document

The Varley–Mulready–Leckie–Stone Families

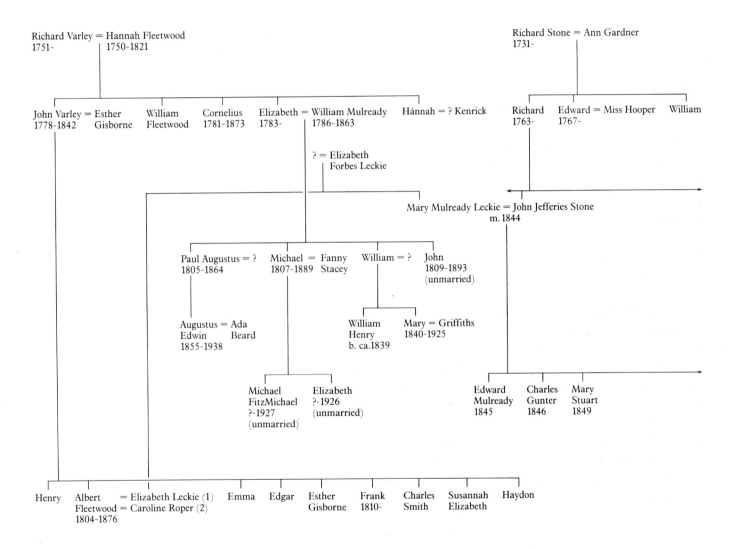

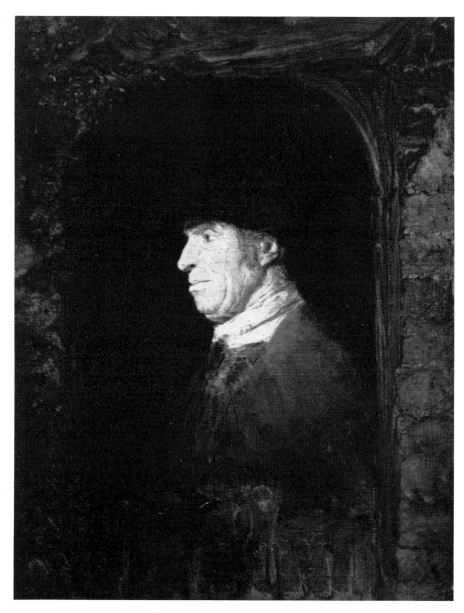

55. PORTRAIT OF THE ARTIST'S FATHER?, *National Gallery of Ireland, Dublin* (cat. 52)

PEOPLE BOTH PUBLIC AND PRIVATE

"The multitude, the group, the man, the face, the eye, the hand, the fingers". William Mulready's notebook.

38

The Varley-Mulready-Leckie-Stone family connections; an incomplete family tree.

39

A MUSIC LESSON, 1809

Oil on canvas stuck on panel, $15\frac{1}{4} \times 12$ in

Private collection (42)

This painting originally belonged to John Jefferies Stone, husband of Mary Mulready Stone (nee Leckie), the artist's ward. Its interest lies in the connection with William Mulready's early life; F.G. Stephens affirmed that its was a self portrait of the artist and annotations to the 1864 South Kensington exhibition catalogue indicate that the female figure is a portrait of the artist, Harriet Goldsmith who is recorded in the artist's account book as having been one of his pupils. Lot number 115 in Sir John Swinburne's sale, Christie's 15 June 1861, *Landscape with a cottage and figures* by Harriet Goldsmith was bought by John Jefferies Stone. The head of the woman looks to have been repainted and one wonders whether this depiction, in view of its subject, received the attentions of Mulready's wife who is said to have painted out the eyes of his figures after the couple quarrelled.

40

MRS. ELIZABETH FORBES LECKIE, 1829

Oil on canvas stuck on panel, $34\frac{1}{2} \times 27$ in

Private collection

This is the only surviving finished portrait of Mulready's long-term companion and mother of his ward, Mary Mulready Stone nee Leckie. See 38. The beginning of an enigmatic inscription in chalk is just visible through the paint at the lower left corner reading "He who does not . . ." It has been suggested by descendants of the subject that she is pregnant.

41

MRS. LECKIE AND PAUL MULREADY, 1826

Pen and brown ink, $4\frac{3}{4} \times 3\frac{7}{8}$ in

Private collection

This slight but sensitive drawing has survived in the collection of a descendant of the artist's second son and provides interesting evidence of the close relationship between Mrs. Leckie and her family and Mulready's own menage consisting, after his separation from his wife in 1810, of himself and his four sons. Paul was born in 1804 a year after Mulready's marriage. The artist was nineteen at the time of his birth. See also 38.

42

A WOMAN WEEPING, c.1804–10

Oil on canvas, $7\frac{3}{8} \times 7\frac{1}{8}$ in

Private collection

It has been suggested that this well-worn, much-handled and lovingly preserved depiction is a portrait of Elizabeth Mulready nee Varley, the artist's wife. The marriage which took place in 1803 when Mulready was seventeen and Elizabeth nineteen was not happy. See 92 and 93. The couple separated formally in 1810.

43

SELF-PORTRAIT, c.1830

Oil on panel, $9\frac{1}{2} \times 7\frac{1}{2}$ in

Private collection

The portrait is referred to in a letter from the artist to Mary Mulready Stone, 17 September 1858: "The portrait of myself has

ultimately found a home in the frame it was in when John [Mary's husband], called on the 3rd. Nothing better could be produced". MS. collection of Brian Stone, Esq. A second letter, undated, refers to a copy Mary has made of the portrait. The child mentioned in the letter was born in 1844: "I have now to request that you will exert yourself in teaching Mr. Stone Jnr. to consider that copy you made of my portrait, as his God-father Lieutenant deserving of great respect and reverence." MS. collection of Tim Stone, Esq.

44

MARY MULREADY LECKIE
SELF-PORTRAIT, C.1840
Drawing
Private collection

Mary Mulready Leckie was the artist's ward and there has always been some speculation among her descendants that she may also have been his daughter. See 38. Mary exhibited at the Royal Academy under her maiden name between 1840 and 1844 and under her married name of Stone between 1845 and 1846.

45

EDWARD MULREADY STONE AS A
BABY, 1846
Chalk, 17 × 14¼ in
Mrs. Everel Wood

Mulready's Godson is here portrayed as about the time he cut the tooth on the subject of which Mulready writes so eloquently to the baby's mother, see 95.

46

MARY MULREADY LECKIE
PORTRAIT OF WILLIAM MULREADY,
C.1840
Private collection

This may be the portrait referred to in the letter quoted above, see 43.

47

GIRL PLAYING THE PIANO, C.1840
(portrait of Mary Mulready Leckie?)
Sepia, 16 × 10 in
Mrs Everel Wood

This drawing exemplifies Mulready's brilliant technique as a draughtsman and his sympathy for Regency and early Victorian fashion in women's dress and hair styles.

48

PORTRAIT OF JOHN VARLEY
Pencil, 6½ × 5½ in
British Museum

Varley died in 1842 aged 70. In this affectionate and informal sketch, probably executed while the subject was himself drawing, Varley appears as relatively youthful. The work, therefore, probably belongs to the period when Varley, Mulready, Linnell, George Dawe and others enjoyed evenings spent drawing together relieved by rounds of boxing. See 38.

49

PORTRAIT OF JOHN VARLEY, 1814
Oil on panel, 3½ × 3 in
National Portrait Gallery, London (41)

This posed portrait of Mulready's friend, teacher and father-in-law is an interesting complement to the drawing no 48 and demonstrates Mulready to have been at his happiest in the portrait field when treating a familiar subject on a small scale.

50

J. LINNELL
PORTRAIT OF MULREADY, C.1833
Oil on panel, 18⅛ × 16⅛ in
National Gallery of Ireland, Dublin

Linnell enjoyed a flourishing portrait practice. This depiction of his close friend and companion of his youth appears to be an unfinished study for the portrait now in the National Portrait Gallery, London in which the artist is presented in an identical pose but with the addition of a palette.

51

MARY ANN FLAXMAN
VARLEY, MULREADY AND FRIENDS
DRAWING, C.1808
Pencil
Victoria and Albert Museum (46)

The artist was John Flaxman's sister and an exhibitor at the Royal Academy from 1786. She lived in Germany as a governess from c.1802 but was back in London living with her brother by 1810. Blake engraved some of her book illustrations and she was evidently an as yet little recognised member of those interconnected circles within which Blake, Godwin, Mulready, the Varleys, Flaxman and Fuseli moved, circles which deserve to be further researched. See 38.

52

THE ARTIST'S FATHER?, C.1808
Oil on panel, 6½ × 5 in
National Gallery of Ireland, Dublin (55)

Mulready's father is reported to have modelled for a number of paintings by Mulready and his friends including Wilkie's *The Refusal: the Song of Duncan Gray* 127, Linnell's *Removing Timber, Autumn* of 1808 and Mulready's *The Village Buffoon* 126. Michael Mulready, after whom one of the artist's sons was named, was a leather-breeches maker from County Clare.

53

HEAD OF AN OLD MAN, C.1810
Pencil, 6 × 7½ in
Private collection

As this drawing has survived in the collection of one of the artist's descendants it may be a family portrait, possibly of the artist's father.

54
J. KING

PORTRAIT OF MULREADY

Oil on canvas, $7\frac{7}{8} \times 5\frac{7}{8}$ in

National Gallery of Ireland, Dublin

A highly formal portrait of Mulready probably painted from a photograph and offering an extremely public portrayal of the artist as an Establishment figure. cf. no. 86.

55
MISS ELIZABETH SWINBURNE, c.1821–3

Oil on board, $9\frac{1}{2} \times 8\frac{1}{2}$ in

Private collection (50)

The youngest daughter of Sir John Swinburne and one of Mulready's pupils, Elizabeth is portrayed here as a young woman cf. 56. She married in 1828 Cardinal Newman's greatest undergraduate friend, J.W. Bowden who died in 1844. He was a distinguished writer on Tractarianism and after his death Elizabeth, who engaged in a long correspondence with Newman, became a Roman Catholic. Sir John Swinburne had been baptised a Roman Catholic but it appears that Elizabeth was the first of the family to return to the old faith. See also 56.

56
MISS ELIZABETH SWINBURNE, 1811

Watercolour, $12 \times 8\frac{1}{8}$ in

Private collection (IX)

Mulready excelled at unposed, informal family portraits of this kind. The representation of the child engrossed in her book, her Swinburne red hair catching the light, surrounded by the comfortable impedimenta of domestic tranquillity – the cat, the cushion, the letter writing implements – is a warm record of the artist's relationship with the Swinburne family. See also 55.

57
MISS EMILY SWINBURNE, 1813–18

Oil on panel, $5\frac{3}{4} \times 5\frac{1}{4}$ in

Private collection

Like her sister, Emily is here depicted with a serious, even studious, mien. Whilst the averted eye was a standard convention for denoting chastity in female sitters, these head and shoulder portraits of the Swinburne daughters convey a relaxed but very definitely non-frivolous characterisation.

58
MISS JULIA SWINBURNE, 1813

Oil on panel, $4\frac{1}{8} \times 3\frac{1}{2}$ in

Brian Stone, Esq.

Julia remained a close acquaintance of the artist for life and she is mentioned as caring for her elderly father, the artist's patron Sir John Swinburne of Capheaton, in 1858, see 91. It is likely that this is the painting executed for Sir John and recorded in the artist's account book in 1813.

59
MISS JULIA SWINBURNE, 1813

Oil on panel, $4\frac{1}{8} \times 3\frac{1}{2}$ in

Private collection (51)

The MS. exhibition catalogue for the 1848 Mulready exhibition mentions a "sketch in oil" of Miss Swinburne. This may be the work referred to.

60
THE CAPHEATON ASS, 1814

Oil on panel, $15 \times 11\frac{3}{4}$ in

Private collection (52)

The Swinburne children's donkey and family pet was also worthy of record. Works such as this were retained by the family after the sale in 1861 at which subject paintings by Mulready as well as works by other nineteenth-century British painters such as Wilkie were sold.

61
FRANCES SWINBURNE

INTERIOR CAPHEATON, 1813

Watercolour, 10×14 in

Private collection (53)

Frances and her sister Emily enjoyed the tuition of Mulready in their home at Capheaton Hall, Northumberland. They became accomplished artists and in this view of an interior at the hall, perhaps the schoolroom though known as the studio, Frances portrays one of her sisters painting from the Antique while another sews.

62
FRANCES SWINBURNE

SKETCH FOR A CONVERSATION PIECE

Black and white chalk, $5\frac{3}{8} \times 5\frac{7}{8}$ in

Private collection

Frances follows Mulready's technique of sketching in chalk the broad outlines of a composition, before developing it in oil.

63
FRANCES SWINBURNE

CONVERSATION PIECE, THE MUSIC LESSON, c.1815

Oil on canvas, $26\frac{1}{2} \times 34\frac{1}{2}$ in

Private collection (54)

Sir John Swinburne was Sheriff of Northumberland in 1799, President of the Newcastle-upon-Tyne Literary and Philosophical Society from 1798 to 1837, President of the Society of Antiquaries of Newcastle-upon-Tyne from 1813 until his death, a member of many other august bodies and a benefactor of the Artist's Benevolent Fund. He was a friend to Mulready as well as his patron for nearly fifty years. He is described as having been a flamboyant character but, portrayed here by his daughter surrounded by his family, he appears the epitome of sobriety and benevolence. The artist's three sisters, Julia, Elizabeth and Frances are grouped around the piano. The large marine painting immediately behind Sir John's head is A.W. Callcott's *Southampton Water*, 1812

whilst the small landscape to the left may be the Patrick Nasmyth which appears as lot 118 in the Swinburne sale, 15 June 1861: 'A Woody Landscape with figures on a road, a river beyond and open distance – warm effect of evening. This charming work was selected for Sir John Swinburne by Mr. Mulready.'

64

SELF PORTRAIT, c.1835
Oil on canvas, $8\frac{1}{2} \times 6\frac{5}{8}$ in
National Portrait Gallery, London

Mulready was regarded by his contemporaries, both women and men, as a remarkably handsome man. He was frequently portrayed both by himself and by others, see also 50 and 86.

65

SELF PORTRAIT, c.1804
Miniature, watercolour, $2\frac{1}{2} \times 3$ in
Mrs. Everel Wood (VIII)

This interesting piece of juvenilia shows Mulready presenting himself through a delicate stippled miniature technique like some curled Renaissance lover.

66

JOSEPH PITT OF PITTVILLE, c.1820
Oil on canvas, 25×30 in
Cheltenham Art Gallery and Museums

This is the only extant commissioned portrait by Mulready of a subject that was not in some sense personally known to him. Most of his portraits represent friends, patrons and family. His account book does, however, indicate the occasional commission of this kind. He fulfilled his obligation here but a certain stiffness and an archaism of style suggests that he was not entirely at home either in this genre of official portraiture or on this scale. The subject, 1759–1842, was a benefactor of Cheltenham and planner of the Pittville Estate.

67

THE COUNTESS OF DARTMOUTH,
Posthumous portrait, 1827–8
Oil on panel, $24\frac{1}{4} \times 19\frac{7}{8}$ in
Private collection (X)

The Countess, who was reputedly an exceptionally tall woman, is portrayed here posthumously in a depiction based on a sketch no longer extant. The Fourth Earl who commissioned the portrait employed Mulready to teach his children, see 70 and 71. The painting on the wall behind the Countess is Claude's *Landscape with the dancing dog* then in the Earl's collection. The figure of the Countess is frozen into an Ingresque immobility within a frame of richly realised and partially seen detail.

68

FRANCES FINCH, COUNTESS OF
DARTMOUTH, c.1826
Pencil and watercolour, mounted in album, $9 \times 7\frac{1}{2}$ in
Private collection (44)

This sketch of the Dowager Countess is mounted at the beginning of a family album containing a poem with illustrations by the Countess.

69

THE HON. WILLIAM WALTER LEGGE,
1828
Oil on panel, 17×21 in
Private collection (XI)

The subject is the only surviving child of the Countess portrayed in 67. Aged 5 in 1828 he grew up to become Fifth Earl of Dartmouth. Mulready has concentrated on evoking the child through the portrayal of his environment; the result is both poignant and suggestive of life for an only motherless child in a large house. The attribution to Mulready has been questioned but the painting is a refined production and exhibits many of Mulready's typical characteristics. The attention to detail and the Dutch inspired domestic interior are also found in 56 and 57.

70

FRANCES DARTMOUTH
OLD YEW TREE IN THE PARK
Charcoal, $7\frac{7}{8} \times 6\frac{1}{2}$ in
Dartmouth family papers, Staffordshire County Record Office (D1501/H/2/4)

A plein-air study by one of Mulready's pupils, or perhaps drawn from a window on a rainy day. It was probably executed at Sandwell, the Earl's country seat in Staffordshire.

71

CHARLOTTE LEGGE
HANNAH MASON
Charcoal, $9\frac{1}{2} \times 7$ in
Dartmouth family papers, Staffordshire County Record Office (D1501/H/2/23B)
(45)

Portraits such as this depiction of one of the Earl of Dartmouth's household servants by his daughter must have been frequently executed in the eighteenth and nineteenth centuries when the children of the aristocracy were given drawing lessons by visiting or resident artists. Few have survived and this therefore provides interesting documentation of social relations in the period as well as an affectionate memento of an individual who, unlike most portrait subjects, had no expectation of being recorded for posterity.

72

WILLIAM GODWIN
(PSEUD. THEOPHILUS MARCLIFFE)
THE LOOKING GLASS THE TRUE
HISTORY OF THE EARLY YEARS OF
AN ARTIST . . .
London 1805, facsimile edition, 1885

The original edition of this account of Mulready's early life recorded in conversations with the author when Mulready was working for him as a book illustrator is now extremely rare. Henry Cole's diary indicates that the publication of a facsimile was mooted as early as 1843 but that Mulready was anxious about the effect of such a reprint on his reputation. See 75.

73
JOHN PYE
PATRONAGE OF BRITISH ART, 1845
Victoria and Albert Museum Library

In a text which remains an important account of the institutions of British art up to the mid-nineteenth century, Pye describes the foundation of the Artists' Benevolent Fund, established as the Artists' Fund in 1810 to assist indigent members of the profession. Mulready was responsible for introducing Sir John Swinburne to the Society. The book is illustrated by a number of portrait sketches executed by Mulready at meetings of the Society including one of Sir John Swinburne. The originals for these illustrations are in the Museum, D28–1886.

74
SILVER CUP
Presented to Mulready in 1822 by the Artists' Benevolent Fund
Private collection

Mulready was one of the founders of the Artists' Benevolent Fund and served as an officer six times. When he retired from the Chair in 1822 members collected money to buy this cup which was presented to the artist at the Freemason's Tavern on 22 January 1823. The speech of thanks delivered on that occasion is transcribed in full by Pye, see 73.

75
HENRY COLE'S DIARY,
3 Feb. 1843, 12 Dec 1847
Victoria and Albert Museum Library

Henry Cole, founder of the Victoria and Albert Museum, became one of the artist's life-long friends. Cole's diary contains many references to the artist. Here Cole is recording discussions about the re-printing of Godwin's early life of the artist.

76
WILLIAM MULREADY'S ACCOUNT BOOK
Victoria and Albert Museum Library

Mulready's account book is a vital and fascinating source of information concerning his teaching activities in the early years, his expenditure, commissions he undertook and prices he charged and his methods of work. It is clear from pages such as these which cover some of the entries for *The Seven Ages of Man*, 118, that Mulready was not only paid extremely generously by his patrons, in this case John Sheepshanks, but also received his payment in instalments sometimes over a long period of time:

77
WILLIAM MULREADY'S NOTEBOOK
Victoria and Albert Museum Library

In this notebook Mulready recorded formulae for the production and deployment of pigments and glazes and technical data of all kinds. He also jotted down intensely private, and sometimes misanthropic, musings on art, representation and the market.

This extraordinary passage suggests a deliberate strategy and a consciousness about the affectiveness of his subject matter and how to make it acceptable to an audience he regarded in a cynical light:

May 1844. Confirmed . . . that in the present state of the art almost any subject matter may be raised

1835 'Feb 7 First thought of "Seven Ages" . . . [word illegible]
July 11 comd by Sheepshanks to paint. Nov 17 traced block.
dec 28 Seven Ages dets to Martin.'
1836 'Jan 7 Began the picture "Seven Ages" outline
 April 21 Martin block "Seven Ages"
 April 21 J Sh 210
 100
 152–10 on acc of Seven Ages
1837 'Jan 31 J Sh 100 on acc of Seven Ages
 Mar 10 157–10 Brother and Sister's 'Ear'
1838 'Ap 10 'Seven Ages' sent to RA back Aug 1
 Retouched
 March 19 J Sh: 105
 April 11 78–15
 28 78–15
 ———
 262–10
1839 'Mar 1 J Sh 50
 May 19 65 balance for Seven Ages
 July 30 40 On acc. for First Love

Cat. 76

into importance by truth and beauty of light and shade and colours with an ostentatious mastery of execution. The higher qualities of art, beautiful form, character and expression are chatted about not felt or understood, but by very few. Expression, if strong, or character bordering on caricature are recognised by the people. Female beauty and innocence will be much talked about and sell well. Let it be covertly exciting, its material flesh and blood approaching a sensual existence and it will be talked more about and sell much better, well in the first state, doubly well in the second, but let excitement appear to be the object and the hypocrites will shout and scream and scare away the sensuality, the birds that would be pecking: when the scarecrow hypocrisy is silent, some blessed watchful crow will bear the fruit to his quiet parsonage.

78

INTERIOR WITH A PORTRAIT OF JOHN SHEEPSHANKS, 1832–4

Oil on panel, $20 \times 15\frac{3}{4}$ in

Victoria and Albert Museum (XII)

This fine and apposite monument to the Museum's benefactor, John Sheepshanks, was the result of long and careful planning by the artist. See 79–81. Sheepshanks was by all accounts not a striking looking man or an imposing figure. Yet Mulready appears to have wished to strike a balance between flattery and a portrait appropriate to his status. He discarded early designs which would have endowed his subject with a straight back and more erect posture in favour of this dignified but essentially informal pose.

79

JOHN SHEEPSHANKS, 1832

Oil on paper fixed on panel, $6\frac{1}{2} \times 5\frac{1}{4}$ in

Victoria and Albert Museum

A study of the features of Sheepshanks in preparation for the major portrait with interior, see 78.

80

PORTRAIT OF JOHN SHEEPSHANKS READING, 1832

Pen and ink, $8\frac{1}{2} \times 4\frac{1}{4}$ in

Victoria and Albert Museum (47)

Sheepshanks was a Leeds woollen manufacturer and whilst it would be inaccurate to suggest in any way that this rugged figure in his shirt sleeves is more 'true' than the figure in the finished portrait, 78, a comparison with the painting suggests the subtle shifts that mark the transition from private record to public statement.

81

SKETCH OF WALL FOR SHEEPSHANKS PORTRAIT, 1832

Pen and ink, $6\frac{1}{4} \times 8\frac{3}{4}$ in

Victoria and Albert Museum (48)

This is one of a series of drawings for the background of 78. None of the paintings named in the frames on the wall represented here was actually in the Sheepshanks collection. *The Wolf and the Lamb* was in the Royal Collection while Wilkie's *Chelsea Pensioners* belonged to the Duke of Wellington. Moreover, their dimensions make introduction into these spaces implausible; Turner's *Temple of Jupiter* is actually 46×70 inches. It would seem, therefore, that Mulready, while considering the background to the Sheepshanks portrait, was meditating upon the idea of a gallery of British art that would contain some of the most distinguished work by himself and his contemporaries. Although the fireplace that appears in the painting is here replaced by a doorway, the reproduction of the frieze clearly identifies this interior with the Bond Street room in which Sheepshanks is portrayed.

82

THE INTERCEPTED BILLET, 1844

Oil on panel, $10 \times 8\frac{1}{4}$ in

Victoria and Albert Museum (87)

The subject suggests a scene from *The Merchant of Venice* but drawings in the Museum collection, 6130–6139, indicate that the painting relates to John Varley's theories as published in *A Treatise on Zodiacal Physiognomy* in 1828, a tract which combined Le Brun inspired theories of expression with the principles of astrology that were popular in the Blake-Varley circle. The centre part of the painting is on a panel screwed into a zinc trough and the edge filled with isinglass and whiting. This indicates that the artist began with the central figure as a study in expression than expanded the field to incorporate the narrative. It is thus a paradigm of Mulready's working method as well as an abstract essay in squares and cubes.

83

MARY WRIGHT, THE CARPENTER'S DAUGHTER, 1828

Oil on canvas panel, $9 \times 6\frac{3}{4}$ in

Victoria and Albert Museum (43)

The subject was, according to annotations to the 1864 exhibition catalogue, the daughter of a carpenter to whom Mulready gave the portrait. The child's name is inscribed on her book. The owner later was in financial difficulties and sold the portrait to Sheepshanks. Whilst detailed and particularised studies of male children are the mainstay of Mulready's oeuvre, representations of female children, whether portraits or narrative subjects, are rare. The portrait of Elizabeth Swinburne is an exception, 56. When they do appear they tend to be strongly idealised. An obvious reason for this difference is the fact that Mulready was the father of four sons and had no daughters but it must also be said that this difference in treatment underlines a social gender distinction that spread throughout society with profound consequences. It is interesting to observe, therefore, that in this portrait of a little girl Mulready reverts to a Reynolds inspired formula.

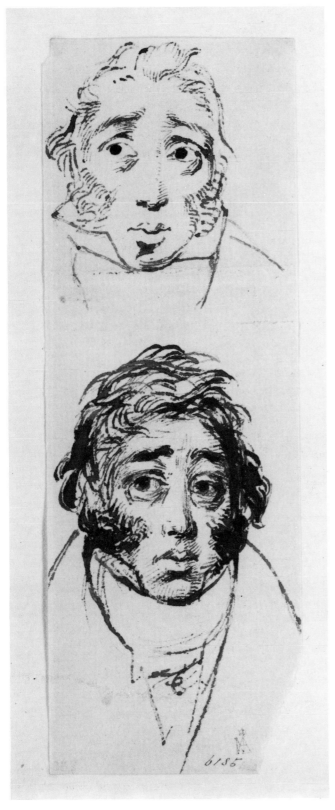

56. SKETCHES OF JOHN THURTELL, *Victoria and Albert Museum* (cat. 84)

84

SKETCHES OF THURTELL,
Pen and ink, $5\frac{7}{8} \times 2$ in
Victoria and Albert Museum (56)

The trainer and boxing promoter John Thurtell, the Mr Turtle of Hazlitt's essay 'The Fight', was tried and convicted for murder at Hertford Assizes in 1823. Mulready attended the trial, executed a series of sketches and wrote a long letter to Sir John Swinburne describing Thurtell. 'I must say that Thurtell appeared to be ever, with the exception of a few minutes, assiduously on the watch and ready to seize upon any little slip in the evidence of the witnesses against him. . . .', Mulready told Sir John. Whilst portraits of criminals have a long pedigree in British art going back to Hogarth's portrait of Sarah Malcolm and beyond, it is interesting to note that, in writing to Sir John, Mulready uses the language of the ringside. Boxing united high and low in Regency society. Mulready, George Dawe and Linnell were all keen boxers. Varley's house was described as a regular school of boxing and Linnell himself referred to the Royal Academy in the early years of the century as 'quite a boxing school'.

85

LÉGION D'HONNEUR MEDAL
Awarded to Mulready at the 1855
Exposition Universelle in Paris
Private collection

Mulready's contribution to the Exposition Universelle of 1855, a successor to the Great Exhibition of 1851 and the first of a series of grand international fairs of art, trade and industry, included *The Wolf and the Lamb* and *Blackheath Park*, 24. Henry Cole and Richard Redgrave worked exceptionally hard to ensure a good showing for British art at the exhibition. There was much sparring between French and British critics but Mulready's work received widespread approbation, being compared both with the eighteenth-century English novel and with the morality of French fables. Back home news of Mulready's success reached his estranged wife who wrote to congratulate him, see 94.

86

CUNDELL DOWNS & Co.

Photograph of WILLIAM MULREADY

$3\frac{7}{8} \times 2\frac{1}{2}$ in

Collection of Jeremy Maas, Esq.

87

Photograph of CORNELIUS VARLEY

$3\frac{1}{4} \times 2\frac{7}{8}$ in

Collection of Jeremy Maas, Esq.

88

ELIZA ROBINSON MULREADY IN HER
80TH YEAR

Photograph inscribed on the reverse,
from a painting by her Grand-son,
Augustus Edwin Mulready, $3 \times 2\frac{1}{2}$ in

Collection of Jeremy Maas, Esq.

This important piece of documentation,
formerly in the possession of a descendant of
William Mulready, is proof firstly of the fact
that William Mulready's estranged wife was
alive in the year of his death – she would
have been eighty in 1863 – and secondly of
the hitherto uncertain identity of A.E.
Mulready, the well-known Victorian genre
painter.

89

WILLIAM MULREADY JNR.

Photograph with inscription as to the
sitter's identity on the reverse,
$4\frac{7}{8} \times 3\frac{1}{2}$ in

Collection of Jeremy Maas, Esq.

This was Mulready's artist son who was a
great source of anxiety to him on account of
his financial affairs and family difficulties.
See also 13 and 96.

90

C. ALDRIDGE (408, Edgware Rd.)

Photograph of ELIZABETH ROBINSON
MULREADY (née Varley)

$4\frac{1}{8} \times 2\frac{1}{2}$ in

Collection of Jeremy Maas, Esq.

The identification is made on the basis of
comparison with number 88. Both items came
from the collection of a descendant of William
Mulready.

91

LETTER FROM WILLIAM MULREADY
TO MARY MULREADY STONE
(NÉE LECKIE)

15 December 1858

Collection of Mrs Everel Wood

"My dear Mary/ I shall be very/ glad indeed to be
with you on/ Christmas day at the hour you name./
There is some uncertainty about/ Michael at present./
You have a great deal too much/ to do in your
family to be expected/ to make such a cross country
journey/ as it is from your house to mine,/ parti-
cularly as I/ am in very fair/ health and you are
far from/ such at home./ Sir John and Julia
Swinburne/ arrived in London on Thursday last/ I
spent the evening of this day with them – and on
Sunday evening/ bad them goodby. They set off on/
Monday for the Isle of Wight, and/ arrived there
safely the same day. Sir John previous/ to leaving
Capheaton, had been/ very unwell for three weeks –
he/ is still suffering some inconvenience/ but we all
expect the Island/ will put him right. This illness
has/ been very distresing to me. The/ darkness of
these silent days, too, has/ caused great discomfort
in my/ painting room. The thing that/ goes on best
is the little Academy/ in Kensington, where I draw
three/ nights in the week, for three successive/
weeks, and then four nights a week,/ for two
successive weeks./ I am much obliged to Henry for/
his favourable report. If you write/ again, tell me
how the little fellow/ in Lancashire are [sic] going
on./ Kind remembrances to all your/ people./ Yours
affectionately/ W Mulready.'

92

UNDATED LETTER FROM ELIZABETH
MULREADY (NÉE VARLEY) TO
WILLIAM MULREADY

Containing accusations of infidelity
and physical cruelty; transcribed
pp. 67–68

*Victoria and Albert Museum Library,
86, NN 1.* August 22, no year, from
The Manor House, Acton

93

DRAFT LETTER CONCERNING
ARTICLES OF SEPARATION IN
WILLIAM MULREADY'S HAND

*Victoria and Albert Museum Library,
86 NN 1*

The artist does not attempt to defend him-
self against some of his wife's accusations
but claims that 'the articles of separation
which accompany this letter were drawn . . .
on much more serious grounds than are herein
stated.' Mulready asserts that 'in consequence
of the great contrition she seemed to feel &
the fear I had that exposure by rendering her
desperate might plunge her into fresh infamy
. . . or some violence against herself I deter-
mined to put that face upon the matter
which the articles [now lost] present.' At
first, Mulready states, his leniency produced
a good effect but subsequently Elizabeth
Mulready began to insist, not surprisingly,
that she wanted one or more of the children,
all four of whom were in Mulready's custody.
When her demand was refused she came to
the house during Mulready's absence and
took one of the children away with her.
There was then a prolonged struggle during
the course of which Elizabeth Mulready is
alleged to have abused and insulted her
mother-in-law (who presumably was looking
after the children), carried off three of the
boys and then, after they had been returned
against her will, carried them off again and,
finally, barricaded herself into a room in
Mulready's house, refusing to leave without
all the children.

94

LETTER FROM ELIZABETH
MULREADY (NÉE VARLEY)
TO WILLIAM MULREADY, 26 April
1855, from Grafton St., MS
Victoria and Albert Museum, 86 NN 1

Elizabeth in a shaky hand congratulates Mulready on the award of the Légion d'Honneur medal and regrets that Varley and the artist's parents are no longer alive to share the 'proud day'.

95

LETTER FROM WILLIAM MULREADY
TO MARY MULREADY STONE
8 December 1845, written after he
has received news that Mary's first
child and his Godson has cut a tooth
Collection of Mrs Everel Wood

Tell Mr. Edward Mulready Stone (the baby) when you happen to see him that I beg respectfully to approach him with my dutiful congratulations upon his accession to another fortune of ivory – long may he live to employ it in the encouragement of commerce and agriculture, avoiding all the mad or wicked temptations of the day to speculate railway shares, and so risk the loss of his precious pearls for stags-horn. I hope also he is not ostentatious of his wealth and that he does not make you feel unpleasantly (Mary is breast-feeding the baby) but this need go no further.'

96

LETTER FROM WILLIAM MULREADY
TO HIS GRAND-SON, WILLIAM
HENRY MULREADY
11 December 1845, MS.
Collection of Jeremy Maas

The child – who cannot be more than nine as he addressed as 'dear little William' – was the son of Mulready's difficult son, William. This touching communication reveals that the Mulready family problems were experienced through the second generation and suggests Mulready's responsible and sensitive approach to the issue of custody.

My dear little William| I hope you have been quite well since I left London.| If you have anything to say to me, you had better write and your Uncle Michael will send your letter to me.| I am told that your father wants you to go to his house on Christmas day.| Some time ago, you asked me to prevent you from being taken to your father's house. What would you like to be done now.| If you do not like to go, I can only say that I do not like you to be forced to go – and that I would prevent it if I could.| Perhaps you will write to me, and then I may know better what I should try to do.| Yours affectionately,| W. Mulready.| To William Henry Mulready| 11 Dec 1845

97

LETTER FROM ELIZABETH
MULREADY (NÉE VARLEY)
TO WILLIAM HENRY MULREADY,
Sunday 20 August 1848, MS.
Collection of Jeremy Maas

This letter constitutes interesting evidence that Mulready's estranged wife at least had contact with her grandchild even if she had been denied custody of her own children, see 92.

3, Sherborne St., Blandford Squ.|Grandmama's love to William the Third sending him a few books. The ragged ones are only fit to be burnt but she thinks he had better read them first. Another time she will endeavour to send him something better.| Sunday August 20th. 1848

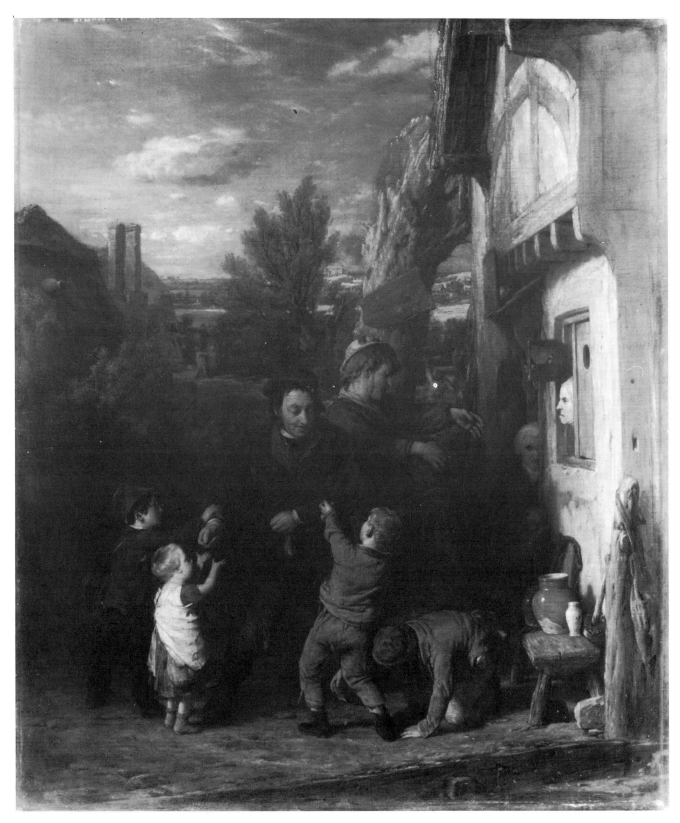

57. FAIR TIME, *The Trustees of the Tate Gallery* (cat. 149)

CHAPTER III
LEARNING AND LIFE

It has long been recognised that the child is a central motif in Victorian art and Mulready, in particular, has been singled out for his role in establishing a genre of child painting. From Philip Aries to Lawrence Stone the family, with the child as its centre, has been increasingly a focus of attention for social historians. But where does art come into this? An expressive view would posit the artist as a member of society, willy nilly producing an imagery that reflects dominant ideology. On this model ideology – in this instance widely held beliefs about human nature and aspirations concerning institutions such as the family – is an overarching monolith from which ideas filter down to be picked up in individual motifs within works of art. At the same time the artist may, according to this model, be seen to move against the stream, to introduce an original commentary of his own upon the dominant ideology. Mulready may, according to this model, be seen as an artist who creates a world of children who 'like humanity in general are intrinsically weak, indolent, irresponsible, tardy, even cruel',[1] a pessimistic pre-Enlightenment view of human nature. Xenophobia, nationalism and racism are all identified as currents flowing through these images. Mulready is upbraded for 'producing unlikely images of colonial people, Indians or blacks while ignoring "the truly frightful role of contemporary children as expendable industrial fodder".'[2] At the same time Mulready's 'revelatory views of children's inner ambivalence, their vulnerability and fear were unusual and constitute a valuable, although jarring, contribution to nineteenth-century paintings of childhood life.'[3]

This unhappy oscillation between the work of art as a gathering ground, a field of presentation for ideas that are manufactured elsewhere, somehow, inexplicably, and the artist as individual producer of ideas that challenge a dominant mode simply by being there, leaves much unexplained. It is precisely at the point when the painting of the child is exhibited at the Royal Academy, at the point when it enters the collection of a prominent politician, at the point when it is engraved for a popular market, that ideology is produced. The private sphere to which the infant belongs is publicly reaffirmed. The contradictions between the inevitability of nature and the benefits of nurture (*The Seven Ages of Man* (85) on the one hand and *A Mother teaching her son* (XV) on the other) can coexist in art. Moreover, it cannot be correct to berate art or artists for failing to re-present on canvas the horrors of child labour; the invisibility of the chimney sweep or of other working class children (whose existence is recorded clearly enough in Mulready's drawings) is assured precisely through the presence of those other well-fed and healthy children. On one level the discourse of free will which is central to so many of Mulready's child dramas obviates responsibility for those children whose life experience is not one of games and playground disputes. But on a more profound level the production and public display of an imagery of childhood celebrating education in the particular and in the general subsumes within it all notion of the particular while depending on the invisible other extreme of childhood experience for its conviction. How could *Brother and Sister* (XXXVI) or *The Younger Brother* (61), a painting popular through its repeats and through its engravings, function so powerfully except through the consciousness of what it was *not*.

Within individual paintings the role of art in legitimising ambiguity and contradiction by celebration in the public arena can be seen to be strongly affective. The very brilliance of colour and the very smallness and neatness of size contribute to that process of legitimisation. Private values are valorized as public both through iconography and through the material fact of the work of art and its currency within the market. These paintings are perhaps subversive but not in the sense that Heleniak

[1] K.H., p. 89
[2] Ibid, p. 112
[3] Ibid, p. 121

indicates; they are subversive in so far as they exploit categories of privacy, intimacy and familiarity in the production of discourses around power and politics in the public sphere. Whilst Frith's *Derby Day* in terms of size and content offers a public sermon on human nature in the spiritual and in the newly anthropological sense,[4] Mulready's art insinuates the private into the public sphere, valorising the family with the child at its heart as public property.

A universalist view of Mulready's depictions of the child, a view which suggests a shift from the 'child controlling nature' of *Kirkstall Abbey*[5] to the 'shuddering child' of *The Toy Seller* (58)[6] implies either some kind of zeitgeist or a psychoanalytic theory which is nowhere argued or theorised. What can be seen in Mulready's depictions of children is a developing and often ambivalent if not contradictory discourse on education. Education was seen as the solution, above all others, to the social and political threat to the ruling class posed by the concentration of large numbers of working class people in the cities. Mulready's depictions of schoolrooms may be wryly humorous, tolerant and may belong to a visual tradition going back to Van Ostade. But we should ask why that humour and tolerance is paraded and why that particular tradition was revived and seen as apposite at this particular historical moment. These schoolroom scenes are simultaneously both an enlightened humanist observation on the desirable practices of child-rearing and education and part of a system of surveillance and discipline that is deeply rooted in the desire for political security, continuity and conservatism in Georgian and early Victorian England.

The spectacle of large numbers of working class children on the streets, in the public eye, was an irritant in the light of developing ideology of the family which gave an important place to the protection of mother and child in the private sphere, safe from the dangers of the public domain. Heleniak has pointed to Mulready's preference for the school at home. Such a preference can be seen epitomised by his frontispiece for *The Mother's Primer* (74). It is, however, more than a personal preference deriving from the artist's own life experience, it is a significant contribution to the debate on infant education.

This debate was being conducted in the last decade of the eighteenth century in the circle of radical thinkers around William Godwin with whom, as we shall see, Mulready had close connections. It is therefore, interesting to note that Mary Wollstonecraft in 1792 wrote: 'In order . . . to inspire a love of home and domestic pleasure, children ought to be educated at home, for riotous holidays only make them fond of home for their own sakes.'[7]

A sequence of Mulready's paintings deal with the role of the mother, or an older sibling, as educator: *The Rattle* (XIII), *Brother and Sister* (XXXVI), *The Travelling Druggist* (77), *The Toy Seller* (58), *A Mother teaching her son* (XV), *Train up a child . . .* (XXI), *Now Jump* (66) and *A Sailing Match* (XIX). Another group treats the schoolroom or the playground: *The Last In* (XVII), *Idle Boys* (cat. 99), *The Fight Interrupted* (XVI). The infant school, which was a development of the 1820s which had begun to fade by 1833, occupied an ambiguous position in relation to the public and private spheres. It was a public substitute for a private responsibility. The infant school movement offered an education which was a substitute for the Dame School and based on theory that was propounded by men. The playground had a central pedagogic role:

> The playground may be compared to the world, where the Little children are left to themselves, there it may be seen what effects their education has produced, for if any of the children be fond of fighting and quarrelling, it is here they will do it, and this gives the master an opportunity of giving them seasonable advice, as to the impropriety of such conduct; whereas if kept in school . . . these evil inclinations, with many others, will never manifest themselves, until they go into the street, and consequently the master would have no opportunity of attempting a cure.[8]

The Fight Interrupted (XVI) rehearses in pictorial terms the arguments outlined above. At the same time, *The Last In*

[4] See Mary C. Cowling, 'The Artist as anthropologist in mid-Victorian England . . .,' *Art History*, December 1983
[5] K.H., p. 38
[6] Ibid, p. 83
[7] She means for the sake of riotous holidays, Mary Wollstonecraft, *Vindication of the Rights of Woman*, 1792, ed. M.B. Kramnick, 1982, p. 279
[8] Samuel Wilderspin, *Infant Education*, 1825, pp. 201–2, quoted in K. Clarke, 'Public and Private Children: infant education in the 1820s and 1830s' in C. Steedman, C. Urwin and V. Walkerdine, eds., *Language, Gender and Childhood*, 1985, pp. 76–7

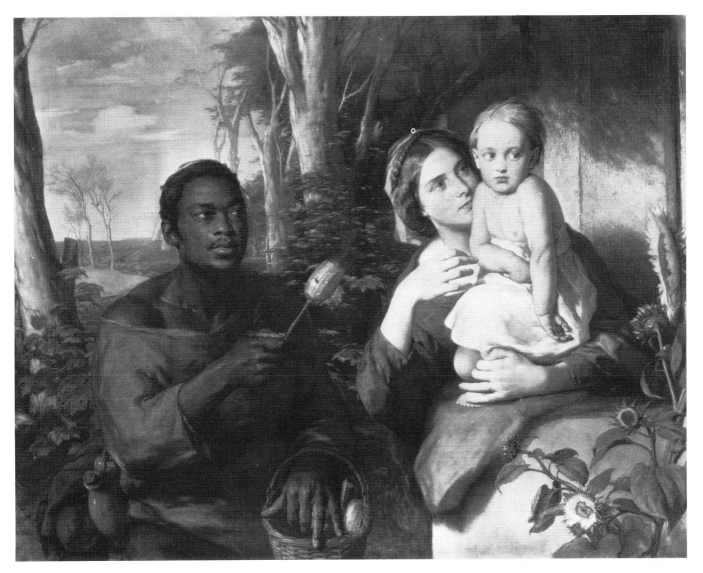

58. THE TOY SELLER, *National Gallery of Ireland, Dublin* (cat. 117)

(XVII) establishes the non-corporal methods of punishment advocated by the infant school educational philosophers and in particular the 'jury system' of shaming whereby the child who had misbehaved was questioned on his or her behaviour by the master before the whole school.[9] The prominence of the master ensures the reproduction of the patriarchal structure of the family. Thus *The Last In* (XVII) provides a microscopic picture in which the educable poor are controlled by non-violent methods within a system of patriarchy that is public but operates in private.

By the 1840s, it has been suggested, concern with education for the poor in middle-class literature had been superseded by concern with the role of mothers particularly in relation to the moral education of their children, a concern that is – in its emphasis on the mother – quite different from Mary Wollstonecraft's interest in the home as a place where education takes place. *A Mother teaching her son* (XV) is a non-naturalistic icon of middle class education; it has to be seen upon an axis which includes at its other extreme *The Fight Interrupted* (XVI). The nudity of the child and its substantial dimensions endow the work with a supra-natural significance. Heleniak rightly

[9] Ibid, p. 79

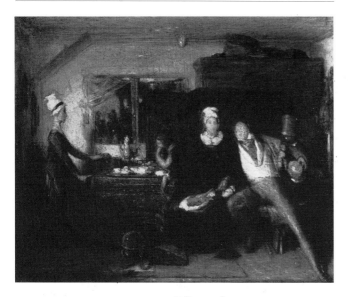

59. OIL SKETCH FOR THE WIDOW, *Collection of Brian Stone, Esq.*
(cat. 129)

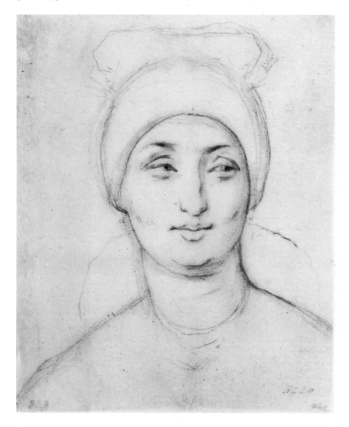

60. STUDY FOR THE HEAD OF A WOMAN IN THE WIDOW, *Victoria and Albert Museum*

draws attention to the religious overtones in the madonna like figure and the doves in the background. What is equally powerful, however, are the ways in which the background motifs function as signs of nature (leaves, twigs, birds) reiterating the text of the painting's accompanying moral verses. They are signs for what is produced without labour, created as biologically normal. Such a non-interventionist 'natural' system has important class implications and helps to establish the clean Christ-like middle-class child as outside of any system of labour and production, safely ensconced in the private sphere of the home.

An examination of Mulready's own life history also indicates that he was acquainted with some of the main arguments over educational philosophy in his day. The second part of this chapter is devoted to an atomisation of conditions intellectual, financial, ideological, within which *Train up a child . . .* (XXI), was painted and received. A detailed examination of this kind shows how Mulready absorbed a potentially radical philosophy and modified that philosophy to reinforce a status quo. An essentially conservative image was created which had the function of eliminating contradictions and ambiguities by appropriating and re-producing potentially subversive imagery within a safe and affirmative narrative.

Mulready was not only a painter of children; he was also a child-painter. William Godwin, radical politician and educationist was a friend and employer of the young Mulready and, in view of his beliefs and his connections, is of special interest to this discussion. In 1805 Mulready then aged eighteen commenced a regular account of his finances. In that year he received £11−5−0 for fifteen designs executed for William Godwin.[1]

His acquaintance with Godwin may date from as early as 1803, the year in which John Varley married Esther Gisborne, the sister of John Gisborne, friend of Shelley and Godwin.[2] Godwin's diary for 1800 contains references to Robert Kerr Porter (for whom Mulready was working at this time) and other artists. Moreover in 1803 Godwin received frequent visits from George Dawe who was one of Mulready's friends.[3]

[1] Mulready's account book
[2] A.T. Storey, *James Holmes and John Varley*, 1894, p. 229
[3] William Godwin's diary, MS. Bodleian Library, Oxford

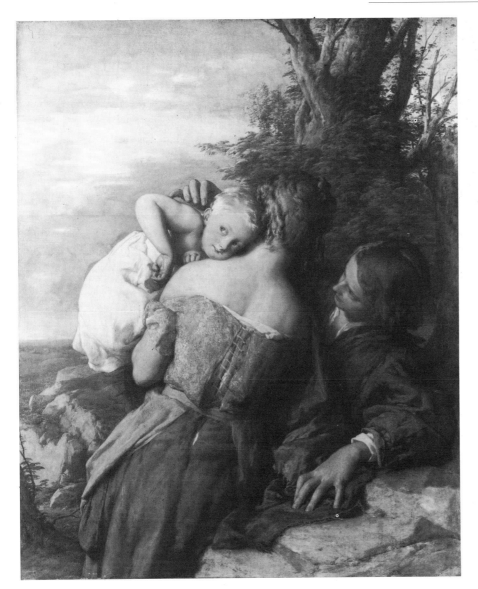

61. THE YOUNGER BROTHER, *Trustees of the Tate Gallery* (cat. 115)

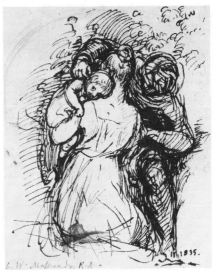

62. SKETCH FOR BROTHER AND SISTER, *Leslie Parris, Esq.* (cat. 116)

In 1803 Mulready was seventeen years of age and John Varley, with whom he took lessons was twenty-four. Godwin was forty-seven. *Political Justice* had appeared in 1793 and *Caleb Williams* in 1794. Three years later Mary Wollstonecraft died leaving him with a step daughter and a new baby to care for. In 1801 he married a widow named Mary Jane Clairmont who also had two children. Financial problems became acute and the two borrowed a hundred pounds and began publishing books for children under the name of *The Juvenile Library*. Godwin's political and social views were so unpopular that *noms de plume* were essential and the first works appeared with the pseudonyms of Edwin Baldwin and Theophilus Marcliffe.

Among the early publications of *The Juvenile Library* was *The Looking Glass: A True History of the Early Years of an Artist*, published in 1805 and 'calculated to awaken the emulation of Young Persons of both Sexes, in the pursuit of every laudable attainment, particularly in the cultivation of the Fine Arts'.[4] Mulready's closest friend and confidant, the artist John Linnell, who in later years

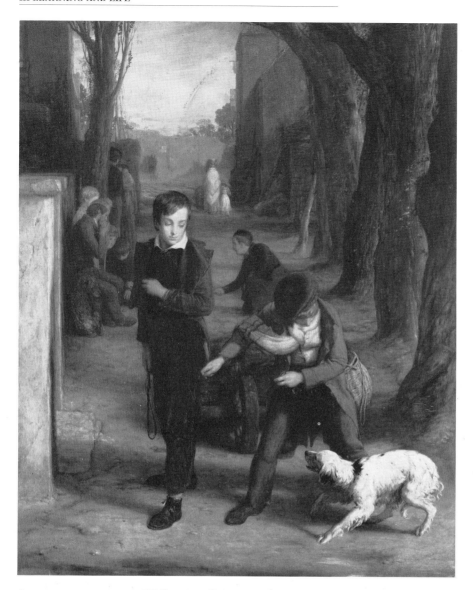

63. A DOG OF TWO MINDS, *Walker Art Gallery, Liverpool*

64. DRAWING OF CHARITY SCHOOL BOYS,
Whitworth Art Gallery, Manchester (cat. 138)

was unable to see the premises of the Juvenile Library at 41, Skinner Street 'without thinking of the evening parties in that fine first floor room overlooking Snow Hill where Mr Mulready and I were frequent visitors', affirmed that the subject of *The Looking Glass* was William Mulready and that the book was a result of conversations between Godwin and the young artist who was then about sixteen years old.[5]

Between 1805 and 1806 Mulready was visiting Godwin several times a week (with or without Dawe), often staying for dinner, tea or supper. On 18 July 1805,

Godwin recorded 'Mulready at tea, narrative [sic].' This must have been the beginning of *The Looking Glass . . .* on which Godwin was to work for the rest of the month.[6] By 1807 when Godwin published *Lamb's Tales from Shakespeare* with illustrations by Mulready, engraved by William Blake (83).[7] Mulready was the Juvenile Library's chief, if

[4] Published by T. Hodgkins, London; it is also published in a facsimile reprint by Bemrose & Sons, 1885, with appendix by F.G. Stephens

[5] Draft letter from John Linnell to James Dafforne, 15 July 1863, MS. The Linnell Trust; J.T. Smith, *Nollekins and his Times*, 1828, II, 200

[6] Godwin's diary

[7] F.K. Brown, *The Life of William Godwin*, 1926, pp. 2309–233

not its only, illustrator (81). Many years later Henry Cole entertained Mulready to tea and listened with interest to his reminiscences of the days when he worked for Godwin, of three hundred and thirty-seven designs in two years at seven shillings and six pence each, and of George Cruik-shank who was the shopboy in Godwin's childrens' book-shop.[8]

Among Mulready's possessions at the time of his death was the Blake/Varley sketchbook now in the Tate Gallery and containing the now celebrated visionary heads.[9] Whether Mulready had any real contact with Blake seems doubtful but it is interesting to note the connection since two of Mulready's designs for *Lamb's Tales from Shakespeare* (The Tempest and Midsummer Night's Dream) present distinctly Blakeian figures. Although *Lamb's Tales* did not offer an opportunity for images of children, the centrality of the child in Blake's world view is an important model for Mulready's later work (see cat. 111).

In calling his little biographical study *The Looking Glass . . .*, Godwin underlined the fact that his whole enterprise sought to rival Newbery's very successful publications for children. The latter had issued *The Looking Glass for the Mind*, a translation and abridgement of Arnaud Berquin's *L'Ami des Enfans*, with prints by John Bewick in 1792 (78) and *Tales for Youth in Thirty Poems* in 1794. Godwin's *Fables Ancient and Modern* of 1805 with seventy-three copperplates by Mulready (79, 80) was probably intended to attract the youthful readership of *The Hive of Ancient and Modern Literature* which Newbery had published in 1799 illustrated with fourteen prints by John Bewick. Godwin's *The Child's True Friend* of 1808 (81) set out to compete for the readership of Berquin's *L'Ami des Enfans*. Mulready was also to work for Newbery's successor, John Harris, whose 'Cabinet' included *The Butterfly's Ball and the Grasshopper's Feast* (1807) by William Roscoe, the Liverpool banker and art collector. It was illustrated by Mulready and sold forty thousand copies.[10]

In such a competitive market Godwin's chief illustrator could not have been unaware of the pre-eminence of the Bewicks. Mulready's illustrations reveal a debt to those of the Bewicks but, more important is the fact that in these little prints Mulready found the perfect prototype for moral drama and narrative painting on a larger scale.

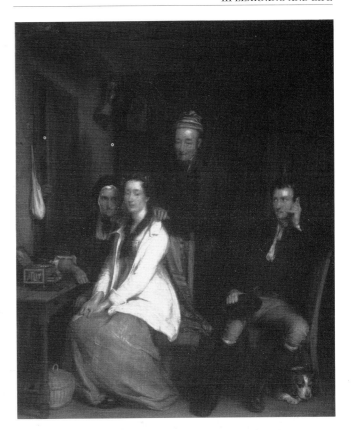

65. DAVID WILKIE, THE REFUSAL FROM THE SONG OF DUNCAN GRAY (cat. 127)

Significantly Mulready's earliest oil pictures measure little more than fourteen by twelve inches, thus replicating the smallness of book illustrations. *Old Kaspar* from Southey's *Battle of Blenheim* painted in 1805 (now lost) measured only $10\frac{3}{4} \times 10\frac{1}{2}$ inches. Old Kaspar had already been portrayed by Thomas Bewick, discoursing on mutability to his grandchildren on page 303 of *The Hive of Ancient and Modern Literature*, first published in 1799. John Bewick's illustration to 'Poor Crazy Samuel and the mischievous boys' (78) might well have inspired *The Village Buffoon* (XXIII), Mulready's diploma painting of 1816. Another print by Bewick (in *The Looking Glass for the Mind*) illustrating 'The Destructive consequences of dissipation and luxury' presents on a small scale the dialogue at the open door, the receding vista flanked by a brick wall and the

[8] Henry Cole, Diary, 9 Jan. 1848, MS. Victoria and Albert Museum Library
[9] Mulready's sale, Christie's 28 April 1864 (86)
[10] 'Art for the Nursery', *Athenaeum*, no. 2924, 10 Nov., 1863, p. 607

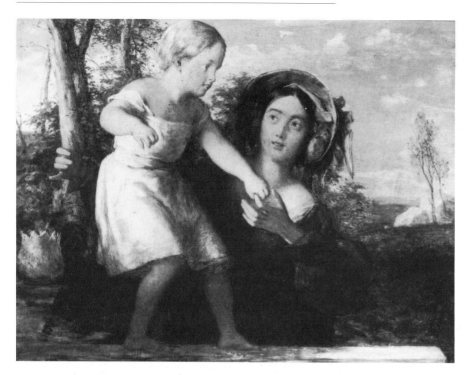

66. NOW JUMP, *private collection*

somehow poignant retreating figures that help to create an atmospheric location which becomes so typical of Mulready's best narrative paintings and which appears early on in his career in his diploma picture. Bewick's illustration to 'The story of Bertrand, a poor labourer and his little family' prefigures many a domestic interior by Mulready and the background conversation piece in John Bewick's illustration for 'Creditors have better memories than Debtors' (*Proverbs in Verse*, 1790) is comparable to the little group at the gateway to the park which appears in the background of Mulready's *Careless Messenger Detected* of 1821 (xx).

Godwin's name disappears from Mulready's account book after 1811. In the following year he was disappointed by the rejection of two fully realised landscapes, *The Mall* and *Near the Mall*. In 1813 he painted *Punch* and *Boys Fishing* and in that same year Mulready's account book records the compositions for *The Cannon*, *The Fight Interrupted*, *Open Your Mouth*, *The Village Buffoon*, a work called 'School' (probably *The Last In*), works called 'Dice' and 'First Child' (the latter was perhaps *Interior: an Artist's Study*). *The Cannon* was not painted until 1827, three

others were realised between 1815 and 1816 and the rest cannot be certainly identified. Such a sudden outpouring of ideas is unprecedented in Mulready's work so far. It seems likely, therefore, that after at least eight years apprenticeship with Godwin, Mulready turned to landscape as the genre most favoured by his friends and associates at that time. These included the Godwins and Mulready took Godwin's stepson out sketching on Hampstead Heath in May 1808.[11] Around 1813 Mulready saw the possibilities in combining the Bewick tradition of moralistic depictions of childhood and the concern with landscape and genre subjects which he had been developing in Kensington and the surrounding area.

Another set of circumstances encountered by Mulready around 1811 may have reinforced this tendency. This was the year in which Mulready met Sir John Swinburne who assured for him some degree of financial security through his payments for drawing lessons to his children,[12] through commissions for family portraits and through

[11] C. Kegan Paul, *William Godwin: His Friends and Contemporaries*, 1876, ii, 168–9; the author prints a letter from Charles Clairmont to William Godwin describing the outing
[12] Mulready's account book

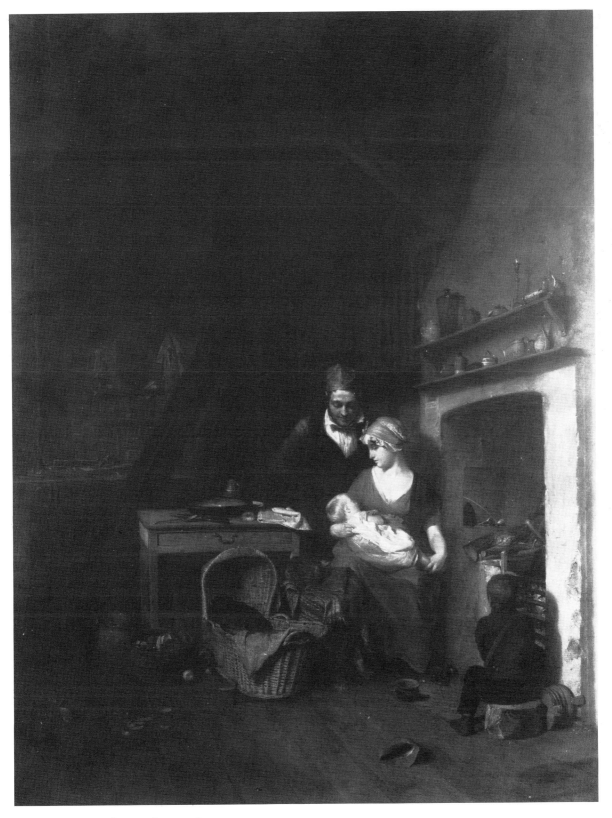

67. THE CARPENTER'S SHOP, *location unknown*

68. STUDY FOR THE WOLF AND THE LAMB, *Whitworth Art Gallery, Manchester* (cat. 104)

his purchase of *Boys Fishing*. Mulready visited Capheaton, an environment that could only have encouraged further an interest in educational philosophy.

The Swinburne family was an interesting example of religious apostasy, radical political tendencies and progressive practices in child-rearing. Sir John had ridden the county with one spur calling himself Citizen Swinburne[13] and his eldest son and heir was living at this time by Lake Windermere with his second wife (formerly his childrens' governess) and his five children, wearing day labourer's clothes and shoeless. His idea of educating his children was to take them out on the lake in a boat and throw them out one by one leaving them to swim to the shore. He is also said to have put the clocks on an hour so that the household set to work at 4-00 am although they thought it was 5-00 am.[14] The upbringing of Sir John's celebrated grandson, Algernon Charles seems to have been almost as unorthodox as that of his cousins.

After publication of *Political Justice* in 1793, Godwin had turned to consider the nature of the child and how he or she should be educated. *The Enquirer: Reflections on Education, Manners and Literature*, published in 1797 was, in a sense, a sequel to *Political Justice*, an attempt to reach the root cause of deviation from an ideal society. In viewing the child in its own right and at the same time as a future adult, a member of society, Godwin was indebted to Rousseau but, unlike Rousseau, Godwin stressed the role of social example in the education of the child. Deviating from Rousseau's ideas popularised through the extensive publication and translation of *Emile* (1762), Godwin based his system on real freedom, unsupported by hidden coercion, in which the child would grow up in society not, as Rousseau postulates, apart with his tutor. Through emulation and free experience the child would, Godwin argues, naturally turn towards wisdom and benevolence. 'Man is a social being', states Godwin and, rejecting the old belief in education as subordination, 'the true object of education, like that of every other moral process, is the generation of happiness.'[15] The

[13] Algernon Charles Swinburne to E.C. Stedman, 20 February 1875, *The Swinburne Letters*, ed. C.Y. Lang, New Haven, Conn., 1960, iii, 9–11
[14] Mrs B. Charlton, *The Recollections of a Northumbrian Lady 1815–1866*, ed. L.E.O. Charlton, 1949, p. 194, pp. 218–19
[15] W. Godwin, *The Enquirer . . .*, 1797, facsimile reprint ed. A.M. Kelly, New York, 1965, p. 1

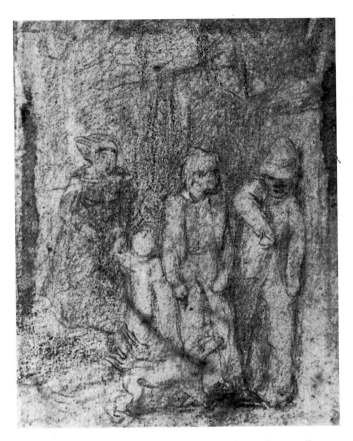

69. STUDY FOR THE WOLF AND THE LAMB, *Whitworth Art Gallery, Manchester* (cat. 104)

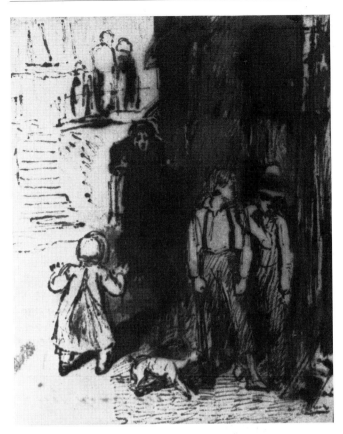

70. STUDY FOR THE WOLF AND THE LAMB, *Whitworth Art Gallery, Manchester* (cat. 105)

essays of *The Enquirer* . . . were, said Godwin, 'principally the result of conversations'. His method of investigating truth was 'an incessant recurrence to experiment and actual observation'.[16]

While Godwin's epistemology marks him as a radical and provides a novel intervention into debates of the period, his interest in education is a development of the concerns expressed by Mary Wollstonecraft in the chapter on 'National Education' that she included in *Vindication of the Rights of Woman* published in 1792.

In *The Looking Glass*, Godwin described the childhood and early youth of Mulready. The young reader is informed of 'what has actually been done, of what was done, for a long time under every disadvantage of a humble situation, and a total absence of instruction and assistance.' The subject is 'no bombastic and impossible character, he was a child like others.'[17] He was not, we gather, a child like Emile. Concentrating as it does an example, *The Looking*

Glass . . . was the natural successor to *The Enquirer*. . . . On a simple level the principles of the earlier theoretical treatise are expounded by reference to the childhood experience of the artist as related by himself.

Mulready's earliest artistic efforts drawn in chalk on the smoke darkened wall of his parent's cottage are described and illustrated; his gradual acquisition of skill through the study of nature, especially the human figure, and his unusual powers of perception are recorded in detail. We are told of the inadequacies and inefficiencies of the various schools he attended (a subject dear to the heart of Godwin who had tried and failed to establish a private school). After many disappointments and some encouragement (especially from Thomas Banks, the sculptor) the heroic determination of the young Mulready

[16] Ibid pp. vi–vii
[17] T. Marcliffe (pseud. W. Godwin), *The Looking Glass: A True History of the Early Years of an Artist*, London, printed for Thomas Hodgkins at the Juvenile Library, 1805, facsimile reprint, 1885, pp. viii–ix

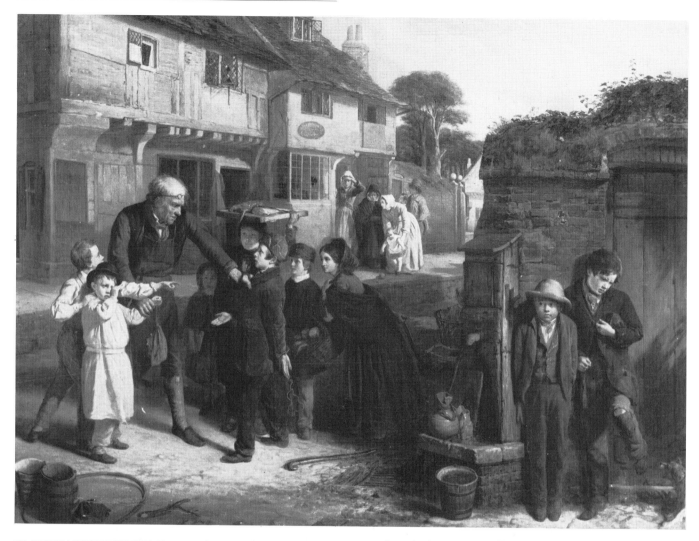

71. WILLIAM HENRY KNIGHT, THE BROKEN WINDOW: WHO THREW THE STONE?, *Wolverhampton Art Gallery* (cat. 103)

won for him a coveted place at the Royal Academy Schools at the early age of fourteen years and six months. By the close of his fifteenth year, we are told, Mulready was able to reject absolutely his parents' suggestion that they should support him for a further seven years and became completely independent.

In its discussion of the first signs of genius and the boy's passion for art, Godwin's account falls into the tradition of 'Lives' initiated by Vasari which, as Kris and Kurz established, are highly ritualised.[18] Mulready continued throughout his life and after his death, to be regarded as 'the lesson of progress' and the example of 'singleness of aim steadfastly pursued'.[19]

The 'Mulready' who is constructed through these texts is the epitome of the self-help ideal. Of course, we cannot take these statements at face value; the youth's magnanimous rejection of his parent's offer of help might well read hollowly if we think of the conflict between the cultivated, if economically straitened, environment of Godwin's circle and his own parents' situation. Psychoanalytically Mulready is, in these narratives, both subject and object, a fact that must have affected his relationship

[18] E. Kris and O. Kurz, *Legend, Myth and Magic in the Image of the Artist*, 1934, transl. A. Laing, Westford, Mass., 1979

[19] Review of an exhibition of Mulready's work at the Society of Arts, *Athenaeum*, no. 1076, 10 June 1848, p. 583; Anderdon catalogue, Royal Academy Library; Obituary by F.G. Stephens, *Athenaeum*, no. 1863, 11 July 1863, ii, 52

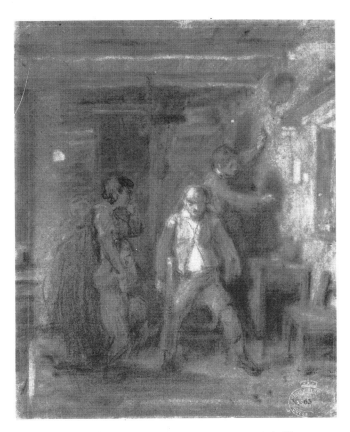

72. STUDY FOR THE ORIGIN OF A PAINTER, *Victoria and Albert Museum*

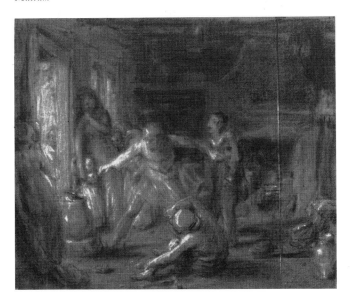

73. STUDY FOR THE CANNON, *Victoria and Albert Museum*

74. DRAWINGS ON ZINC FOR THE MOTHER'S PRIMER, *Victoria and Albert Museum* (cat. 118)

to his art. He is both teller and told, the voice and the story. It is significant that his version of the story of The Corinthian Maid re-presents the classical account by re-placing the lovers with children (72).[20] Mulready is, himself, the Corinthian maid.

There is a sense in which the child becomes, in Mul-ready's work, the only possible signifier. In paintings which feature adult participants (*The Convalescent from Waterloo* (XXVII), *The Widow* (XXII) or *Train up a child . . .* (XXI).) The actions of the adults only become comprehen-sible by reference to the response of the child or children as recorded in facial expression and physical gesture. It is

[20] The painting is now known only from a drawing, see Rorimer, 76

75. THE WEDDING MORNING, *Lady Lever Art Gallery*, *Port Sunlight*

thus the child who is the mediator in the practice of signification, not in any mystical Wordsworthian way, but almost as a straightforward matter of procedure.

The Godwinian principle of close examination and interview was adopted and adapted in Mulready's own artistic practice. Many studies of children testify to his commitment to the study of childhood in its every aspect. One sheet of studies, apparently executed in Kensington Gravel Pits includes a series of small drawings and the following annotations: 'Child in the Mall, light brown hair – pale loose old great coat, DB and crome frock greeny orange, dirty white stock. Taking off. The left arm in. Very old drab hat. Dark green waist. Dark [word illegible]. Grey trousers. No stock. Very large loose shoes tied round his ankles with pack thread. Tommy West.'[21] Such observation could be supplemented from his own experience as a parent. We are told that the house where he lived with his sons was 'cold and comfortless' and that the Mulready boys kept themselves warm by developing a taste for dancing of an eccentric kind.[22] One writer suggests that Mulready's relations with his children were not good[23] but an envelope postmarked 1842 contains thumb-nail sketches of Mulready's family as imaginary characters in a charade and suggests cheerful engagement in family past-times. Paul is 'Noodle' and Mulready himself 'Lord Grimsdale.'[24]

Towards his ward and her son, born in 1845, Mulready was particularly tender. 'Tell Mr Mulready Stone when you happen to see him,' he instructed her on 8 December 1845 after receiving news that the baby had cut a tooth, 'that I beg respectfully to approach him with my dutiful congratulations upon his accession to another fortune of ivory – long may he live to employ it in the encouragement of commerce and agriculture, avoiding all the mad or wicked temptations of the day to speculate railway shares, and so risk losing his precious pearls for stags-horn. I hope also he is not ostentatious of his wealth,' continues Mulready, thoughtful for the young woman who is breast-feeding, 'and that he does not make you feel unpleasantly, but this need go no further . . .' (cat. 95).[25] In another letter of the same year Mulready promises Mary, 'as for your own precious self and your own precious baby, I will give you both a coat of paint that will preserve you and carry you down to posterity, ever fresh and ever fair.'[26]

The rhetoric, the very self-conscious and deliberate stylisation of language, in which Mulready couches his evidently keenly felt sentiments is an indicator of the process of stylisation, synthesis and didactic programming through which Mulready translates the experience of Tommy West in the Mall in his shoes that are too big for him or Edward Mulready Stone with his new tooth into the substance of his art. Experience and observation – the very qualities that Godwin advocated – are invoked and utilised as part of an ideological process that transforms the particular and everyday occurrence of children's lives into a didactic essay on childhood in general. Historically Mulready is instrumental in disseminating those very notions of self-help, self-reliance, social skills and 'natural' moral education that were to become prominent landmarks in the philosophy of Victorian England. He is effectively the link, the producer of an accessible and readily marketable imagery, between Godwinian educational idealism and that early Victorian pragmatism which found its expression in school building and Arnold-

[21] Whitworth Art Gallery, University of Manchester, D.121. vi.1895
[22] J.C. Horsley, *Recollections of a Royal Academician*, ed. Mrs. E. Helps, 1903, p. 20
[23] A.T. Storey, op. cit., pp. 238–9
[24] MS. collection Mr. Brian Stone
[25] W. Mulready to Mary Mulready Stone, MS. collection of Mrs. Everel Wood
[26] W. Mulready to Mary Mulready Stone, MS. 30, no month 1845, collection Mr. Brian Stone

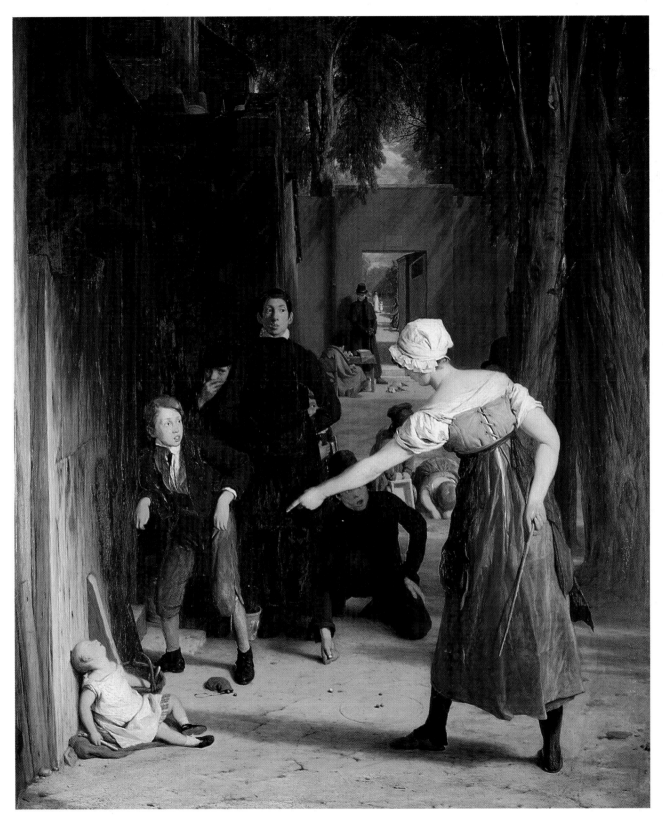

XX THE CARELESS MESSENGER DETECTED, *The Trustees of the Lambton Estate* (cat. 106)

113

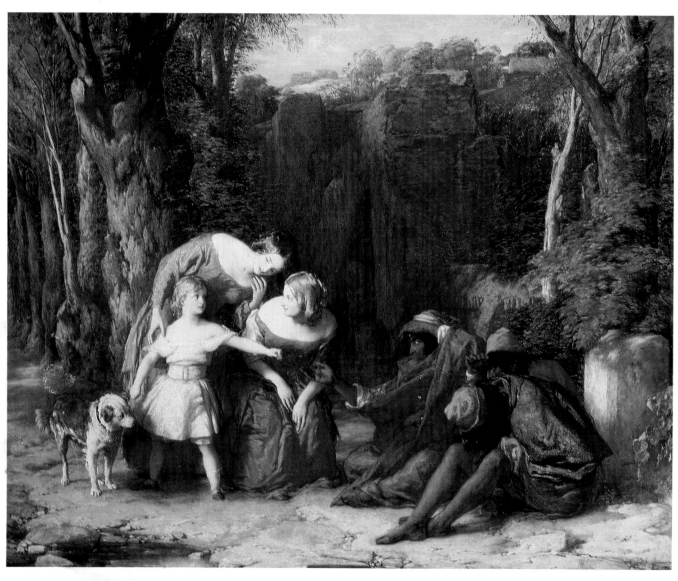

XXI TRAIN UP A CHILD IN THE WAY HE SHOULD GO . . . , *The Forbes Magazine, New York* (cat. 112)

XXII THE WIDOW, *Sir Richard Proby* (cat. 128)

XXIII THE VILLAGE BUFFOON, *Royal Academy, London* (cat. 126)

XXIV GIVING A BITE, *Ulster Museum, Belfast* (cat. 131)

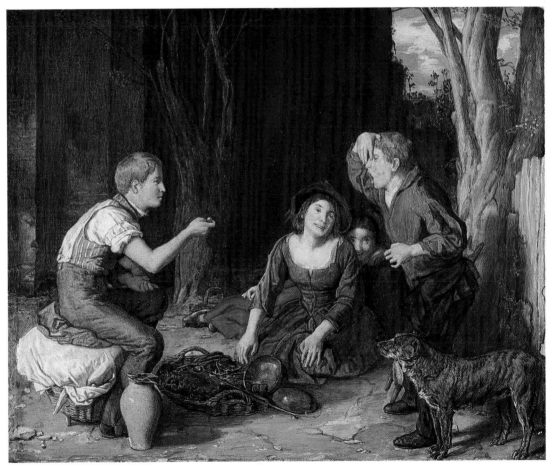

XXV THE BUTT, *Glasgow Museum and Art Galleries* (cat. 142)

XXVI THE BUTT, *Victoria and Albert Museum* (cat. 143)

XXVII THE CONVALESCENT FROM WATERLOO, *Victoria and Albert Museum* (cat. 108)

XXVIII GIVING A BITE, *Victoria and Albert Museum* (cat. 132)

ian educational reform. 'In order to open their faculties [children] should be excited to think for themselves; and this can only be done by mixing a number of children together, and making them jointly pursue the same objects,' wrote Mary Wollstonecraft.[27] 'The social affections are the chief awakeners of man,' states Godwin[28] and 'a boy educated apart from boys is a sort of unripened hermit.'[29] Paintings such as *The Fight Interrupted* (XVI), *The Wolf and the Lamb* (XVIII) and *The Last In* (XVII), and engravings after those paintings, translated Godwinian ideas into the domain of popular cultural exchange in the first half of the nineteenth century.

≥ ≥ ≥

Mulready is said to have regarded *Train Up a Child in the Way He Should Go and When He Is Old He Will Not Depart from It* (XXI) (a quotation from *Proverbs*) as his best work. It was painted on commission for Thomas Baring, MP and the artist chose to exhibit it in Paris in 1855 where it won for him the order of the Legion d'Honneur at the Exposition Universelle. F.G. Stephens referring obliquely to Mulready's separation from his wife and his unorthodox menage, says that 'this subject was chosen by Mulready [when] he had attained that middle platform of life, whence most men are able to survey all they have passed by in the course of existence, and, to some extent, anticipate much that is to come. Nothing could have been clearer to the painter,' suggests Stephens, 'than that his own life illustrated the force of this injunction to parents that they should train their children with the expectations of the result of their own conduct.'[30]

This is a further example of the interlocking narratives of Mulready's life history and his image-making; it is a fact that needs to be born in mind when considering the reception of Mulready's work and the meanings that it produced for contemporary audiences. It would seem that there is invariably – in dealing with these major exhibited canvases – an invisible text, the received account of Mulready's life, that functions within and against the trajectory of the painting's narrative.

Stephens's criticism effectively makes of *Train up a child* . . . a manifesto for Mulready's life and art, a synthesis and a commentary. The gloss that Stephens provided

rescued the painting from a confusion of misunderstood and semi-understood meanings. So a painting which generally baffled people when it was seen in public was elucidated for an audience after the artist's death by reference to the events of the artist's life, the one being read off against the other in mutual enhancement. The variety of titles that have been attached to *Train up a child* . . . signal a failure of signification, an area of disturbance in which an image did not deliver up what was expected. *Integrity*, *Vocation* and *It is more blessed to give* are all titles that the painting has borne at one time or another. Everyone remarked upon the colour (widely disliked as too fiercely red) but few felt able to be clear about the subject.

Throughout the period of the painting's gestation during 1841 and in 1853 when Mulready took it back to his studio for re-painting after a fire in Baring's residence, *Train up a child* . . . is constantly referred to as 'Lascars'.[31] So for the artist in private the painting possessed an identity widely divergent from the one it offered when exhibited in public. Lascars are the Indian seamen who are in receipt of charity and there are strong reasons for supposing that the exhibited title was Baring's choice. Mulready's titles as recorded in his account book tend to give the essence. Thus *The Whistonian Controversy* of 1843 (XXXI), also painted for Baring, appears in the artist's account book simply as 'Dispute'. The exhibited title shifts attention from the recipients to the donor and hence removes the painting from the specific and topical to the general and religious.

We are not much accustomed to hear Lascars discussed today. The East India Company, whose chairman had been Francis Baring, founder of the Baring Brothers Finance house and grandfather of Mulready's patron, recruited for its ships among the slums of Scottish and English towns, its expeditions being necessarily both military and economic. As few of these recruits survived the Indian wars or prevalent disease, it was necessary to recruit native sailors for the voyage home.[32] Mulready had com-

[27] M. Wollstonecraft, op. cit. p. 273
[28] W. Godwin, *Enquirer*, p. 3
[29] Ibid, p. 59
[30] F.G. Stephens, op. cit., p. 84
[31] Mulready's account book
[32] See H. Furber, *John Company at Work: A Study of European expansion in India in the late Eighteenth Century*, New York, 1970, pp. 278–9

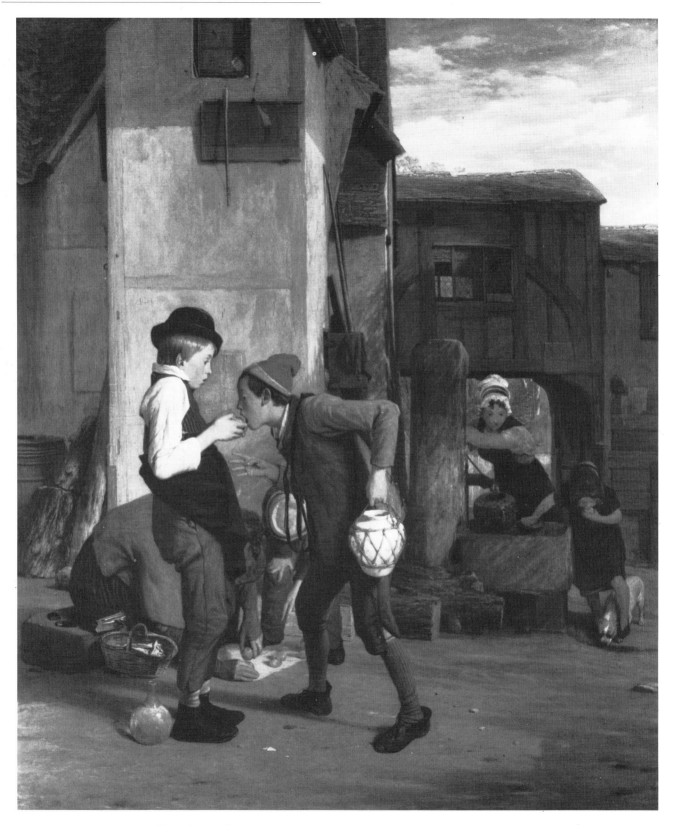

76. LENDING A BITE, *private collection* (cat. 130)

menced his painting by early 1841 by which time the plight of lascars in London had been recognised in the national press. On 5 October 1838 the police had to disperse a mob of several thousand people who had assembled to witness the bizarre antics, or so it seemed to *The Times* correspondent, of some fourteen lascars performing the burial rites of one of their number who had died shortly after their vessel put into London docks.[33]

This account is followed on 8 October by a letter from the Episcopalian clergyman of the church in whose vicinity these rites took place, pointing out that dissenters and poor Irish papists swarmed the area and were totally unprovided for by the one little chapel of which he was rector.[34] By December 1841 the matter had become far more serious. 'The Asiatic crews of the East Indiamen in the docks appear to be suffering greatly from the cold and many of them have lately complained to the magistrate of want of sufficient clothing and provisions and also want of accommodation', reported *The Times* on 10 December 1841. Lascars were adding to London's already considerable population of street vagrants and their inability to adapt to conditions drew the attention of the correspondent of *The Times*. 'The peculiar habits and religious prejudices of these strangers are seldom attended to, nor is their clothing adapted to the climate of England. During the week it has been a distressing sight to see the Lascars huddled together in and about the office [of the magistrate], shivering and appealing to the police and people having business in the court for warm clothing and food. The persons of some of them were in a most offensive state and covered with vermin. The nuisance calls loudly for a remedy.'[35] Three days later *The Times* published a letter from a well-informed gentleman drawing attention to the neglected state of the Lascars and their visibility in the public streets of Back Lane, St. George's in the East and High Street, Poplar, in other words in the heart of dockland. The correspondent goes on to remind readers of arrangements for accommodation in the Lascar House which operated until the withdrawal of the East India Company charter and the opening of trade with India.

[33] *The Times*, 5 October 1838, p. 3
[34] *The Times*, 8 October 1838, p. 3
[35] *The Times*, 10 December 1841, p. 6

77. STUDY FOR THE TRAVELLING DRUGGIST, *Trustees of the British Museum* (cat. 110)

78. POOR CRAZY SAMUEL AND THE MISCHIEVOUS BOYS, illustration by John Bewick to A. Berquin, *The Looking Glass for the Mind*.

79. E. BALDWIN, *Fables Ancient and Modern*, 1805, vol. I (cat. 120)

Tale_1.st

The Child's true friend.
London, Pub. June 4.1806, by Tabart & C. New Bond St.

81. FRONTISPIECE TO *The Child's True Friend* (cat. 121)

80. E. BALDWIN, *Fables Ancient and Modern*, 1805, vol. II (cat. 120)

Hedges have Eyes, and Walls have Ears.

82. TRUSLER'S *Proverbs exemplified and illustrated by pictures from real life* (cat. 122)

Vol. 1. *To face the title.*

TALES

FROM

SHAKESPEAR.

DESIGNED

FOR THE USE OF YOUNG PERSONS.

BY CHARLES LAMB.

THE FOURTH EDITION.

IN TWO VOLUMES.

VOL. I.

LONDON:
PRINTED FOR M. J. GODWIN AND CO.
AT THE CITY FRENCH AND ENGLISH JUVENILE AND SCHOOL
LIBRARY, NO. 41, SKINNER-STREET.

1822.

Prospero and Miranda.

83. *Lamb's Tales from Shakespeare*, 1822 (cat. 123)

The writer, in sympathy with the period in which the East India Company enjoyed a monopoly, concludes: 'What a wretched account of England, these poor men must have to give when they return to their own country, and what a strange impression they must receive of that people who are said to have HUMANITAS by a moral power.'[36]

The unusual subject matter and the circumstances surrounding the production of Mulready's *Train up a child . . .* require us to see it as to some degree determined by the collaboration between artist and patron, though the nature of the involvement and the degree of responsibility is by no means clear. At the same time, however, at one level the 'Lascars' project provided for Mulready by displacement the possibility of working on a representation of those dominated and impoverished Irish which for reasons psychological and political he could not overtly or consciously address. The Lascars were, as is clear from the accounts in the newspapers, a category of underdog, a vagabondish liability that could be lumped in with poor Irish and Papists. Moreover, the subject also provided Mulready with the opportunity of exploring, with a degree of grandeur hitherto unprecedented in his oeuvre, the theme of educating the child that had been a part of his life and his art for the best part of half a century.

The public meanings of the painting must, however, be related to the nexus of power, commerce and morality that was constituted in discourse around the idea of the East India Company. The national newspaper, in the correspondence quoted, had set out the agenda: peculiar habits of aliens, law and order, morality and charity. Heleniak speaks of Mulready 're-enacting the myth of British Imperial beneficence, but on English rural soil'.[37] Certainly the ideology of British Imperialism provides the language, the imagery and the assumed frame of reference for a work of this kind. But the profound ambivalence

[36] *The Times*, 13 December 1841
[37] K.H., p. 100

125

that it displays, the way in which it encourages misrecognition of its subject, the way in which it neutralises the topical and the political by assimilating it into an essentially literary field cannot be explained or understood merely by reference to an umbrella term that covers centuries of histories.

The misrecognitions were immediate; when it was shown at the Royal Academy in May 1841 *The Times* reviewer described the subject as 'a child giving alms to a [sic] beggar'.[38] Waagen and Gautier, seeing the painting some years later both took the recipient of the child's charity to be gypsies.[39]

The latter's description of 'une atroce vieille à la figure de stryge, à teint de cuir de Cordue, flanquée de deux bandits accroupis dans leurs haillons' is a marked response. The topicality of Mulready's painting was thus subsumed into two separate possible frames of reference: the cardinal virtue of charity illustrated through example or a scene of *banditti*. Iconographically Mulready's painting draws on a wide range of imagery associated with religious and secular disquisitions on charity; Greuze's *Dame de la Charité* comes to mind and so does the image of familial piety exemplified by the group of the Madonna, St. Anne and the Christ child. The country setting carries the subject of lascars yet further from its roots in nineteenth-century London dockland and securely fixes its meanings in literary convention far removed from political controversy. Here we are back with the Bewicks' book illustrations in a world of fable and exemplary tale. Childrens' moral fables traditionally have country settings and the audience of *Train up a Child . . .* recognised in Mulready's three lascars the proverbial beggars of Aesop's *Fables* or *Proverbs exemplified and illustrated by pictures from Real Life* published in 1790 with prints by John Bewick. Even the dog and the pointed cap that are characteristics of Bewick's depiction reappear in Mulready's scene, reassuring the viewer that we are really at home in fable here. Mulready's lascars are a pathetic crew not fearsome noble savages as Henry Monro represented them.[40]

By absorbing the discourse of racial difference (essentially one of power) into a discourse of education in charity, Mulready has subsumed the actual and the topical into the timeless and the general. The religious and

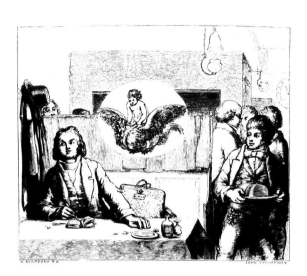

WILL WATERPROOF'S LYRICAL MONOLOGUE

MADE AT THE COCK.

O PLUMP head-waiter at The Cock,
 To which I most resort,
How goes the time? 'Tis five o'clock.
 Go fetch a pint of port:
But let it not be such as that
 You set before chance-comers,
But such whose father-grape grew fat
 On Lusitanian summers.

84. Moxon's *Tennyson* (cat. 167)

popular art conventions that are mobilised in this imagery are the means by which this is effected. Lascars, like the poor and the working class, only pose a threat if they are outside the system. The boldness of choosing to represent a subject as close to the public eye as lascars were in 1841 is the boldness of retrenchment; those lascars are grafted into a narrative of education and moral example centred around a white child and conveyed by reference to sets of conventions that invoke the non-temporal, the permanent and the true.

[38] *The Times*, 28 June 1841, p. 5
[39] G. Waagen, *Galleries and Cabinets of Art in Great Britain* (vol. iv of *Treasures of Art in Great Britain*), 1854, p. 100; T. Gautier, *Les Beaux-Arts en Europe*, Paris 1855, p. 29
[40] Pen and ink drawing, inscribed 'Monro fecit March 6 1813', private collection, reproduced in *Dr. Monro's Academy*, exhibition catalogue, Victoria and Albert Museum, February–May 1976, no. 21

SECTION III
LEARNING AND LIFE

'The true object of education . . . is the generation of happiness', William Godwin.

98

THE LAST IN, 1835
Oil on panel, $24\frac{1}{2} \times 30$ in
Trustees of the Tate Gallery (XVII)

As with *Interior of an English Cottage*, 157 and *Interior: An Artist's Study*, 159, Mulready constructs a box-like space with deep recession and a vanishing point in the far distance. The central axis of the composition is articulated through the right hand edge of the desk, down through the foreground boy's back and up via two hands to the tree on the hillside. Against this grid figures bow, sway and hop in elegant serpentine movement. The method of creating movement with figures against a clearly defined geometrical structure relates to Wilkie's early success with works like *Blind Man's Buff*. But the dialogue that Mulready establishes between a framed 'Nature' and a scene of nurture is a manifestation of a recurrent preoccupation in Mulready's work. As a schoolroom scene this story of classroom choices and conflict – presumably the boys who still linger in the doorway have decided not to come in at all – contrasts with *Idle Boys* of 1815 now known only from a photograph.

99

PHOTOGRAPH OF MULREADY'S IDLE BOYS
Tate Gallery Archive, Trustees of the Tate Gallery

This copy of an old and damaged photograph of *Idle Boys* of 1815 provides some indication of the appearance of Mulready's 1815 schoolroom scene that is now lost. Here the debt to Van Ostade is very apparent. Victorian schoolroom scenes by artists like Webster followed this early model rather than the much more elaborate and philosophical discourse on education which we find in no. 98.

100

THE RATTLE, 1808
Oil on panel, $14\frac{3}{4} \times 13\frac{3}{8}$ in
Trustees of the Tate Gallery (XIII)

One of the few surviving works from Mulready's earliest period. Mulready and Wilkie borrowed works by Dutch artists such as Van Ostade to copy and this painting is close to Wilkie's *The Cut Finger*. The main influence seems, however, to have been De Hooch. The sequence of vistas through a workshop into a parlour where pictures hang on the walls, and the realization of crumpled cotton and paper catching the light, reveal Mulready's profound debt to the Dutch school. At the same time an interest in human emotion registered at one remove – the child's delight is read only by reference to the adult's face and gesture – which was to direct much of Mulready's mature work is already here in embryo.

101

THE RATTLE, 1808
Study, oil on panel, $4\frac{1}{8} \times 3\frac{7}{8}$ in
Victoria and Albert Museum

The vista that is so striking in the finished painting is here replaced by a third figure in voyeuristic pose.

102

THE FIGHT INTERRUPTED, 1815–16
Oil on panel, $28\frac{1}{2} \times 37$ in
Victoria and Albert Museum (XVI)

As with *Punch* 31, 32 and *The Careless Messenger Detected* 106, the scene is located in Mulready's Kensington environment; the sobriety of the schoolmaster and the peaceful occupations of the distant schoolboys contrast with the evidence of recent disturbance in the foreground. Contemporary educational theory advocated the playground as an essential

part of the learning process but the painting also offers evidence of Mulready's debt to Van Ostade's schoolroom scenes.

103

WILLIAM HENRY KNIGHT

THE BROKEN WINDOW: WHO THREW THE STONE?, 1855

Oil on canvas, 29 × 38 in

Wolverhampton Art Gallery (71)

Typical of the mid-nineteenth-century fashion for dramas of childhood, Knight's painting replicates not only the narrative content of works like Mulready's *The Fight Interrupted*, *The Careless Messenger Detected* and *The Wolf and the Lamb*, 102, 106, 105, but also borrows compositional devices from these earlier paintings. Thus the two guilty boys in Knight's work are generally similar to the protagonists in *The Wolf and the Lamb* and both the angry shopkeeper and the pump in the foreground appear to have come straight from Mulready's *The Fight Interrupted*. Mulready's influence on artists like Knight, G. Smith and Thomas Webster was very considerable. Producing works that were less complex than Mulready's in terms of content and composition these artists satisfied a popular market for sentimental genre scenes involving children.

104–105

DRAWINGS FOR THE WOLF AND THE LAMB

(68–70)

$4\frac{1}{8} × 3\frac{3}{8}$ in

$4\frac{5}{8} × 3\frac{5}{8}$ in

$11\frac{3}{4} × 5\frac{3}{8}$ in

Whitworth Art Gallery

The painting for which these are studies was purchased from the Royal Academy by King George IV. Whilst the painting is characterised by a frozen and arrested movement, the drawings reveal Mulready experimenting with a more easily articulated grouping and a less rigidly disposed composition. *The Wolf and the Lamb* was probably Mulready's best-known painting; the proceeds of the engraving were given to the Artists' Benevolent Fund. The title with its overtones of the Bible and of Fable is typical of Mulready's exploration of themes of education through experience.

106

THE CARELESS MESSENGER DETECTED, 1821

Oil on board, $30 × 25\frac{7}{8}$ in

Trustees of the Lambton Estate (XX)

This painting was purchased by a member of the Earl of Durham's family for the sum of £315 in 1821. Like *Punch*, 31, 32, the location is Kensington – a view of Kensington Gardens is visible through the gate – and effective use is made of a semi-urban setting and a long wall. The messenger, or nurse as he is called in the oil sketch, has been sent on an errand to purchase candles taking his baby sister with him. He is distracted from his duty and whilst the baby falls asleep holding the candles the messenger enjoys a game of marbles until his irate mother discovers him. The composition, using a long narrow vista, is typical of Mulready's most complex inventions employing figures arrested in movement or partially seen. Notice, for example, the eye of a hidden child that is just visible in the triangular space left between the large defiant boy's arm and his body which forms the apex of the triangular group.

107

THE CARELESS NURSE, 1821

Oil on canvas, $9\frac{3}{4} × 7\frac{3}{4}$ in

Manchester City Art Galleries

This study for 106 was purchased from the artist by John Pye, see 73. It differs in small ways from the exhibited painting and has been called by a variety of titles including: 'the negligent brother'. The outline of the subject that appears on Mulready's tomb follows neither the finished painting nor the sketch precisely and is also different from a third variant that appears in James Dafforne's engraving.

108

THE CONVALESCENT FROM WATERLOO, 1822

Oil on panel, $24 × 30\frac{1}{2}$ in

Victoria and Albert Museum (XXVII)

Unlike Wilkie's *Chelsea Pensioners* . . . , this Waterloo painting offers a sombre and melancholy view of war and its aftermath. It is, nonetheless, essentially a patriotic painting; whilst the vacant spaces and the poignant face of the young wife produce an air of desolation and the huge felled trees provide a discreet metaphor for the many comrades who did not survive, the wrestling boys in the foreground illustrate the inevitability of struggle. They, and the new baby that forms the centrepiece of the distant family group, reassure us of the health of the nation and its future army.

109

FATHER AND CHILD, 1825

Oil on panel, $8\frac{1}{2} × 7$ in

Mrs Peter Hardwick (XIV)

The painting was purchased from the artist by the Duchess of Gloucester for £31–10–0 as a birthday present for Lady Louisa Legge, one of the daughters of the Earl of Dartmouth and a pupil of the artist. As in many of Mulready's interiors there is a specific contrast between the intimacy of the world inside – the bowl and spoon, the warm hearth, the gleaming china – and the alien world outside. Here this other world is suggested by the vendor with a basket on his head whose austere visage is severed by the door jamb and sight of whose body is blocked by the figure of the mother.

110

THE TRAVELLING DRUGGIST, 1825

Pen and sepia and sepia wash on paper, $4\frac{5}{8} × 3\frac{5}{8}$ in

Trustees of the British Museum (77)

A sketch for the painting exhibited at the Royal Academy in 1825 of which two versions are known to have existed, one of them

formerly in the collection of Sir John Swin-
burne. The subject carries ironic overtones
and, like *The Toy Seller*, 117, recounts events
occasioned by the arrival of a stranger at a
country home. The sick child in a night cap
holds a pear in one hand and a piece of bread
and butter in the other. Ink sketches like
this with colour notations by initials were
an early stage in Mulready's methodical pro-
cedures; they were followed by what he called
chiaroscuro drawings which were finished
chalk 'cartoons' and oil sketches blocking in
areas of dark and light. See, for example, 159
and 161. The final exhibited painting was
the outcome of this sequence.

111

A SAILING MATCH, 1833
Oil on panel, 14 × 12¾ in
Victoria and Albert Museum (XIX)

This is a replica of a larger painting of the
same title exhibited in 1831, location unknown
and accompanied by the following quotation
from *As you like it*: 'Creeping like a snail
unwillingly to school . . .'. Like *The Last In*
98 it contrasts the values of formal education
– the boy in his hat crossing a bridge at the
behest of his parent – with the process of
learning through play. The boy in the near
foreground blows through a paper roll in an
attempt to provide the wind necessary to
beat his rival in the race but in the background
another boy appears who has made a techno-
logical advance. He emerges from a cottage
jubilantly waving a pair of bellows. It is,
however, never clear where Mulready stands
on these issues; like Blake whose influence is
often apparent both theoretically and com-
positionally – there are overtones here of
'The Nurse's Song' and 'The Schoolboy' in
Songs of Experience – Mulready does not estab-
lish clear-cut categories of right and wrong,
good and bad but deals with the question of
choice.

112

TRAIN UP A CHILD IN THE WAY HE
SHOULD GO . . . , 1841
Oil on panel, 25¼ × 30½ in
The Forbes Magazine, New York (XXI)

Arguably the most extraordinary of Mul-
ready's depictions of childhood, this scene in
which a Christ-like child who could be a girl
or a boy is encouraged to give a coin to three
lascar beggars is, like *The Toy Seller*, at least
on one level an exploration of the issues of
racial and class difference. As with *The Toy
Seller* 117 a vertical dark area emphasized by
the line of the ruined buildings – a metaphor
for the ruin of an ancient civilisation – separ-
ates black from white. But here the hand of
the third lascar penetrates the space of the
white women and their child. The title of
the painting in full derives from a quotation
from Proverbs: 'Train up a child in the way
he should go and he will not thereafter depart
from it.' The overt message of the painting
is thus a dual one: train up a child to be
charitable and train up a child not to be a
burden to society.

113

MOTHER TEACHING HER SON, 1859
Oil on panel, 17½ × 13½ in
Victoria and Albert Museum (XV)

The painting was exhibited with a quotation
from Pope's *Moral Essays*: 'Just as the twig is
bent the Tree's inclined.' Like *Train up a
child . . .* 112 it deals with the influence of
early experiences on the formation of character.
Mulready's concern with such matters may
well have owed something to his relationship
with William Godwin, a liberal educationist
and with radical thinkers in the Blake circle.
But in this late work the sentiments are
thoroughly conventional and wholly com-
mensurate with mid nineteenth-century pre-
occupations about the influence of mothers
on childrens' education, a theme amply ex-
plored in the novels of Dickens and George
Eliot. The model for the mother may have
been Mary Mulready Stone, see 44, 47, but
the pose is that of a madonna and child and

the background provides a carefully orches-
trated series of images which reinforce analo-
gies between plants and children, between
natural fecundity and motherhood.

114

BROTHER AND SISTER, 1835–6
Oil on panel, 19 × 9¾ in
Victoria and Albert Museum (XXXVI)

115

THE YOUNGER BROTHER, 1857
Oil on canvas, 30½ × 24¾ in
Trustees of the Tate Gallery (61)

116

BROTHER AND SISTER, 1835
Pen and ink, 4 7/16 × 3 1/16 in
Leslie Parris, Esq. (62)

The Younger Brother is a late version of *Brother
and Sister* or *Pinch of the Ear*, as it was some-
times known. Drawings and some life studies,
see 144 indicate that Mulready was interested
in constructing a composition around a back
view. In the later version of the subject
more of the young man's face is seen and his
fingers are flexed upon a stone outcrop rather
than resting, as in the 1835–6 painting, on
a tree trunk. The rattle that establishes the
spiralling movement of figures and tree, re-
iterated in ringlets, drapery and the fluidity
of paint, which is a feature of the early ver-
sion is absent in the 1857 painting. Most
significant, however, are the changes between
the drawing and the painting. In the drawing
a darkly hatched male figure reaches over and
around the woman's body, trapping her with
his knee. In the painting the knee is replaced
by a tree trunk and the sexual tension implicit
in the sketch is much reduced. Instead the
woman's dress is allowed to slip from her
shoulder thus moving the emphasis from the
male to the female figure.

117

THE TOY SELLER, 1857–63

Oil on canvas, unfinished, 44 × 56 in

National Gallery of Ireland, Dublin (58)

In addition to the oil sketch of 1835 in the Museum, FA 149, there is a small version in oil on panel recently in the sale room. Number 117 was unfinished at the time of the artist's death. In averting his or her eyes from the negro toy seller the child encounters the sunflowers in a direct line of vision. The toy seller who holds out a rattle is portrayed with Titianesque brilliance of colour and handling and with sympathetic attention to physical features. Whilst the separation between black traveller and white woman and child is clearly demarked by the dark foliage-filled space between them, the representation cannot be said to indicate xenophobia or racial fear. The black's head is framed against an exotic open blue and the mother moves to draw the child towards the toy seller. In so far as there is a process of stereotyping at work here it is at a covert level through the narrative in which black suppliant encounters white woman and through the implied equation between negro and sunflower. In looking away the child encounters the image in nature of the noble growth under a sunny sky. The connotations are thus of the noble savage, the exotic stranger, and the imagery of the painting is, therefore, a manifestation of imperialism.

118

THE SEVEN AGES OF MAN, 1835–8

Oil on canvas, 35½ × 45 in

Victoria and Albert Museum (85)

This painting, executed for John Sheepshanks was Mulready's one serious attempt at a large scale allegorical presentation. Thematically related to Mulready's life-long concern with the educative process, *The Seven Ages* is based on Jacques' celebrated speech in *As you like it*, and used as the frontispiece to Van Voorst's *Illustrations to Shakespeare's Seven Ages*. The engraved design and the painted version developed alongside as can be seen from the entries in Mulready's account book, see 76. Shakespearian subjects of this kind were popular with Ford Madox Brown, William Bell Scott and the Pre-Raphaelites in the late 1840s.

119

DRAWINGS ON ZINC FOR THE MOTHER'S PRIMER

$3\frac{3}{8} \times 3\frac{3}{8}$; $1\frac{5}{8} \times 3\frac{3}{8}$ in

Victoria and Albert Museum (E2978–1910) (74)

The Mother's Primer was published by Henry Cole in 1844. Mulready here employs his favoured device of the enlarged internal window, cf 98 and 159, to suggest the heights of attainment to which a home-based education might lead. The lower part of an Antique statue on a pedestal surrounded by books can be glimpsed behind the appropriately age-related educational activities going on in the front part of the picture space.

120

E. BALDWIN

FABLES ANCIENT & MODERN, 1805

Vols. I & II

Victoria and Albert Museum (79, 80)

E. Baldwin was a pseudonym of William Godwin. Mulready was employed by Godwin in the early years of the century as the main illustrator for the publications in his *Juvenile Library*. These little hand coloured, unsigned plates are vignettes of childhood scenes which clearly relate to the dramas Mulready developed in his mature paintings.

121

THE CHILD'S TRUE FRIEND, 1808

Victoria and Albert Museum (81)

This was written and published by Godwin and illustrated by William Mulready; the tenor of such texts was one of education in morality through the social experience. As a pioneer in child-centred literature, Godwin made an important contribution to children's illustrated books and undoubtedly exercised a considerable influence on the young Mulready.

122

TRUSLER'S PROVERBS EXEMPLIFIED AND ILLUSTRATED BY PICTURES FROM REAL LIFE, 1790

Victoria and Albert Museum (82)

As an illustrator Mulready must have been aware of the work of John Bewick, the illustrator of this collection of Proverbs. It is, therefore, interesting to notice not only the reappearance of proverbial sayings in the titles of Mulready's paintings but also that Bewick makes use of the sharply receding perspective that is a major feature in many of Mulready's pictorial dramas. See, for example, *The Village Buffoon* and *First Love* 126, 136.

123

LAMB'S TALES FROM SHAKESPEARE, 1822

4th edn., vol. I

Victoria and Albert Museum (83)

William Blake was also associated with Godwin's circle. Mulready designed and Blake engraved the plates for this edition of one of Godwin's most successful publications for children.

124

WILLIAM ROSCOE

THE BUTTERFLY'S BALL AND THE GRASSHOPPER'S FEAST, 1807

Victoria and Albert Museum

William Roscoe was a Liverpool banker and collector of Italian Primitives. As well as writing a *Life* of Lorenzo de' Medici he was something of a pioneer in the production of fantasy tales for children. This volume, illustrated by Mulready, anticipates the illustrative work of Edward Lear and other mid-century artists.

125

THE MULREADY POSTAL ENVELOPE (97)

On 13 December 1839 Mulready was commissioned by Henry Cole, then assistant to Rowland Hill inventor of the penny post and post office reformer, to design the first pre-paid postage envelope. The design was completed two days later. It was approved by the Chancellor of the Exchequer on 4 January and a few days later Royal Academicians gave their approbation at their Council meeting. An initial drawing, see g, was amended to produce the design showing letters being distributed around the Empire. It was engraved on a hardened steel plate by Perkins and Heath, see h.

a) One penny letter sheet, National Postal Museum, London.

b) Registration proofs of penny and two pence wrappers authorising it to go into print, National Postal Museum.

c) Proof on India paper with an autograph of Rowland Hill and one unfolded envelope, National Postal Museum.

d) Proof of a postal envelope inscribed in Mulready's hand: 'To Elizabeth Forbes Leckie from W. Mulready, 1840', John E.C. Stone Esq., Mrs Forbes Leckie was Mulready's lifelong companion.

e) Specimen envelope overprinted across the bottom, National Postal Museum.

A few days after the issue of the Mulready postal envelope, as it was quickly named, on 12 May 1840, Rowland Hill wrote in his diary: the envelope 'is abused and ridiculed on all sides', see l. The envelope was almost immediately withdrawn.

f) Twopenny envelope withdrawn from sale February 1841, National Postal Museum.

g) Original drawing by Mulready showing a railway viaduct, an image closely associated with the idea of progress. The railway was a key factor in Hill's postal reforms but the image was discarded in the final design. The envelope is addressed to the artist by himself. Pen and ink, John E.C. Stone Esq. (98)

h) Original plate for the envelope, Victoria and Albert Museum.

i) Prints of Britannia used as a model by Mulready when designing the postal envelope, Trustees of the Tate Gallery, Tate Gallery Archive.

j) Annotated newscutting; Mulready was extremely distressed by the unfavourable response from the public. While he protested that he was paid nothing for his services, other reports suggest that he was paid £200. Trustees of the Tate Gallery, Tate Gallery Archive.

k) Postmaster's notice regarding the sale of Mulready stationery, photograph of original in the National Postal Museum.

l) Sir Rowland Hill's diary, 12 May 1840, bound volume, 7 × 9½ in. Post Office Archive. The entry reads:

'I fear we shall be obliged to substitute some other stamp for that designed by Mulready which is abused and ridiculed on all sides, In departing from the widely established "Lion & Unicorn" nonsense, I fear that we have run counter to settled opinion & prejudice somewhat rashly. I now think it would have been wiser to have followed established custom in all the details of the measure as far as practicable. The conduct of the public, however, shews that although our attempt to diffuse a taste for fine art may have been imprudent, such diffusion is very much wanted. If the curent should continue to run so strongly against us it will be unwise to waste our strength in swimming against it, & I am already turning my attention to the substitution of another stamp . . .'.

A great many satirical drawings and caricatures of the Mulready envelope were produced for commercial distribution. Many were explicitly anti-Irish. They initiated a craze for illustrated envelopes commemorative and humorous.

m) Reproduction of a drawing, now missing, by William Thackeray, on the back of the menu for a Royal Academy dinner, photograph, National Postal Museum.

n) JOY AND GRIEF, caricature, Southgate no. 1, 6 June 1840. The dignified figures of Mulready's design are replaced by drunks and pickpockets.

o) BLARNEY STONE, caricature, Southgate no. 4, 6 June 1840. A Chinese Mandarin threatens a foreign office official who is opening a box of opium.

p) RELIGIOUS TOLERANCE, caricature, Southgate no. 6, 17 June 1840. Britannia's lion has become a donkey and Papists carry placards with socialist and non-conformist slogans. A kilted figure is being fed a baby by a prelate and a priest is pulling beer. (99)

q) PICKWICKIAN, caricature, Southgate no. 5, 12 June 1840. Britannia's lion is being given a letter to eat and bottom right are featured unhappy letterless people.

r) MOLL-ROONY, published by Thomas White, signed CJG. This draws attention to features of the design that were thought ridiculous in a utilitarian object. The conversation between the mother and children in the lower right corner concludes with the child saying he cannot sit down because he has no hinderpart. (100)

s) Lithograph of a caricature, dated 26 May 1840, addressed to John Bull, published by Thomas MacLean.

t) Souvenir and greetings facsimile, from the Eighth Philatelic Congress of Great Britain held in Harrogate, May 1921.

Items m) to t) all exhibited courtesy of the National Postal Museum, London.

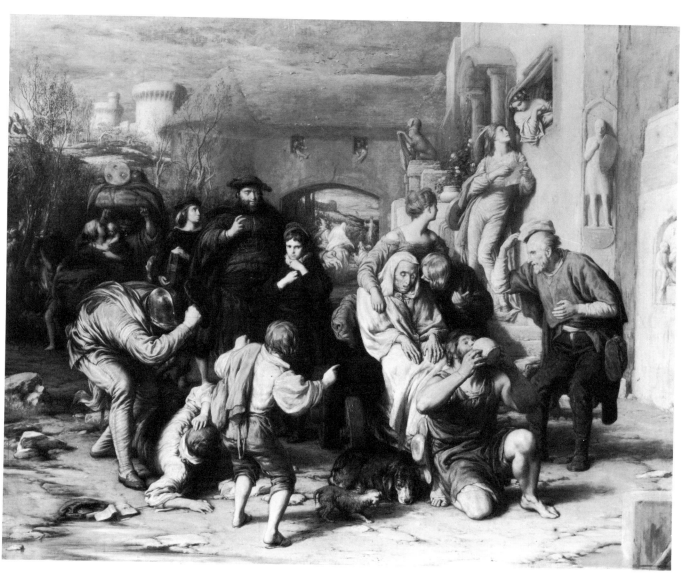

85. THE SEVEN AGES OF MAN, *Victoria and Albert Museum* (cat. 118)

CHAPTER IV
DIALOGUES AND TRANSACTIONS

PART I

Mulready's *A Mother Teaching her son* (XV)[1] received adverse criticism at the Academy where it was exhibited in 1859. Mulready's practice had been declining since 1842 and in 1859 entries in his account book cease. *The Toy Seller*, a subject that Mulready had first painted in 1835 was left on his easel unfinished at the time of his death (58). From the early 'forties the decrease in his output is accompanied by a clear change in compositional type; his early pictures are in the main compositions with a marked recession, like *A Dog of Two Minds* of 1830 (63). This type is replaced after the mid 'thirties by a frieze-like grouping of figures on a foreground plane and then beyond, separated from the viewer by a parapet or window, a landscape backdrop. *The Last In* of 1835 (XVII) and *Brother and Sister* of 1836 (XXXVI) are pictures of this type. Simultaneously there is a shift from Dutch and Flemish influence to the expansive gestures of High Renaissance masters. During this period, Mulready's subject pictures become increasingly like History paintings in manner and execution.

At the same time there is a noticeable change from built-up to rural settings and from the prosaic to the lyrical. One reason for this may be that Mulready's own environment was transformed between 1820 and 1850.[2] As his surroundings changed, Mulready no longer sought suitable locations for his subjects in his immediate environment but created lyrical and imaginative rural settings. The vernacular interior of *Idle Boys* (cat. 99) and the built-up setting of *The Fight Interrupted* (XVI) give way to the lyricism and rustic charm of *The Last In* (XVII). The closed setting of *Lending a Bite* of 1819 (76) is replaced by an open landscape setting in *Giving a Bite* of 1834 (XXVIII).[3]

Despite his reduction in output, Mulready continued to command high prices. The unfinished painting *The Toy Seller* (58) fetched nearly two thousand pounds at the artist's studio sale indicating that if Mulready's diminished activity was due to disillusionment with his public, the public wished to continue its dialogue with the artist. Pre-Raphaelitism is unlikely to have been a major factor as there are signs of a decrease in output as early as 1841 when Mulready exhibited only one painting, *Crossing the Ford* (90) and there is little evidence in his work to suggest that he was influenced more than very marginally by the younger generation. However, Holman Hunt and Henry Wallis were said to be among Mulready's most intimate acquaintance[4] and, although Percy Bate in his early study of the Pre-Raphaelites and their associates makes no mention of him,[5] nineteenth-century writers in general drew comparisons between Mulready and the Pre-Raphaelites. Ruskin, for example, thought of Mulready as a potential Pre-Raphaelite who failed because he was only half 'sincere' and fell back upon conventional Dutch influence, composition and sentiment.[6]

Enjoying the friendship of the Callcotts and the Eastlakes, Mulready must have been early cognisant with theoretical discussions about the colour values of Italian Primitives, even if the examples he had seen were limited. His notebooks were full of jottings relating to colours and varnishes and, as F.G. Stephens pointed out, there are signs, even in *Lending a Bite* on which he was working in 1818 (76), that Mulready was aiming at a pitch of colour beyond the scope of his Dutch models and in divergence from the interests of his contemporary, Wilkie.[7] In *Father and Child* of 1825 (XIV) (which admittedly may have been retouched before being exhibited in 1845 but nevertheless antedates the first Pre-Raphaelite pictures), Mulready used a white ground on which he applied paint in an extremely fine stippled effect. The colour is translucent and glowing with rich clashes of tone in the clothing worn by the three figures. The mother's bodice is of a purple worthy of Henry Wallis and is offset by the blue of her

[1] K.H., 171, *The Lesson*
[2] See ch. I
[3] K.H., cat. 97, 139
[4] F.G.S., preface
[5] P. Bate, *The English Pre-Raphaelites, Their Associates and Successors*, 1910
[6] J. Ruskin to W.J. Stillman, 15 October 1855, in J. Ruskin, *The Works*, Library edn., xxxvi, 222
[7] F.G.S., p. 101

sleeve and apron. The auburn haired male wears crimson and orangey red; the child is dressed in white with the faintest touch of green around her bonnet and blue around her neck. The warm colour centre of the pair is emphasised by the orange pot, red bowl and by the glowing embers of the fire. The mother's dress is painted with fluid brush-strokes and blobs whilst, in the case of the child's clothing, the pigment is dragged over the surface and appears to have been subsequently carefully scratched. Thackeray, seeing the painting at the Royal Academy in 1845 exclaimed 'the colour blazes out like sapphires and rubies'.[8] The same writer had already remarked that *Interior: An Artist's Study* (95) exhibited at the Royal Academy in 1840 showed affinities with 'the clear bright manner of Van Dyck and Cranach and the early German school'.[9] The comparison is particularly interesting at this relatively early date. When the Pre-Raphaelites exhibited their first notable paintings, Mulready was represented at the Academy with *The Butt* (XXVI) which is every bit as finely painted as *Father and Child* (XIV), exhibits the same brilliant colour and is a good deal larger. A basket containing lavender placed beside a crimson skirt is as vibrant in effect as the treatment of the clothing in *Father and Child*.

As Ruskin was quick to notice in his letter to *The Times* of 1851, Mulready had anticipated Pre-Raphaelite preoccupations with transparency of paint, especially in flesh tints and in the use of a white ground.[10] The treatment of the child's face and clothing in *Crossing the Ford* of 1842 (90) and the introduction into these areas of small quantities of a very acid green are a clear illustration of this. The splendid stippled effects achieved in *Interior with a portrait of John Sheepshanks* (XII) and *Choosing the Wedding Gown* (XXXV) are the product of the sort of minute care and application which Holman Hunt sought to emulate in *Valentine Rescuing Sylvia from Proteus* of 1851.

Looking at the sombre tones of *The Rattle* (XIII) and *A Dog of Two Minds* (63) with their obvious affiliations with Dutch art,[11] Mulready seems an unlikely source of inspiration to the Pre-Raphaelites. But if we turn to his pastoral subjects where psychological tension and narrative climax are heightened by attention to landscape and the minutiae of everyday life, paintings like *The Sonnet* (XXXIV), *First Love* (XXX) and *Train up a child . . .* (XXI), we can readily discern possible prototypes for Holman Hunt's *The Hireling Shepherd*, Arthur Hughes's *The Long Engagement*, Millais's *The Huguenot* and Ford Madox Brown's *Stages of Cruelty*, all painted after 1851.

Mulready's *Seven Ages of Man* (R.A. 1838) (85) is unwieldy in composition and over-ambitious in its comprehensiveness but it provides an interesting link with the concerns of the younger generation. In composition it may owe something to the Nazarene illustrative tradition. With its portrayal of universal human characteristics: schoolboy daring, young love, motherhood and so on it is also a pictorial summary in a literary medium of the themes Mulready had already explored in individual painting. It lacks the hieratic quality of Overbeck or Ford Madox Brown. Nevertheless it is an English Shakespearean subject of the sort favoured by Ford Madox Brown during the early years of his career when he worked on subjects like Chaucer and Wycliffe (1845–51 and 1847–8). Mulready also offered the Pre-Raphaelites real encouragement[12] though they had to wait until 1863 to hear him publicly affirm his faith in their artistic powers and his belief in the new school they had founded. But by then Mulready was a grand old man of English art and his blessing must have been all the more impressive.[13]

As a teacher in the Life class at the Academy Mulready must have had considerable influence over Millais and Holman Hunt. The latter remembered in later years only his scorn for Mulready's 'waxen effigies' and 'Dresden china prettiness'.[14] But Millais based *The Rescue* (1855) on Mulready's scene *The Fire* engraved on p. 181 of Van Voorst's edition of *The Vicar of Wakefield* of 1843.[15] Millais's painting was later used as the basis of a design for a medal by the Liverpool Shipwreck and Humane Society, for whom Mulready had designed a shipwreck scene. The illustration that Mulready provided

[8] W.M. Thackeray, 'Picture Gossip', *Fraser's Magazine*, June 1845
[9] W.M. Thackeray, 'A Pictorial Rhapsody', *Fraser's Magazine*, 1840
[10] J. Ruskin, letter to *The Times*, 30 May 1851, *The Works*, Library edn. XII, 326
[11] See also ch. I, part ii
[12] F.M. Hueffer, *Ford Madox Brown: A Record of his Life and Work*, 1896, p. 77
[13] Evidence of W. Mulready before the Royal Academy Commission of 9 March 1863, *Report of the Commissioners . . .*, in *Parliamentary Papers*, XXVII, 1863
[14] W. Holman Hunt, *Pre-Raphaelism and the Pre-Raphaelite Brotherhood*, 1905, I, 48–9, 85
[15] See A. Staley, *Romantic Art in Britain, Paintings and Drawings 1760–1860*, Detroit Institute of Arts and the Philadelphia Museum of Art, 1968, p. 321

for 'The Pale Student', a poem included in James Grant's *Madonna Pia and other Poems* (1848) possesses a combination of intense emotionalism, medievalism and deliberate angularity that seems likely to have made it a source of inspiration to Millais and Holman Hunt; there are reverberations of 'The Pale Student' in Holman Hunt's figure of Julia disguised as Proteus's servant in *Valentine Rescuing Sylvia from Proteus* (1850) and in his Claudio (*Claudio and Isabella*, 1850). There are also similarities between 'The Pale Student' and Hunt's frontispiece to *The Germ* comprising an illustration to Woolner's 'My Beautiful Lady'.

Thomas Woolner, one of the original Pre-Raphaelite Brothers, declared an admiration for Mulready and purchased a number of his works.[16] The men and women who patronised and befriended the Pre-Raphaelites in the 'fifties were, in some instances, also acquaintances and men with whom Mulready conducted transactions. Thomas Miller was keen to patronise Mulready and Lady Trevelyan of Wallington Hall took lessons from him.[17] Moxon's edition of Tennyson's poems, one of the great illustrated book projects of the century, contains designs by Rossetti and other Pre-Raphaelite artists and also by Mulready. It was one of his last completed commissions (84).

The success of the Pre-Raphaelites in paths which Mulready had in some sense prepared may have contributed to his decision – conscious or otherwise – to paint little after 1842 and to confine himself primarily to Life drawings, a manifestation of his growing concern with art education. Another factor may have been the flood of Subject and narrative paintings appearing before the public by a host of artists from the early 'forties onwards.[18]

C.R. Leslie, W.P. Frith, Augustus Egg and Thomas Webster were producing and exhibiting a mass of genre scenes many of which involved children and many of which, based on familiar literary texts, were instantly accessible in a way Mulready's work tended not to be. *The Seven Ages* (85, cat. 18 and 76) can be regarded as constituting Mulready's bid to enter the rapidly expanding market for literary paintings; it was accompanied by the sort of lengthy verbal explanation with which Ford Madox Brown was to support his dialectical paintings *Work* and *The Last of England* (1855 and 1852–65). Although

it attracted a great deal of attention when it was first exhibited and earned its author the title of King Mulready[19] it does not stand up as the scourge of French History painting that Thackeray evidently fancied it to be.

The paintings that Mulready executed following the success of his illustrations to Van Voorst's *The Vicar of Wakefield* (1843) (see cat. 163–165) persuaded Thackeray to lift his embargo on reviewing paintings at the Academy illustrating scenes from this most popular of all novels[20] and continued to attract more attention than in any other of the artist's works until the end of the century. *The Whistonian Controversy* (XXXI, cat. 139) was admired by Benjamin Robert Haydon[21] and described by Thackeray as 'one of the finest cabinet pictures in the world'.[22] But it was *Choosing the Wedding Gown* (XXXV, cat. 140) that created the greatest sensation. Even before the exhibition opened Henry Cole identified it as 'the picture of the year' and said that it reminded good judges of Van Eyck, Titian and Rembrandt'.[23] One reviewer thought its grace and delicacy 'beyond those of all Tennyson's Idylls', extravagant praise in an era that mopped up copies of Tennyson's medievalising poetry like blotting paper and an interesting indication of how period identities could be collapsed in the minds of contemporary viewers.[24] Twenty years later it was recalled as a constant source of surprise as well as delight' at the Royal Academy exhibition,[25] and in 1875 Ruskin remarked that *Burchell and Sophia (Haymaking)* (XXXIII) and *Choosing the Wedding Gown* (XXXV) remained in his mind 'as standards of English effort in rivalship with the best masters of Holland'.[26]

Only Palgrave, many years after they were exhibited, was prepared to criticise these paintings on the grounds

[16] H. Hunt, op. cit. I, 118; it must be realised, however, that Woolner was something of a dealer buying and selling frequently
[17] Lady Dilke, *The Book of the Spiritual Life*, 1905, p. 23
[18] See K.H., ch. III for some interesting comparisons
[19] W.M. Thackeray, 'A Letter from Michelangelo Titmarsh, Esq. to M. Anatole Victor Isidore Hyacinthe Achille Hercule de Bricabrac, Peintre d'Histoire, rue Mouffetard a Paris', *Fraser's Magazine*, June 1838
[20] W.M. Thackeray, 'May Gambols; or Titmarsh in the Galleries', *Frasers's Magazine*, June 1844
[21] B.R. Haydon, *The Diary*, W.B. Pope, ed. Cambridge, Mass., 1960, v, 7 May 1844
[22] W.M. Thackeray, op. cit.
[23] H. Cole, 'Miscellanies', collection of published writings of Henry Cole, Victoria and Albert Museum Library
[24] Anon reviewer, *Athenaeum*, 1549, 4 July 1857, 857
[25] Anon, 'Artist's notes from Choice pictures', *London Society*, X, 1866, 435
[26] J. Ruskin, *The Works*, XIV, 300–1, Academy Notes, 1875

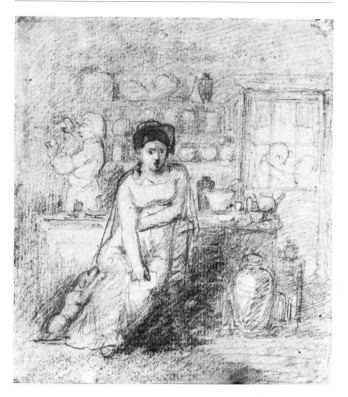

86. THE CHEMIST'S SHOP, *Whitworth Art Gallery, Manchester*

that Mulready, unlike Wilkie, was less successful 'in drawing the figures presented by others than in those which he created for himself.'[27]

Choosing the Wedding Gown and *The Whistonian Controversy* were paintings of the literary 'fifties (see cat. 139 and 140) appreciated as such by the artist's contemporaries. In them Mulready could outdramatise Leslie and Egg but may, perhaps, have felt something of Palgrave's reservations for he did not capitalise on the success of the *Vicar of Wakefield* canvases although he could undoubtedly have sold oil paintings of every subject engraved by Van Voorst many times over. Despite the adulation he enjoyed on account of the success of *The Vicar of Wakefield* paintings, however, a number of Mulready's works had not found purchasers at the time of their exhibition. The growing popularity of literary subjects from the easels of Leslie, Egg, Frith and Webster and many others was accompanied by a flood of illustrated publications. Mulready dabbled a little in book illustration but this work constituted for him a regressive move rather than an advance.

Now in his 'fifties, Mulready must have recalled the many commissions for illustrated books which he undertook in the first decade of the century (see ch. III). Many less able artists like William Henry Knight and George Smith were now painting frank imitations of Mulready's own pictures; William Henry Knight's *The Broken Window: Who threw the Stone?* of 1855 (71, cat. 103) owes an overall debt to *The Fight Interrupted* (XVI) and George Smith's *The New Boy*, exhibited at the Academy in 1859 borrows the subject and the treatment of Mulready's schoolroom scenes.[28] Thomas Webster was producing pictorial dramas which superficially resemble *The Wolf and the Lamb* (XVIII), *The Careless Messenger Detected* (XX) and other works by Mulready which had become household images through the wide circulation of prints. The exhibition of his work at the Society of Artists in 1848 was a culminating point in Mulready's career, a big retrospective as we would now call it, from which it was difficult to set forth in a new direction. His increasing concern with the nude and with the role of the Life class in art education was recognised with the exhibition of his Life studies at Gore House in 1853 and it was this genre that occupied him above all else for the latter years of his life.

One more factor which needs to be taken into account when seeking explanations for the trajectory of Mulready's career is the extraordinary fiasco of the Mulready postal envelope. This episode represents a nadir, a profoundly affective experience of failure in an otherwise exemplary adult career. The history of the envelope should not be passed over or relegated to the sidelines as an example of eccentricity or as an obscure fragment of design or philatelic history. It should be seen, on the contrary, as an essential part of Mulready's enterprise, a key component in the structure of his public life. Understanding its failure and Mulready's response to that failure is to understand not only the gradual slowing down of his artistic activities in the years immediately following the disaster (not too strong a word) but also the essential limitations of his pictorial art within the context of his own age.

[27] F.T. Palgrave, *Gems of English Art*, 1869, pp. 21–2
[28] *Illustrated London News*, 12 August 1859, p. 167, ill.

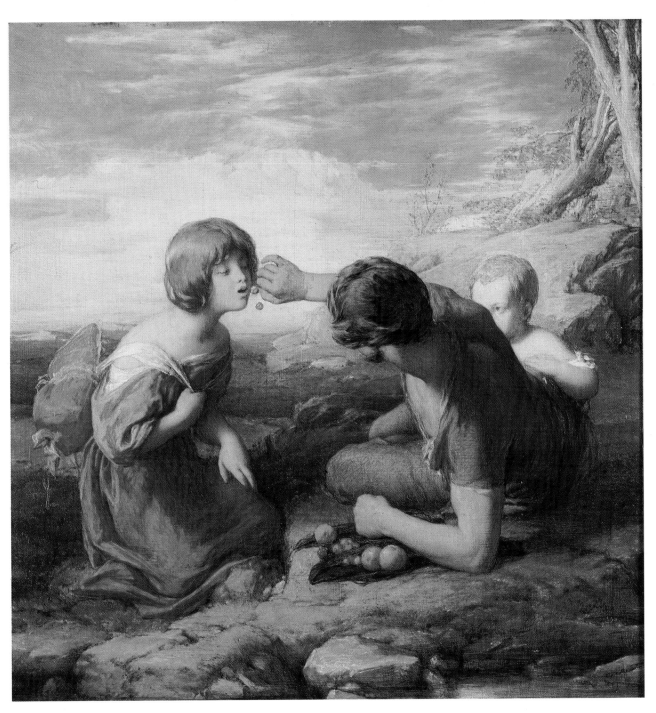

XXIX OPEN YOUR MOUTH AND SHUT YOUR EYES, *Victoria and Albert Museum* (cat. 135)

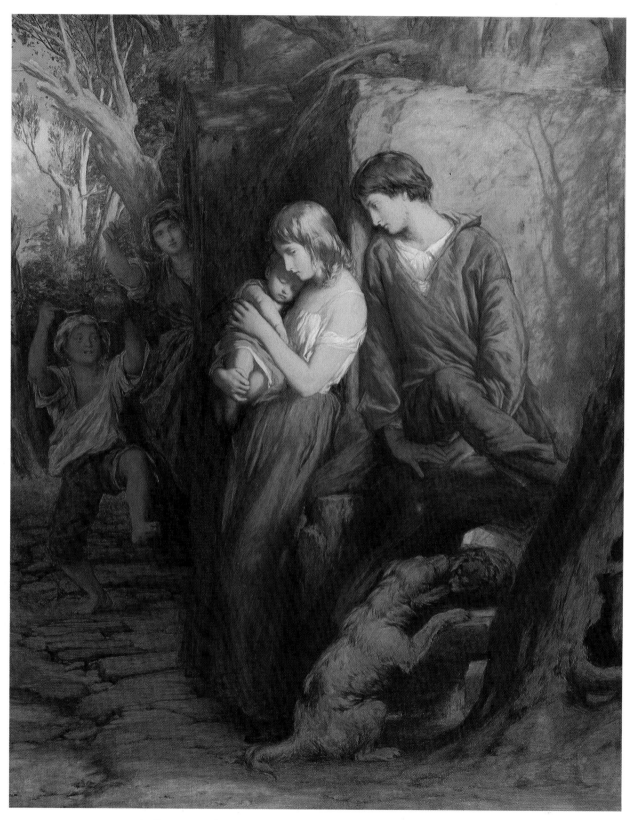

XXX FIRST LOVE, *Victoria and Albert Museum* (cat. 136)

XXXI THE WHISTONIAN CONTROVERSY, *Lord Northbrook* (cat. 139)

XXXII INTERIOR OF AN ENGLISH COTTAGE, *By Gracious Permission of Her Majesty Queen Elizabeth* II

XXXIII HAYMAKING, *Lord Northbrook* (cat. 163)

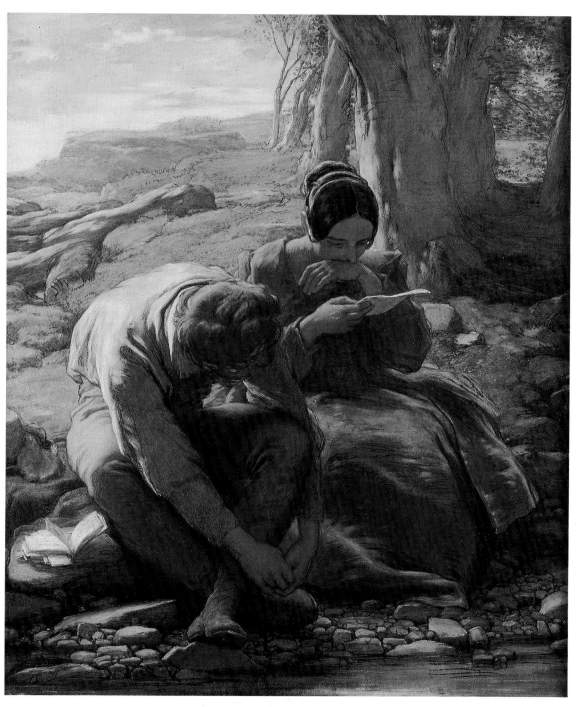

XXXIV THE SONNET, *Victoria and Albert Museum* (cat. 160)

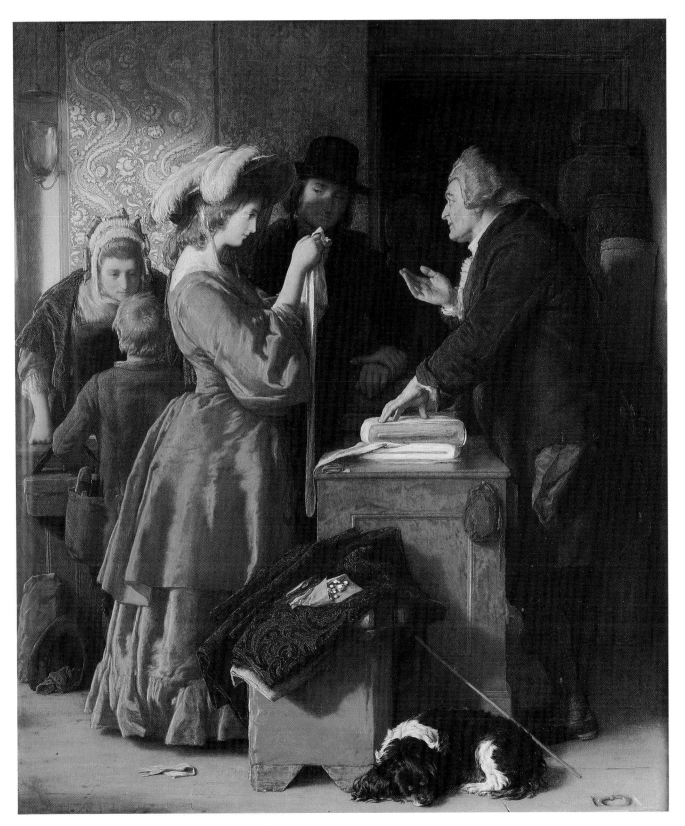

XXXV CHOOSING THE WEDDING GOWN, *Victoria and Albert Museum* (cat. 141)

XXXVI BROTHER AND SISTER, *Victoria and Albert Museum* (cat. 114)

The commission for the postal envelope was auspicious for Mulready on a personal level for one reason only: it was the occasion of the commencement of his friendship with Henry Cole. The latter visited the artist on 13 December 1839 on the instigation of Mr Francis Baring, Chancellor of the Exchequer, to commission a design for an innovatory pre-paid postage envelope. A design by Corbould had been rejected and Mulready was chosen only after several Royal Academicians, including Shee, Westmacott, Howard and Hilton had been consulted. Rowland Hill, Postmaster General, was busy at this time working out how the system of penny postage he had invented could be applied uniformly. However, Cole undoubtedly knew that Hill felt strongly that any design should be symbolic of the great benefit that postal reform would bring to the people of Britain and ultimately to the colonies.[29]

Mulready set to work with his customary diligence, studying existing engravings of Britannia in order to produce a model[30] and, after discarding a preliminary sketch featuring a railway viaduct with a train crossing it, symbol of progress and industry (98),[31] produced a design with Britannia at the centre from whose outstretched arms eager postal angels fly to the far reaches of the world where William Penn is seen meeting the Indians (right) and Asians are seen riding elephants (left). Below mothers and children eagerly scan epistles from loved ones absent from home in the remotest parts of the British Empire (97).[32] The design was engraved by John Thompson and, at the beginning of 1840, was approved by the Queen and the Royal Academy Council (see cat. 125).[33]

Great was Mulready's mortification at the public reception of his design. Despite close scrutiny through the engraving process one of the angels is lacking a foot but that was a minor detail in the storm of abuse that greeted the issue. Only six days after the first envelopes were available for sale, Rowland Hill wrote in his diary: 'I fear we shall be obliged to substitute some other stamp for that designed by Mulready which is abused and ridiculed on all sides (cat. 125 l).'[34] Mulready found himself called 'Mulled-it-already'[35] and other pejorative names, the press was full of letters from members of the

public ridiculing the design and someone even went to the lengths of forging a reply from Mulready which the artist was obliged to repudiate.[36] So huge was the number of caricatured envelopes that poured onto the market that eventually they became the subject of a philatelic study.[37]

Cole described Mulready's design as 'poetic' but forty years later admitted public opinion 'that this fine design was quite unsuitable for its purpose' to be sound. 'The baldest simplicity only was necessary', wrote Cole. 'Had an allegorical fresco for any public building been required to symbolise the introduction of the universal penny postage, nothing could have been better than Mulready's design, and I still hope to see it perpetuated in some fine work of art.' Meanwhile, he suggested, it would do no harm for the students of the National Art Training School to use it as an exercise in enlargement.[38]

Thackeray and Smirke defended Mulready's design though the former is also known to have drawn a parody during a Royal Academy dinner[39] but the experience was a searing one for the artist. Frith recalled Mulready refusing to visit Augustus Egg's house for fear of meeting John Leech who had caricatured the envelope in 'The Regicide Postboy'. 'I don't mind a bit about that', Mulready allegedly told Frith, 'but what I think I have a right to object to is the insult offered me by a little bottle in the corner with a leech in it. He implies I am a leech, a blood sucker, in respect of the remuneration I have received for my art generally, and no doubt for that confounded postal envelope in particular. Now, you know that my prices have never been extravagant. . . .'[40] Frith was astonished

[29] Sir Henry Cole, KCB, *Fifty Years of Public Work*, 1884, I, 62–3, Rowland Hill's diaries, MS. Post Office Archive
[30] Three engraved insignia mounted on card and annotated in Mulready's hand, Tate Gallery Archive, 72–16/36
[31] Pen and ink, collection of Mr John Stone
[32] Rorimer, 121 identifies no. 6464 as a related drawing but the motif here is quite different and the drawing, on the back of a series of notes about the Artist's Benevolent Fund, seems more likely to be related to Mulready's design for that organisation's insignia than to the envelope
[33] Sir Henry Cole, op. cit.
[34] MS. Post Office Archive
[35] *The Weekly Dispatch*, 10 May 1840
[36] W. Mulready to the Editor of *The Morning Herald*, 22 May 1840, MS. Victoria and Albert Museum, 86 N 1
[37] Major E.B. Evans, *A Description of the Mulready Envelope and of Various Imitations and Caricatures of its Design*, 1891, reprint, 1970
[38] Sir Henry Cole, op. cit.
[39] Photograph National Postal Museum, whereabouts of original unknown
[40] W.P. Frith, *My Autobiography and Reminiscences*, 1888, 5th edn. I, 178–9

at Mulready's ignorance of Leech's characteristic signature and explained the matter to him. The imputation of financial gain or speculation appears to have rankled especially strongly with Mulready for a news cutting from *The Weekly Dispatch* 10 May 1840, describing the envelope as a 'thorough disgrace in point of execution and conception to any schoolboy' and now among the artist's papers in the Tate Gallery archive is annotated in the artist's hand: 'I do not know who the originator of this . . . may be. I was employed . . . to make a design on a given space. I made it in December last but I made no charge whatsoever for it and have not received one farthing nor heard one word about money for it since. W.M. May 16, 1840.'[41]

The vast stock of envelopes prepared for issue was finally destroyed by a specially made cutting machine, the attempt to do the job in closed stoves having failed.[42] The ignominy was less easily disposed of. The one consolation of the affair for Mulready may have been that it was the means of bringing his work to the attention of the Chancellor of the Exchequer's brother. The original design for the envelope went to Thomas Baring after correction of the handicapped angel.[43] Baring became an appreciative patron and in 1847 bought *Haymaking* (XXXIII), the first of a number of Mulready's works to enter his collection.

On a personal level it is easy to see how the events surrounding the production of the postal envelope must have made Mulready shrink from the public exposure. His integrity was impugned, his artistic talent made the object of ridicule and his ethnic origins paraded before the world and jeered at.[44]

What Mulready had unwittingly provided in the design for the postal envelope was a focus for anti-establishment protest and the airing of prejudice on many levels. High art forms, allegory and pictorial narrative were instantly recognised by the public which took this rare opportunity to make known its distaste and dislike of their exclusivity (see cat. 125 n-r). Mulready's capacity to produce pictorial narration in the Academy did not extend to a project that required the expertise of popular graphics, the skill of the cartoonists. The design was regarded as ridiculous, bathotic and pretentious. The association of something as mundane as the receipt of a letter with High Art visual rhetoric called forth protest; the Pickwickian caricature shows

Britannia's lion being fed a letter and an unhappy group of people at the bottom right who are the letterless of the population. The conventions of artistic representation (and possibly also the popularity of paintings in the Academy showing scenes of families receiving letters) were dismantled and held up for examination. Thus in the Moll-Roony envelope (100) the image of the mother and her children in the lower right of Mulready's envelope, an incomplete image which allows space for the address to be written, is replicated but with balloons coming from the figures' mouths. The mother says: 'My dear children should never look into people's letters. Go and sit down.' The child replies: 'I can't Ma'm cos I've got no hinderpart'. In an important way the publication of the envelope became the ground on which the battle over Fine Art and Design could be fought in the public arena and the conflict between High Art and Popular art forms could be nationally debated outside the parliamentary commissions and the special committees.

Not surprisingly the envelope was also the occasion for rhetorics of different kinds; one caricature substitutes female figures for all the characters imaged in Mulready's design. In so doing it ridicules the idea of women receiving letters and at the same time devalues the principle of the postal envelope. A ladies' school releases scores of envelopes which float round the world, falling at the feet of, for example, a washerwoman who is presumed illiterate. In *Blarney Stone* (an anti-Irish reference) a Chinese mandarin pokes a finger at a foreign office official who opens a box of opium whilst in *Religious Tolerance* (another anti-Irish envelope (99)) Britannia's lion is a donkey and people carry placards inscribed 'Socialism for ever' and 'Religious equality' whilst a kilted figure is fed a baby by a prelate. There were also allusions to particular contemporary events and in one envelope published by William Spooner Britannia is replaced by Sir Charles Napier ready to fight in Syria by sea or land. This last example evacuates Mulready's domestic view of the Empire and reclaims the imagery of Britannia's realm for the rhetoric of war.

[41] MS. 72–16/36
[42] Information from the late Mr. Rigo de Righi, National Postal Museum
[43] Sir Henry Cole, op. cit.
[44] See Introduction for a discussion of the anti-Irish envelopes

PART II

It is only relatively recently that British Subject painting, the genre in which Mulready excelled, has attracted serious attention from art historians. Moreover whilst, as we have seen, Mulready had a very considerable British following in his own lifetime and after, outside Britain it was a different matter. Mulready was praised by one French critic when he exhibited at the Exposition Universelle in 1855 for 'de petits tableaux finement pensés et executés avec beaucoup d'esprit.[1] This, however, was the most that could be said in France of paintings like *The Wolf and the Lamb* (1820) (XVIII) and *The Butt* (XXVI) both of which were on show in Paris. Most critics at that exhibition were unwilling to devote much space to Mulready because they thought that his genius was, in a characteristically English way, very superficial. 'Il ne pénètre pas le fond même de l'âme', as one writer expressed it.[2] The view that subject paintings like those of Mulready are charming, well-executed but trite would probably still be the reaction of many people today.[3] Heleniak has signalled the complexity of subject matter in some of Mulready's paintings and related it in a general way to social concerns of the first half of the nineteenth century. We should also be alerted by the failure of some of Mulready's subjects to find approval or to secure purchasers. In the second half of this chapter I will be looking at the way in which contemporaries 'read' Mulready's paintings, at the construction of the pictorial dialogue in his work and at the underlying pre-occupation with the notion of transactions and dealings which many of Mulready's Subject paintings have in common.[4]

'We must learn to read pictures and nature as others read books', remarked Wilkie in a dialogue with his friend John Burnet. 'I see', replied Burnet, 'that the progress of a painter is as laborious as the Pilgrim's Progress.'[5] No less laborious or fraught with moral problems was the task of the spectator. Mulready's paintings do not portray a cheerful, simple, or a sentimental, view of domestic life. They are difficult and to apprehend the complexity of their construction we need to acknowledge the deliberate opacity of their presentation. *The Widow* is a case in point. 'I hardly know how to speak of Mulready',

confessed Ruskin in *Pre-Raphaelitism* of 1851, 'in delicacy of drawing, and splendour of colour, he takes his place beside John Lewis and the Pre-Raphaelites; but he has throughout his career, displayed no definiteness in choice of subject. He must be named among painters who have studied with industry and have made themselves great by doing so; but, having obtained a consummate method of execution, he has thrown it away on subjects altogether uninteresting, or above his powers, or unfit for pictorial representation.'[6]

Mulready's friend, Wilkie, was praised for avoiding anything vulgar in his pictures and his homage to Hogarth is to be seen rather in the location of *The Chelsea Pensioners . . .* in a London street with close similarities to Hogarth's arrangement in *Canvassing for Votes* than in any direct borrowing or immediate social satire.[7] Moreover, his subject matter was itself elevated. The same cannot be said of Mulready. When he exhibited *The Widow* in 1824 (XXII) Mulready was criticised for throwing away much talent in conception and execution 'on a very uninviting subject.' The reviewer in the *New Monthly Magazine* continues:

'That "such things be" as we meet with here is true enough; but it is not so true that either the morals or the manners of the age are likely to be bettered by thus depicting them. In fact we canot admit that the extreme cleverness displayed in this picture throughout atones for the scarcely covert grossness of it. Mr. Mulready should not have painted a picture of which he would be sorry to be called upon to explain the purport to any inquirer.'[8]

The Widow is probably one of the pictures that Ruskin

[1] E. About, *Voyage à travers l'Exposition des Beaux-Arts*, Paris, 1855, p. 11
[2] E. Balleyguier, *Le Salon de 1855*, Paris, 1855, p. 33
[3] Mulready was described by a contemporary as creating 'a world of cinnamon-jacketed boys', Athenaeum, 1549, 4 July 1857, 857, and the view has been tenacious
[4] The substance of this section is taken from two articles, M. Pointon, 'William Mulready's *The Widow*: a subject "unfit for pictorial representation"', *The Burlington Magazine*, CXIX, May 1977 and M. Pointon, 'Pictorial narrative in the art of William Mulready', *The Burlington Magazine*, CXII, April 1980. For a detailed discussion of the British exhibits at the 1855 Exposition Universelle, see M. Pointon, 'From the Midst of Warfare and its Incidents to the Peaceful Scenes of Home': The Exposition Universelle of 1855, *Journal of European Studies*, XI, 1981
[5] J. Burnet, *The Progress of a Painter*, 1854, p. 79
[6] J. Ruskin, 'Pre-Raphaelitism', *The Works*, Library edn., XII, 364
[7] D. and F. Irwin, *Scottish Painters at Home and Abroad*, 1975, p. 172
[8] *New Monthly Magazine*, XII, 1824, p. 159

thought dealt with a subject 'unfit for pictorial representation'. An examination of the iconography reveals why the subject was unacceptable to an early nineteenth-century audience. It also shows that Mulready inherited from Hogarth not merely an unequivocating approach to subject-matter of a provocative kind but also a considerable feel for subtle narrative and pictorial irony.

It was the precision of subject and treatment in *The Widow* that caused offence. The picture was exhibited with the words: 'Thus mourned the Dame of Ephesus her Love.' The immediate source for the subject was probably Peter Pindar's *Tales of the Hoy*[9] but the original source is to be found in the *Satyricon* of Petronius. Pronouncing herself stricken with grief at the death of her husband, the Dame of Ephesus mounted a vigil at his tomb, only to be seduced by the soldier who was guarding the body of a robber in an adjacent tomb. In *The Widow* the story is re-enacted in an English parlour at tea-time.

The Dame sits at one side of the table, eyelids heavy, hands limp and knees beneath her black silk dress slightly apart (60). The seducer, sprawled easily with his shirt collar unfastened, is seated beside her, mouth half open and head inclined towards the Dame in an insinuating fashion. His pose is reminiscent of that of the count in *Marriage a la Mode*, II, a copy of which was among Mulready's collection of engravings at the time of his death.[10] The seducer's air of abandonment in this proper domestic setting suggests corruption; a contemporary audience, familiar with Lavater and popular theories concerning physiognomy would have readily recognised the *louche* undercurrents of this dialogue. The Dame's left hand barely touches his knee while he, in a gesture of explicit sexuality, with his right hand fondles the ear of the widow's spaniel puppy who lies somnolently in her lap. From the fingers of her right hand hangs a key ring containing four keys. On the other side of the table sits a prudish maid with an expression of extreme hostility and censoriousness on her face. One is reminded of that model of self-righteous indignation on her way to church in Hogarth's *Morning*. The maid's left hand is placed on a wooden document box. She is an important figure in the composition from its inception and through all stages of development (59).

There are a number of children in the room; a sulky girl sits at the table behind her mother, chin in hands in a brooding attitude, while three younger children frolic around the seducer. One has taken possession of his top hat, gloves and stick, another pushes a mechanical money box in the shape of Punch into the seducer's pocket, whilst the youngest grasps his left leg. An empty purse and a spinning top lie on the floor. Immediately behind the table, lace curtains are hooked back over an internal window to reveal the interior of a shop and, beyond it, through another window, the street with houses and a distant church. Hanging dead centre from the parlour ceiling and already present in the oil sketch for the painting (59) is a large egg.

The sexuality of the central couple is reinforced by the presence of the pubescent girl and the old maid as well as by the infants who clamber at their knees. But the painting operates in a many layered narrative and the toys, taken in sequence, suggest duplicity, treachery and cunning. Mulready would have been familiar with the introduction of toys like spinning tops into the work of Van Ostade and other painters of the Dutch school. The futility of the spinning top fallen on its side, the uselessness of the empty purse and above all the figure of mockery, Mr Punch as money box, pushed by a childish hand into the pocket of the seducer produces a web of signification which links seduction with foolishness, childishness and loss of fortune. If we are inclined to ask, as indeed we must, why a man in Mulready's difficult position vis a vis his private life and his public reputation should have chosen such a risque subject, the answer seems to lie here. For this is above all a discourse on sexual transactions and their consequences. It would seem that despite what might be presumed to be his better judgement, Mulready created in *The Widow* a profoundly autobiographical document.

Petronius's narrative of the Ephesian Dame was concerned with lust and it was Mulready's translation of this into an overt, up-to-date imagery that shocked his audience. Even more shocking, he introduces a further

[9] John Wolcot, pseudonym Peter Pindar (died 1819), *The Works*, four vols. pub. 1816 included 'Lyric Odes to the Royal Academicians', 'Subjects for Painters' and 'Tales of the Hoy' one of which was 'The Widow of Ephesus'

[10] Studio sale, Christie's 28 April, 1864, lot 38

element that is not present in Petronius by the emphasis he lays on material wealth. Two distinct events are taking place in two distinct spatial areas within the picture. Outside is the church with the world that sanctifies matrimony (a state that Mulready had good reasons for regarding with scepticism). Inside the shop a monetary transaction is taking place but, simple though it is, it necessitates—at least for one customer in the right foreground of the shop—the careful counting of money in his palm. Within the parlour are to be seen the fruits of a thriving business in the good family furniture, some of it dating back to the eighteenth century and connoting, therefore, solid thrifty values, other items like the Persian rug and coffee pot more fashionable and modern. Here a transaction of a different sort is being negotiated by devious means. This is a transaction that involves not merely money, though that is important (witness the keys, document box, child's money box and empty purse) but lust and the well-being of a family unit that includes a maidservant and four children. The anecdote of the well-to-do widow, wooed by a fortune hunter hoping to benefit from the proceeds of her late husband's business is common enough. But in the association of money with sex implicit in *The Widow*, the painting exceeded the boundaries of nineteenth-century decency.

The children are unruly and undisciplined perhaps because they lack a father. But the man for whose attention three of them clamour is pursuing his purpose in the same single minded fashion that characterises the woman in the shop as she makes her purchases from the bespectacled man behind the counter. The eldest child is left in miserable isolation and, if we were in any doubt as to whether the seducer would make a suitable father for the children, we have only to look at the ominous egg that hangs from the ceiling. It is most improbable that Mulready would have known of Piero della Francesca as early as 1823, the date when he painted *The Widow*. The egg is most immediately associated with resurrection and rebirth. Here it may also signify the evil that is about to be hatched. Perhaps it is there to remind us that 'Remorse, the fatal egg by pleasure laid'[11] is all that the widow or her seducer can ultimately expect.

Other works by Mulready also address the dark side

of human nature and the seamier side of society, but escaped public censure. When Mulready submitted *The Village Buffoon* (XXIII) to the Royal Academy in 1816, the subject appeared obscure to the council and Wilkie, who was intimate with Mulready, was called upon to explicate it to the general meeting. He described it as 'an old man soliciting a mother for her daughter who was shown unwilling to consent to so disproportionate a match'.[12] *The Village Buffoon* could thus be seen as an inversion of the scene that Wilkie had painted in *The Refusal from The Song of Duncan Gray* (1814, reworked 1817) (65) and for which Mulready posed as a model. Wilkie portrayed a girl foolishly refusing to accept the attentions of a most acceptable young man; Mulready in a sinister inversion shows a wise girl horrified by the attentions of a foolish old man. Unlike Wilkie's painting which is based on Burns, Mulready's *The Village Buffoon* has no literary source and little humour. The old man has money; he wears spats and is the owner of the silver tipped cane lying in the foreground. The object of his desire huddles in acute embarrassment by the doorway of her home while the heavy black shadows under the dark wall of the cottage where the mother sits with her daughters and the long shadow cast across the sunlit street by the grotesquely soliciting old man create an ominous atmosphere. The true nature of the situation is not very humorous. As with *The Widow*, Mulready is exploring the dramatic consequences of money and power manifest through lust.

Whilst Wilkie was painting his heartwarming *Chelsea Pensioners reading the Dispatch from the Battle of Waterloo*, Mulready was painting an anonymous soldier convalescing from his wounds (XXVII). Pale and ailing, accompanied by his care-worn wife and three children he takes an airing on the beach. Absence of dialogue, and a featureless landscape produce an air of melancholy immobility that is little relieved by the wrestling boys. The barracks in the distance indicate where the soldier really belongs. The painting seems to treat the aftermath of war as far from glorious and it is significant that, like *The Widow*, it remained on the artist's hands. It cannot, however, be

[11] William Cowper, *The Progress of Error*, 1782; the pictorial antecedents in Hogarth and Rowlandson are also concerned with this progress

[12] F.D., 4 November 1816

regarded as a pacifist painting because the function of the two boys fighting in the foreground 'is to reveal the fundamentally war-like nature of humanity, which will ensure that war will constantly recur'.[13]

Mulready painted many pictures that are, in contrast, light-hearted in mood and lyrical in subject. They too, however, pose profound questions of content and interpretation. The sort of question that we ask ourselves before *First Love* (1840) (XXX) and *The Butt* (1847) (XXVI) is are they pleasing pictorial records of actual occasions of pure fantasy? If they tell a story how is it told? What can the artist hope to achieve in pictorial narrative and what are the means at his disposal? Should we like Hippolyte Taine lament the fact that Mulready employed a paint brush instead of a pen.[14]

Taine, like so many French commentators, was a more sincere admirer of English literature than of painting. His expressions of regret about Mulready's medium undoubtedly include a note of irony. Nevertheless, he missed the fact that it was precisely the ambiguities (that were less evident in the *written* story) and the opportunity for speculation offered in Mulready's *painted* stories that delighted an English audience. Translating the incidents of the picture into words was the task of the viewer whose originality and skill would be challenged to a greater or lesser degree according to the quality of the painting he was looking at. Thackeray's rapture before *First Love* (XXX) is the excitement of someone who discovers he is collaborating with the artist in unravelling a story, bringing all his intuition into play in order to read the signs and translate the meaning:

'Let us look at the design and conception of 'First Love'; and, pray, sir, where in the whole works of modern artists will you find anything more exquisitely beautiful? I don't know what that young fellow, so solemn, so tender, is whispering into the ear of that dear girl (she is only fifteen now, but sapristi, how beautiful she will be about three years hence!!), who is folding a pair of slim arms round a little baby, and, making believe to nurse it, as they three are standing one glowing day under some trees by a stile. I don't know, I say what they are saying; nor if I could hear would I tell – 'tis a secret, madam. . . .'[15]

Whether or not the presence of children in paintings such as these can provide a reminder of unacknowledged sexual activity,[16] in this instance Thackeray clearly 'read' the arms folded round the baby in terms of fertility and sexuality. But it is not a question of a simple narrative; there are many strands at work here. Mulready generally declined to offer any verbal explanations for his pictures. The titles do, however, frequently convey an enigma, a mystery that the viewer must unravel. *The Careless Messenger Detected* (XX) or *The Wolf and the Lamb* (XVIII) carry, in their titles, the same solemn biblicalc cadences as the hymns and poems of Isaac Watts. Mulready may not be actually telling us that these are religious parables but the visual and verbal language of the Bible and Aesop's *Fables* was surely a familiar part of his audience's moral education. They would have asked who is the messenger and in what way has he been careless? What will be his punishment? Will he be forgiven? Which is the wolf and which the lamb? Why is the lamb not in his fold? Will the 'shepherd' save the lamb from the wolf's clutches? Will the wolf lie down with the lamb or will hostilities continue?

The title of *First Love* (XXX) is similarly important. If this is 'First Love' we ask ourselves, what is 'Second Love'? Is the harassed housewife who shouts at her eldest daughter from the doorway of her house an indication of what life really holds in store for this besotted young couple. But then could 'First Love' be taken to be the love that the child has for its mother? A Title on its own can, however, only assist the viewer. Mulready's paintings at their best succeed because the composition is so calculated as to reinforce the idea verbally expressed in the title. Our initial reaction to *First Love* might well be one of admiration for its formal qualities rather than for its evocation of mood or suggestion of narrative. Before noticing the uninhibited *rapprochement* of the dogs in the foreground, the jeering boy who reminds us of how the young man might have behaved in a similar situation only a few years earlier, and the maternal role adopted by the girl, we might well look at the balanced group of the

[13] J. Hichberger, 'Military Themes in British Painting', Ph.D., University of London, 1985
[14] H. Taine, *Notes on England*, 1873, pp. 333–4
[15] W.M. Thackeray, 'A Pictorial Rhapsody', *Fraser's Magazine*, 1840
[16] K.H., p. 129

young man and the girl inclining towards each other yet separated by the strong vertical made by the angle of the wall against which both are leaning. The profile of the youth matches that of the girl and the diagonal of his leg corresponds to that of her right arm. Mulready rejected a striking, back view of the girl (strongly reminiscent of that in *Brother and Sister* (XXXVI)) in order to achieve this subtly related group of figures.

The emphasis that nineteenth-century artists placed on the fleeting moment of time instead of the 'timeless function of the potent image' might easily tempt artists into triviality.[17] There can be no doubt that Mulready at times lapsed into triviality; *Now Jump* (66) and *A Sailing Match* (XIX) celebrate moments of no inherent moral value and lack the exemplary significance that might have redeemed them. At his best, however, Mulready sought to unite the timeless image and the fleeting peak moment of narrative. In *The Fight Interrupted* (1816) (XVI), age and experience mediate with reasonableness in an incident of youthful confrontation that reaches its climax in a school playground beneath the most primitive timepiece and reminder of transience, the sun dial. On the pump as a further reminder of temporality are carved the names of other boys who have passed through the playground and among them the artist has included his own initials, a powerful statement of identification. An abandoned cricket bat on the left and a book on the right signify a past and a future in which the protagonists would be otherwise occupied than in the painting's present time.

Despite its title, *The Fight Interrupted* (XVI) depicts the time some minutes after the sober and black-clad school-master has separated the combatants. Whilst he was working on the picture, Mulready described it to Farington as 'Schoolboys separated after fighting'.[18] It is typical of the artist's tendency to universalise that he should have exhibited the painting with a less descriptive title. The action does not, however, lack clarity. The master has one boy by the ear with his right hand, while with the other hand he is about to remonstrate with another boy who, as an observer, is recounting what happened and pointing an accusing finger. This boy is a tell-tale because he deferentially doffs his cap to the teacher and receives a look of loathing from the corner of the combatant's eye.

Another boy, somewhat older, tries to attract the master's attention and points to the other party in the fight who, favoured with the attention of several friends, leans against the pump on the right of the picture one hand holding a painful knee, the other gingerly pointing to his cut lip which is being examined by his friend. Another boy bends in the centre foreground to retrieve coat and hat that have been dropped in the fray.

The master and the boy whom he holds by the ear are on the left of the picture in an enclosed space bordered on the right and the left by the leaning trunks of two great trees and backed by a wall and the ramshackle roof of a shed. Even the trees show signs of wear and the tail of a kite hangs pathetically from a branch testifying to a game that came to a premature end. The tree trunk on the right is the point of intersection of the gesticulating hands of three different individuals. Then there is the hiatus marked by the stooping boy in the foreground and, moving over to the right, a second climax with the group that is bounded on the left by the vertical of the school portico and on the right by the vertical line of the pump. The left hand of the tall boy links the two. The various narrative elements are thus articulated structurally and colour is also effectively used to link the different sections of the picture from the palid boy on the far left to the white sleeve of the suffering youth by the pump on the right.

This is not a straightforward account of the playground bully, a pictorial statement of absolute right or absolute wrong. Mulready presents us with a complex psychological and philosophical situation concerning human nature. Blame is not apportioned, evidence is in conflict and no simple solution is suggested. This is the fight interrupted, an uneasy peace that is likely to be broken before very long. Age and experience can pacify but cannot finally resolve fundamental human conflicts. Through the variety of human expression in the picture and the sensitive use of environment, Mulready endows this incident with a universal significance.

The Careless Messenger Detected (XX), purchased from the

[17] E.H. Gombrich, *Art and Illusion: A Study in the Psychology of Pictorial Representation*, 1960, p. 118
[18] F.D. 8 November 1815

artist by the Earl of Durham in 1821, functions through a similar structure of counterpoise. Here again the composition is framed between verticals and an architectural background establishes a sequence of differentiated planes that correspond to differentiated states of mind, conditions of life and circumstances of action. An explanation of the painting's events is supplied in the annotations made by Mulready's son and others to the catalogue of the exhibition following the artist's death.[19] The careless messenger (or careless nurse as he has been called in the oil sketch that once belonged to John Pye (cat. 107)) is a small boy who has been sent on an errand to buy candles, taking his baby sister with him. On the way home he meets friends at play and puts down his sister who falls asleep grasping a candle in one hand and, with the other hand, the basket containing the remainder of the candles. We can observe the development of the feminine back-laced bodice, bare shoulders and white cap of the study into the central figure of fierce authority in the painting, a figure who wields a cane which only we can see but which the young mother's son fears.

The technique of recording on the face of a child a response to the action of an adult whose face is hidden was established by Mulready in *The Rattle* of 1808 (XIII) and never abandoned. Here he strikes a relentless line across the front plane of the painting with the gesture of the woman's left arm just as he had in *The Fight Interrupted* (XVI) with the extended arm of the central boy. Beyond the figure of the woman, unequivocaly authoritarian in its posture, is a pictorial layer of fragmentation and confusion, both literally in the sense that the woman's body superimposes itself on the childrens' and breaks them up, and metaphorically in so far as the hapless messenger is arrested in motion by fear. Only the largest youth, confident on the threshold of manhood, dares to eye the young woman. Beyond lies the gate into Kensington Gardens[20] where a gentleman quietly passes the time of day with a water-seller and a mother peacefully strolls with her small child in the park. The spheres therefore that Mulready establishes by the planar divisions receding into the background are implicitly separate; the punitive parental force in the foreground (indicating in its faceless presence authority in the abstract as well as in the particular) is not permitted

to impinge upon the genteel leisured security of the background even though that security, without the exercise somewhere of authority, would be seriously threatened by the incipient anarchy of duty abandoned and of play instead of work as presented in the middle plane of the picture.

Reviewing *The Wolf and the Lamb* (XVIII) when it was exhibited in Paris in 1855, Gautier noticed that 'une des plus curieuses peintures' was pictorially effective through its special synthesis of ethnic everyday life objectively seen ('il vous fait sans présentation entrer profondément dans l'intimité du pays') and universally applicable truths ('Ce loup et cet agneau sont deux caractères – Addison ou la Bruyère ne les peindraient pas mieux – et le tableau joue dans son cadre étroit une scène de la comédie eternelle').[21] Gautier was right, Mulready's methods of work were designed to enable him to combine an authentic view of the outside world with the timeless qualities of myth and fable.

Page after page of the artist's notebooks were covered with information concerning colour, glazes, methods and materials. Each exhibited painting was the result of months of preparation not only of technique but also of content. As Palgrave remarked, 'each one appears to be an experiment in advance'.[22] The origin of Mulready's pictorial narrative was sometimes no more than a verbal note. For example a page reads:

Actors
Deaf } Woman diverting her son's attention
Blind } in the ward. Her ready to burst
With a dog who begs of the preacher
Workhouse idea
Hussars attacked by a warrior Bald man
Drunken mechanic } Hat
Asleep whore watching him } Handkerchief'

Jottings like this were then developed by detailed on-the-spot annotated studies in which the artist recorded the most minute details of clothing and physiognomy. He was undoubtedly influenced here by the fashion for physiognomic experiment that had made Lavater's work so popular

[19] South Kensington exhib., 1864
[20] Ibid
[21] T. Gautier, *Les Beaux-Arts en Europe*, Paris. 1855, pp. 19–22
[22] F.T. Palgrave, *Essays on Art*, 1866, p. 128

87. THE INTERCEPTED BILLET, *Victoria and Albert Museum* (cat. 82)

throughout Europe but Mulready's drawings are rarely deductive; and when for example, he became interested in criminal physiognomy, he went to court to make his studies inductively working from the particular to the general.

Attributes and accessories are essential to narrative art and it is only by the same attention to detail that Mulready gave, that we can hope to see his pictures as they would have been seen by his contemporaries. The difference in dress between the errand boy and the school-boy in *A Dog of Two Minds* (1829–30) (63) is the key to an understanding of their different stations and the threat that the one poses to the other. A picture like *The Travelling Druggist* (1825) (77) comes to life by reason of a network of personal attributes. This is plain when we read a description of the picture that was published in 1864:

'The scene is the door of a cottage at which a Turkey rhubarb merchant has halted, and is weighing in a

small pair of scales a modicum of that useful drug which, at its earliest introduction, was believed in even more firmly than it is now. A woman stands inside the doorway, bearing in her arms a hulking and petted boy, whose evident disgust at the dose being prepared for him is exquisitely given. He holds in one hand an unripe pear, and in the other a slice of bread and butter. He has a night cap on his head. By way of moral, there stands in the fresh air, and with a skipping rope in her hand, a hale and hearty girl, as if to show what would be the best medicine for the spoilt boy.'[23]

The detail in Mulready's narrative paintings is not only thoroughly researched but also rigorously controlled. Explicit action tends to be suppressed in favour of evocative mood. In an early sketch for *First Love*[24] a small child tries to attract the attention of his sister by dragging at her skirt while she exchanges endearments with a young man in a doorway. This motif was abandoned in the finished painting in order to leave the central group isolated and intact, its sultry charm threatened only from a distance by the scoffing child. Mulready saved up the image and introduced it into one of his designs for *The Vicar of Wakefield* in 1843 where it appears in chapter XV as pure invention, totally unsupported by any textual reference. In the scene from this novel when Olivia is about to elope, the narrative sequence of events is more important than mood, development more significant than idyll. Here the child is a poignant reminder of the family that Olivia has just deserted.

The particularity derived from Mulready's close observation of the social scene is balanced by a deliberate attempt to universalise the subject, which led F.G. Stephens, the artist's first biographer, to speak of Mulready's ability to impart 'that artistic completeness we see in historical painting' and 'what we may call philosophy' to his works.[25] The participants in Mulready's dramas may be strongly individualised in facial expression and pose but they are frequently anonymous. They are seldom dependent on literary sources and, although Mulready's drawings show

[23] Science and Art Department of the Committee of Council on Education, South Kensington Museum, *A Catalogue of Pictures . . . of the Late William Mulready, Esq., R.A.*, 1864, p. 55
[24] Pen and ink, Whitworth Art Gallery, Manchester
[25] F.G.S., p. 1

him to have studied extensively from life, by the time the figures reach his paintings they have lost their names. They differ thus from the generalised figures by Wheatley, Morland and Bigg and from the great mass of participants in nineteenth-century paintings who have names like Bubbles or The Blind Girl, or emerge from the pages of popular literature to take up temporary residence on the artist's canvas. Even when there would seem to have been a model originally, as with *Father and Child* (1825) (XIV, cat. 109), the finished painting is developed as a more universal statement.

In the best of Mulready's work, the crystalline clarity of detail does not detract from the overall idea (what Stephens would call the 'philosophy' of the painting) nor does it blur the polysemic narrative. The spottiness for which the Pre-Raphaelite painters were criticised was never one of Mulready's faults even though his own brilliant colour and attention to detail inspired the younger generation of artists. In *The Fight Interrupted* we have seen how the artist imposed a structural and thematic unity on his subject. The process by which this was achieved is worthy of closer examination.

Mulready's notes show him to have been much preoccupied with grouping and classifying objects. The notion of universal analogy, a system at work in nature in which each element could be seen to relate, was a commonplace among writers like George Field with whose *Chromatology . . . of 1835* Mulready was certainly familiar.[26] Mulready executed a mass of drawings of a detailed kind relating to objects from nature both animal and vegetable. His notebook contains many jottings revealing his ruminations on the subject of classification and the natural world such as the following:

> '*A well ordered multitude*, one, divided, subdivided and further divisible upon further research. Phenomena, Choice, The Multitude, the group, the man, the face, the eye, the hand, the fingers. The forest, the clump, the tree, the branch, the leaf, as there is a time so there is a distance for all things. The distance which shows the parts of larger things, shows the whole of smaller things.'

Whether or not Mulready is aspiring here to a form of transcendentalism is uncertain but the moral implications,

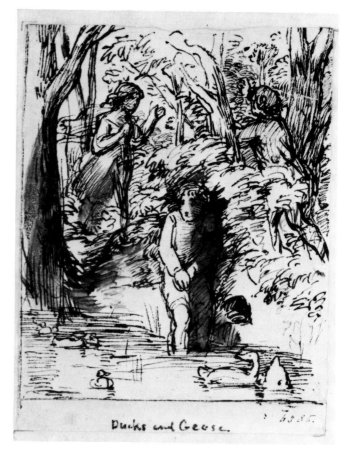

88. DUCKS AND GEESE, *Victoria and Albert Museum*

in the use of words like 'choice', are clear. Natural history and particularly botany was established as a general science of order within the description of the visible; the object of natural history is provided by surfaces and lines, not by functions or invisible tissues. 'The plant and the animal are seen not so much in their organic unity as by the visible patterning of their organs. . . . Natural history traverses an area of visible, simultaneous, concomitant variables without any internal relation of subordination or organisation.'[27]

Mulready's studies were essential to the construction of narrative, the imposition of order in the visual field. He recognised that the many-stranded narrative scene requires the promotion of an incident as central, and that the success of a subject which seeks to balance the

[26] It is listed in his notebook, Victoria and Albert Museum
[27] M. Foucault, *The Order of Things* (*Les Mots et les Choses*, 1966), 1970, p. 137

universal and the particular depends on the controlled reiteration of image and idea, a process of repeating motifs with variants and underlining the way in which categories can be understood as part of a general idea (see cat. 138). And it is at this point that a concern with narratives involving children and his life-long study of the nude can be seen to intersect. As Ruskin clearly recognised, Mulready's Life studies constituted a branch of Natural History. 'You are to study men not lice and entozoa,' he exhorted his readers, drawing attention to Mulready's drawings as examples of the most degraded and bestial forms of art.'[28] Ruskin's hostility suggests that he felt his beloved natural sciences were in some way at risk from Mulready's analytical approach to a genre that must have represented, for a man of Ruskin's personal history, a particularly difficult object of aesthetic attention. Mulready's *The Bathers* of 1848–9 (cat. 144) puzzled reviewers by its failure to present to the viewer a single face in its entirety;[29] it is a painting in which Mulready can be seen to construct a class (hairwashing, bathing babies, games in the water) exclusively for the purposes of examining its members from different angles in its surface variety. Here we have the one and the many arranged into a composite display: the specimen nude, examined with microscopic precision in the studio, but subsequently removed to its 'natural' habitat as the ornithological draughtsman used to represent the bird, drawn in scientific detail from its dried skin. *Bathers Surprised* (96) plays off a single nude in the foreground, the type, against a mass of fragmented bodies in the background (cat. 145). And the large drawing of women bathing in the National Gallery of Scotland is executed on several pieces of paper stuck together revealing the technical apparatus associated with this process of assemblage.

Comparing sketches with finished paintings we can often see Mulready as well as assembling, refining and concentrating in order to achieve this balance between the central incident and the narrative implications, between the individual observation and the general idea. The chiaroscuro sketch for *The Butt* shows the basic composition already complete.[30]

The protagonists are not fundamentally changed in the next stage which is the watercolour study (142) or in the finished painting (143) but other features in the composition are radically reorganised. In place of the little girl holding a hoop and seen from behind in the foreground, Mulready introduces the figure of a much older girl kneeling facing the viewer and, behind her, another girl peeping over her shoulder. An earthenware jug, on which the marksman places his ammunition, is placed in the foreground on the left and a dog is introduced on the right. The effect of these changes is to tighten up the composition and heighten tension. Both boys are seen in profile, one with his mouth screwed up in concentration, and his arm thrust forward with muscles tensed, the other with his mouth wide open, his elbow drawn back and his fingers splayed. The 'S' curves of the boys' backs, one dark and the other light, form two sides of a vessel shape, the very shape, in fact, of the earthenware jug in the foreground. The girls' merriment heightens the effect of the boys' concentration and, by showing the girls full face, Mulready is able to establish a circle of directed gaze. Thus the boys stare fixedly at each other, the girls in a gender determined arrangement look at the butt and the dog gazes impassively at the marksman.

Mulready's most effective narrative subjects are constructed according to a strict principle of pictorial order. In *The Widow* (XXII) the idea of money and in *The Convalescent . . .* (XXVII) the idea of war knit together the disparate parts of the narrative through reiterated images. In *The Wedding Morning* (75) the dominant class of imagery is concerned with clothes, a rich terrain for classification.[31] The mother adjusts the bridegroom's collar and his little sister tries to do up his buttons while his young brother explores his pockets. Nearby the open drawer of a work-table displays all that is necessary for mending and sewing. On the right the father with an air of scepticism examines his hat and the festive garments that spill out of a trunk onto the floor. Thus the subject of a young man and his family making preparations on the morning of his wedding (the inverse of the traditional representation of the bride

28 J. Ruskin, 'Val d'Arno', 1874, *The Works*, XXIII, 18
29 *Art Journal*, 1849, p. 168
30 Victoria and Albert Museum, 6303
31 Clothing is one of the systems chosen by Barthes to interrogate Saussure's simple distinction between *langue* and *parole*, R. Barthes, *Elements of Semiology* (1964), New York, 1968, p. 25 passim

at her toilet) is narrated through unity of design achieved by thematic coherence.

In *Lending a Bite* of 1834 (76) the thematic coherence is established through a taxonomy of mouths; the main action takes place in the middle plane where one youth nervously and with considerable reluctance allows another boy a bite of his apple. The drama of suspicion and determination is simultaneously enacted on the foreground plane between a dog and a monkey. The composition is striking: a vertical division cuts the painting in half. On the left the owner of the apple has elbows drawn back, mouth open, fingers tightly clutching his apple. On the right, the hungry boy presents the reverse image with thrusting body and splayed fingers. The matrix of the picture is the centre left where the serpentine line of heads and backs that runs from the tail of the dog to the head of the baby, who sleeps in his sister's arms in the background, terminate. Here are seen in a relatively small area four expressive mouths. The baby's is open as he peacefully sleeps ignorant of the scene, so are those of the two boys. The girl smiles serenely. The open mouths convey the theme of the painting which is less a story than a situation and, in case there were any danger of our ignoring them, Mulready depicts two large open-mouthed earthenware vessels hanging from the arm of the hungry boy.

This overall unity of imagery, a unity established by the enumeration of parts and the systematic demonstration of visible similarities, ensures a sense of decorum which, in itself assists the 'reading' of the picture. Perhaps Addison and La Bruyère would not, after all, have been displeased had they heard the name of William Mulready linked with their own.

SECTION IV
DIALOGUES AND TRANSACTIONS

'We must learn to read pictures and nature as others read books', David Wilkie, quoted by J. Burnet.

126

THE VILLAGE BUFFOON, 1815–16
Oil on canvas, $29 \times 24\frac{1}{2}$ in
Royal Academy, London (XXIII)

The dialogue is between an old man of means – notice his silver tipped cane in the foreground – and a poor young woman. It was Mulready's Royal Academy diploma painting and Wilkie was called upon to explain to the Council what the subject was, suggesting that Mulready's narrative technique with an absence of literary text, was already difficult for his contemporaries to 'read'.

127

D. WILKIE
THE REFUSAL from Burns's DUNCAN GRAY, 1814
Oil on panel, $24\frac{3}{4} \times 20\frac{3}{8}$ in
Victoria and Albert Museum (65)

This painting by Mulready's friend, David Wilkie, provides a complement and a contrast to *The Village Buffoon*, 126. Based on a literary source, it shows a foolish young woman rejecting the advances of a worthy suitor for whom Mulready was the model.

128

THE WIDOW, 1823
Oil on canvas, laid on panel,
$27 \times 31\frac{1}{2}$ in
Sir Richard Proby (XXII)

This painting was not sold until many years after it was completed and exhibited. It was accompanied by a quotation referring to the Dame of Ephesus, a character in the *Satyricon* of Petronius who was seduced while in mourning for her husband. Ruskin, who thought the subject risqué, was probably voicing popular opinion when he complained that the subject was unfit for representation. John Varley is alleged to have sat for the figure of the suitor. The transaction that is underway in this well-furnished parlour, and which is evidently strongly disapproved of by the widow's maid and her eldest daughter, is both monetary and sexual and is underlined by the shop scene in the background where money can be seen changing hands across a counter.

129

THE WIDOW, 1823
Oil sketch on panel, $5\frac{1}{8} \times 6\frac{1}{2}$ in
Private collection (59)

This work is mentioned in a letter to Mrs Leckie dated Capheaton, Jan. 1846: 'The sketch for the picture of The Widow is much more curious and more valuable than *Margaret of Anjou* from Scott's *Anne of Geierstein*. There are dealers who would get fifty or sixty guineas for it. If anybody offers forty, take it.' MS. collection of Brian Stone, Esq. In the event Mrs Leckie appears to have decided not to sell.

130

LENDING A BITE, 1819
Oil on panel, 30×26 in
Private collection (76)

Painted for the Earl Grey, the work is first recorded in Mulready's account book in 1818, deleted; in November 1819 it reappears with the following reference: 'Nov. 6 Earl Grey Lending a Bite £210 half done in 1818 but entirely repainted.' Mulready makes effective use of profile and the transaction with the apple so cautiously dealt with in the foreground is reiterated both in the group partially seen in the complex gap between the pair of protagonists and in the figure of the girl by the well. In this gap six hands are seen in a small area. As so often with Mulready, the woman and female children play a supportive role in dialogues between male

children. The fragmented mid-ground figures look forward to *The Careless Messenger Detected* of 1821, 106, while the house and the pump look back to the early cottage subjects.

131

GIVING A BITE, 1834
Watercolour, $14\frac{1}{2} \times 13$ in
Ulster Museum, Belfast (XXIV)

In this replica or study for no. 132, the vignette format of the composition is clearly revealed and the loose and very expressive use of watercolour is apparent.

132

GIVING A BITE, 1834
Oil on panel, $20 \times 15\frac{1}{2}$ in
Victoria and Albert Museum (XXVIII)

Panel provided a smooth surface ideal for the fine effects and thin but brilliant paint layer in which Mulready excelled. He had begun working on panel as a young man producing a Dutch inspired matt surface; he continued to use this support but with very different effects in his later work. This is a repeat of no. 130 executed for John Sheepshanks and incorporating distinct changes. In particular the built-up environment is transformed into a lyrical rural setting and the introduction of a monkey lends the scene an air of quaint fiction removed from the somewhat documentary and prosaic but nevertheless charming atmosphere of the 1819 version. Here are thinly laid pigments, feathery brushstrokes and more than a feel for Gainsborough. The sharp impact of the boldly defined composition of 1819 gives way to suggestive imprecision and a welter of additional detail.

133

THE FIRST VOYAGE, 1833
Drawing, 19×24 in
Anthony Mould Ltd., London

This is a finished preparatory study for the painting now in Bury Art Gallery. From the early 1830s Mulready began to set his scenes in generalised country settings and to introduce monumentalised figures such as the

very classical looking boy and girl on the right. The child's 'first voyage', an irony is surely intended, takes place in a tub across a pond.

134

CARGILL AND TOUCHWOOD, 1831
Oil on panel, $20\frac{3}{4} \times 16\frac{1}{2}$ in
Yale Center for British Art

On the relatively rare occasions when he portrayed scenes from popular literature – this is based on Scott's *St. Ronan's Well* – Mulready chose to emphasize the quality of dialogue. The work has the slightly archaic quality of a conversation piece that is consonant with the period flavour of the novel. Interestingly at the point in the novel that Mulready chose to portray, Scott adopts a passage from Butler's *Hudibras*. Mulready used this passage as an accompaniment to the painting when he exhibited it at the Royal Academy in 1832. Thus the painting of a literary conversation encapsulates a literary source within a second literary source. The discourse of reading and communication, as it functions in the pictorial and in the verbal media, may thus truly be said to constitute the basis of the work. It was purchased by Lady Swinburne for £157–10–0 and the same year it appeared as the frontispiece to *St. Ronan's Well* in the first complete illustrated edition of Scott's novels published by Cadell. Many artists were employed on this series including the photographer David Octavius Hill, Landseer, Wilkie, C.R. Leslie and Webster. Mulready was also responsible for illustrating *Anne of Geierstein*. A letter from Mulready to Henry Graves, the engraver, dated 29 December 1831 and requesting return of his frame, MS., National Library of Scotland, 2255/80, suggests that Mulready gave Graves the actual oil painting to work with rather than a drawing or preparatory study and also that the decision to engrave was taken before the painting was exhibited. Probably it was executed with the engraving in mind in which case its appearance at the Royal Academy would have provided Cadell with welcome publicity. Mulready received

£25 for the copyright. Cadell re-issued Mulready's designs in the grand Abbotsford edition of the Waverly novels published between 1842 and 1847 and commissioned from the artist also a series of seven illustrations to *Peveril of the Peak*. Paintings or, at least, finished studies of all these subjects were formerly in the Swinburne collection but are now missing. Also, missing are oil on panel paintings of *Margaret of Anjou* from *Anne of Geierstein*, *Edith Plantaganet* from *The Talisman* and several subjects from *Peveril of the Peak*.

135

OPEN YOUR MOUTH AND SHUT YOUR EYES, 1835–8
Oil on panel, $12\frac{1}{2} \times 12$ in
Victoria and Albert Museum (XXIX)

A fine example of Mulready's mature technique – brilliant pigment over a white ground – this is another painting based on a childish game involving oral satisfaction, see also 130–2. Here, however, the protagonists are a young man, accompanied by a baby, and a nubile girl with exposed shoulders. The image undoubtedly possessed explicit erotic overtones for a contemporary audience and is a reminder of the risqué connotations of games as they occur in a literary narrative tradition, as for example, in the Hunt the Slipper scene in Goldsmith's *The Vicar of Wakefield*. There seems no doubt that the erotic content was very deliberately produced by the artist who possessed a clear understanding of his audience, and of the operation of desire with regard to ownership of paintings with suggestive imagery such as this. See, particularly, his own statement in his private notebook, 77, transcribed.

136

FIRST LOVE, 1838–9
Oil on canvas, $30\frac{1}{2} \times 24\frac{1}{2}$ in
Victoria and Albert Museum (XXX)

Here the intimacy and stillness of the young couple – their rapprochement imaged in the affectionate meeting of their dogs – are harshly contrasted with the jeering boy and shouting

mother. As with many of Mulready's paintings, the titles signal complex layers of narration. Is 'First Love' the love of the child for its mother or of the youth for the young woman? If this is 'First Love', what is second love? The boy suggests what the young man has been and the housewife implies what the young woman will become. Thus within the pictorial imaging of a moment are suggested both a past and a future as well as a present that is all too fragile.

137

CARTOON FOR FIRST LOVE, 1838

Red chalk, $7\frac{3}{8} \times 5\frac{1}{2}$ in

The Visitors of the Ashmolean Museum

In this exquisite chalk drawing Mulready worked out in an absence of colour but with an emphasis on chiaroscuro the precise narrative construction of his painting.

138

DRAWINGS, c.1828

Whitworth Art Gallery, Manchester

Mulready observed with close attention the characteristic clothing and gestures of people in the streets of Kensington and Bayswater. These drawings and their accompanying notes display a concern with taxonomy that is precisely in accord with Mulready's systematic exploration of the visible world. They are typical of the mass of reference material that he accumulated for use in his subject paintings.

D121.i.1895. In this sheet Mulready identifies the worker not only by clothing such as 'leathern aprons *but by the colour of his dirt . . .*'. Paviours, he notes, have sandy dirt about them. 'The working Navigator is also the same kind of fellow but his dirt is redder – more clayey.'

D121.v.1895. This sheet contains notes on the uniforms of the London Charity schoolboys. 'The charity boys of London are another class affording strong shows of contrast, but not so much as the former', ie bargemen of Staffordshire. 'One or two schools wear Brown Drab. One school wears green cloth . . . like

the Blue Coat Boys . . .' Mulready's *The Dog of Two Minds*, 1829–30, Walker Art Gallery, Liverpool, shows a confrontation between a schoolboy in uniform and an errand boy. Blake had drawn attention to the hypocrisy surrounding the creation of the charity schools in 'Holy Thursday' in *Songs of Experience*. Later in the century Dickens created the unforgettable Rob the Grinder in *Dombey and Son* as an example of the child whose charity school uniform exposed him to intolerable taunts and whose education led him into bad ways. (64)

D121.vi.1895. The upper part of this drawing suggests that Mulready asked the child in the Mall, see no. 22, whose name is recorded as Tommy West, to take off his outer clothes. The detail of 'very large loose shoes tied round his ankles with pack-thread' is especially poignant.

139

THE WHISTONIAN CONTROVERSY, 1844

Oil on panel, $24 \times 19\frac{1}{2}$ in

Lord Northbrook (XXXI)

It is part of the irony of Goldsmith's *The Vicar of Wakefield* that the vicar who is such a passionate advocate of matrimony unwittingly causes the break-down of his own son's marriage plans by insisting on an abstruse theological debate with his son's future father-in-law. The interior scene is reminiscent of Wilkie's *The Letter of Introduction* and earlier Hogarthian conversation pieces. We are required to 'read' the implications of the dialogue by engaging with the nervous response of the vicar's son as he enters the room. The elderly disputers and their dusty volumes, prominently stacked in a still-life composition in the foreground, contrast sharply with the freshness of the youth's face.

140

CHOOSING THE WEDDING GOWN, 1844

Cartoon, red chalk, $20\frac{1}{8} \times 17\frac{1}{2}$ in

The Lord Northbrook

It was Mulready's habit to work out in detail in chalk the compositions of his finished oil paintings. Whilst these are not in the strict sense cartoons, refined drawings like this served a similar purpose.

141

CHOOSING THE WEDDING GOWN

Oil on panel, $21\frac{1}{4} \times 17\frac{3}{4}$ in

Victoria and Albert Museum (XXXV)

This work and nos. 139 and 163 are based on designs for Van Voorst's 1843 edition of *The Vicar of Wakefield*, 164. The theme of transaction in the shop interior that Mulready so much enjoyed is here explored on several levels and sanctioned by the popular literary source in which the scene is recollected rather than presented as actuality. It did not, therefore, provoke the kind of adverse comment that greeted *The Widow*, 128. Moreover, whilst the vicar, according to Goldsmith, chose his wife with the same care as she chose the material of her wedding gown, the commodity exchange is enshrined within the institution of marriage. Brilliant in colour and execution – the bunch of snowdrops is particularly worthy of attention – the painting attains its consummate narrative effect through a sequence of controlled looks and gestures. The shop-keeper looks at the vicar, the vicar looks at the future Mrs Primrose and she looks at the cloth she is about to purchase. In the background a more mundane dialogue takes place between a boy whose pocket is stuffed with shopping and the shop keeper's wife.

142

THE BUTT: SHOOTING A CHERRY, 1847

Watercolour, $9\frac{3}{8} \times 11\frac{1}{4}$ in

Glasgow Museum and Art Galleries (XXV)

Here Mulready turns again to the profile and type opposed to countertype that he had used so effectively in *Giving a Bite* and *Lending a Bite*, 130–2. Thus the left-hand boy's mouth is closed and the right-hand boy's is open; the boy on the left advances his right arm and the boy on the right draws back his left arm. The game, which is also a transaction, becomes the rationale for a refined study in physiognomy and expression while the mood is set by the laughing girls and patient dog who are assigned the role of passive observers.

143

THE BUTT, 1847–8

Oil on canvas, $15\frac{1}{4} \times 18$ in

Victoria and Albert Museum (XXVI)

Mulready worked on this canvas when he was staying at Capheaton as the guest of Sir John Swinburne. According to F.G. Stephens Linnell found the canvas with a hole in it and much dust on the surface and persuaded Mulready to repair and complete it. This suggests that the origins of the painting lie at a much earlier date but the account book gives no confirmation of this.

144

THE BATHERS, 1848–9

Oil on millboard, $18\frac{1}{4} \times 14\frac{1}{8}$ in

The Hugh Lane Gallery of Municipal Art, Dublin

Mulready's reputation for Life drawing was unparalleled in Britain at the time of his death. He worked regularly from the Life both at the Academy and at an independent Life class which he helped to establish at a private venue in Kensington, see 91. This painting represents a rare essay in oil in the same genre. Whilst study of the nude undoubtedly constituted for Mulready a form of professional discipline and a way of developing both his capacity for observation and his powers as a draftsman, it should not be seen as separate from the rest of his work. The single figure seen from behind, cf 114–116, like Ingres's Valpincon 'Bather' invites speculation. But unlike Ingres's nude she is incomplete. The narrative of the background only reinforces that fragmentation. Here are events that are never completely realised and a major figure that can never be adequately examined.

145

BATHERS SURPRISED, 1852–3

Oil on panel, $23\frac{1}{4} \times 17\frac{1}{4}$ in

National Gallery of Ireland (96)

Mulready's debt to Titian's *Venus Anadyomene* must have been evident to contemporary viewers. The surprise is presumably caused by the impending arrival of a male spectator. Yet the central viewer engages with a spectator off stage to the right who, given the Venus reference, must surely also be male. The wholeness of the foreground figure in her seated tranquillity is offset by the confusion and fragmentation behind and around. Only the idea of the invisible male presence unites the composition. The disjuncture between foreground figure and background composition suggests interesting comparisons with the narrative paintings in which an exciting tension is generally maintained between the object to be gazed upon, frequently painted with great elaboration, and the narrative connections to be made.

CHAPTER V
RURALISM AND ITS DISCONTENTS

This chapter attempts to recognise and to define what is happening in a series of works by Mulready that deal with rustic themes; that is with works that project a view of the countryside and present images of individuals who are, whether by virtue of clothing, demeanour or occupation, in some sense identifiable as rural. Recognising the dichotomy between town and country, examining the development of a Victorian rural mythography, have been the object of widespread research over the past twenty years. In the work of writers like Raymond Williams, Eric Hobsbawm and G.E. Mingay a vast amount of archival research begins to enable us to challenge long-received notions about rural life. The overwhelming problem of what might be the relationship between a sequence of images of rural life, the dominant urban *idea* of rural life and the experience of those living and working in the countryside remains.[1]

In the case of Constable whose paintings largely depict named places and who writes eloquently about his own roots, a viable way of interrogating imagery through factual data has been established.[2] Unlike Constable, Mulready moved from the particular named locations of his early landscape to an imagery of the countryside that is non-specific yet overpowering in its insistence upon a rural identity. Whilst the upland scenery that recurs in paintings like *The Sonnet* (XXIV) and *Brother and Sister* (XXVI) probably derives from the Northumbrian landscape associated with Sir John Swinburne's residence at Capheaton, it is conventionalised to such a degree that it does not offer clues of a biographical nature. He was a Londoner producing paintings of rustic scenes for an essentially urban audience.

A variety of ways forward are possible. We might ignore the facts of agrarian history in the nineteenth century and treat Mulready's oeuvre as an enclosed system of representation; in this case we would notice that his early drawings of single rustic figures in the Georgic mode, whether buxom market girls or barefoot beggars (89) develop into compositions that are indebted to his immediate predecessors. Wheatley and Morland come to mind when we look at *Horses Baiting* (19) or *A Gypsy Encampment* (15) as well as Dutch artists like Wouwermans. From these there then evolves a type of painting in which large-scale figures (often in poses that are indebted to Michelangelo or Classical sculpture) appear to be engaged in what might be regarded as trivial pursuits against a landscape backdrop. This account would be predicated on the assumption that Mulready knew nothing of agrarian history and that it had no relevance to his work.

A second way forward would posit a general overall knowledge of the outstanding areas of problem and anxiety which rural life raised for an urban audience. Evading the question of regional difference – the fact that what is true for one county of England at this period is almost never true for another and there are enormous fluctuations in employment levels and other conditions across the country – we would devise a general 'consciousness' that the informed city-dweller might be expected to possess. This in itself is, of course, immensely difficult since any such notional person can only have had, at best, a fragmentary and partial view and if we turn to poetry and novels for evidence of what that might have been we are measuring one fiction against another.

However, supposing that we do identify a 'view' of the rural, something akin to a period eye, what would it contain? Certainly employment, poverty and the administration of the poor law would be insistently present. It would also have to include issues such as winter unemployment and the sexual division of labour. Also present would be illiteracy, social relations, marriage and morality, community, rights to common land and the game laws, relations between employers and farm labourers and the administration of the parish.

[1] Pace John Barrell who has pioneered the serious consideration of this and to whom I am indebted for some helpful discussions concerning the matter of this chapter
[2] See M. Rosenthal, *Constable, the Painter and his Landscape*, New Haven and London, 1983

It is not possible in Mulready's case to demonstrate that he *knew* any of this (his letters are confined almost exclusively to domestic topics) but we can assume that he possessed a period consciousness, at least at some level, of the problems of the rural poor and the issues that were endlessly debated. The 1834 poor law, after all, affected the whole working population. The corn laws and the debate over grain prices were of intense concern to both the rural and the urban poor. Mulready had lived through the depression following the Napoleonic wars and the fluctuating economy of the early 'thirties and was, when he was working on some of his best-known rural subjects, experiencing in common with the rest of the population the prolonged depression of 1837–42. As J.F.C. Harrison puts it: 'It is hard to escape the impression that very large numbers of people in the 1840s were completely bewildered by the environment in which they found themselves.'[3]

If we assume a degree of awareness of conditions and issues that derives not from late twentieth-century social history but from what people thought at the time was important, we can address the problem of an art that offers a vision at odds with that record. To say just how and to what extent it is at odds would require a whole book rather than a chapter but (taking again the trajectory of Mulready's oeuvre) we can point to the apparent insistence on a basic documentation that is at work in the *Interior of a Herd's House at Mounces Knowe* (25) (a Northumberland location) dated 1814. Like Wilkie at a comparable date Mulready is concerned to record ethnic detail in a way that was to become enormously popular in the work of Landseer and which must owe some inspiration to Scott and Burns. One suspects that this drawing was the record of a rare experience of the inside of a cottage from an artist who specialised in the appearance of the outside of cottages in the early stages of his career. *Interior of a Herd's House . . .* includes many features that reappear in *Interior of an English Cottage* (XXXII); notice for instance the storage rack above the window which here appears merely as a useful part of the furnishing but which in the later painting is instrumental in producing a claustrophobic overhung structure. The picture to the right of the window reappears, so does the cradle and the fireplace.

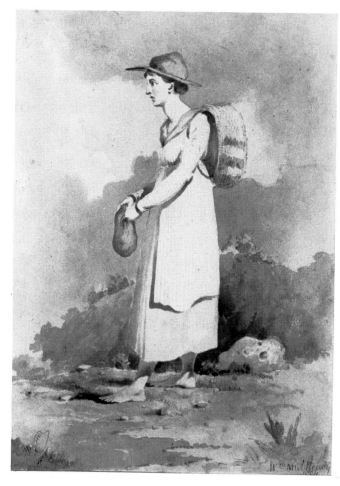

89. A MARKET GIRL, *private collection* (cat. 146)

It is significant that the Herd's interior is empty; it is treated as a still life and one might reasonably conclude that this act of separating the environment from the rural inhabitant was an essential stage towards the production of Mulready's rural imagery. The presence of the herd himself, muddy and uncouth, let alone that of his undoubtedly numerous family would have fractured the process of mythography. The same point might be made with reference to *A Shepherd Boy and Dog* (91) of 1828.[4] Here a beautiful boy, a Corydon or a Thyrsis, slumbers on a high plateau watched over by his faithful hound.

We can point to *The Sonnet* (XXXIV) of which the thematic pivot is an act of reading taking place in a

[3] J.F.C. Harrison, *Early Victorian Britain, 1832–51* (1979), 1984
[4] Watercolour, $9\frac{3}{4} \times 6\frac{3}{4}$, location unknown, ex Haldimand collection. This is probably a repeat of the painting of the same title, also missing, oil on millboard, c.1809, formerly collection of John Jefferies Stone

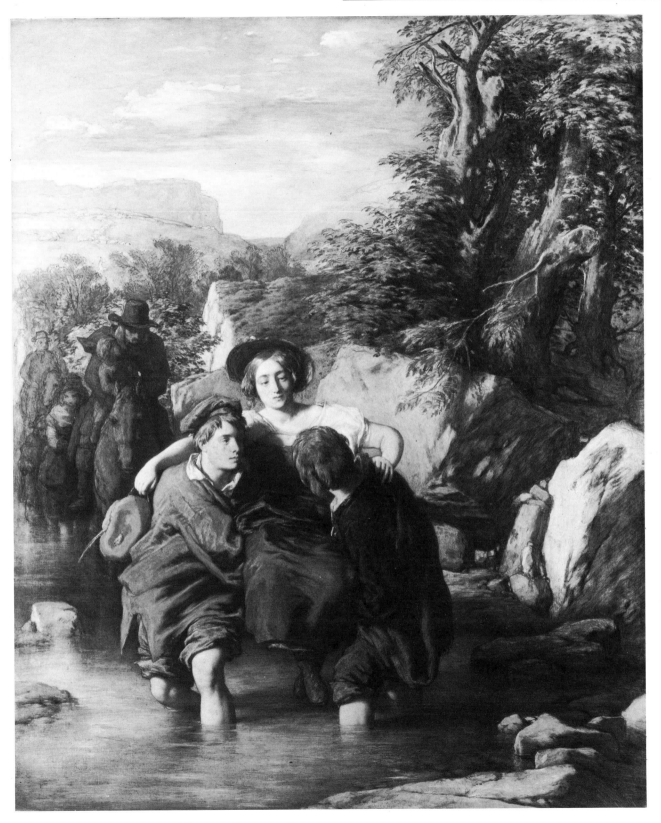

90. CROSSING THE FORD, *Trustees of the Tate Gallery* (cat. 162)

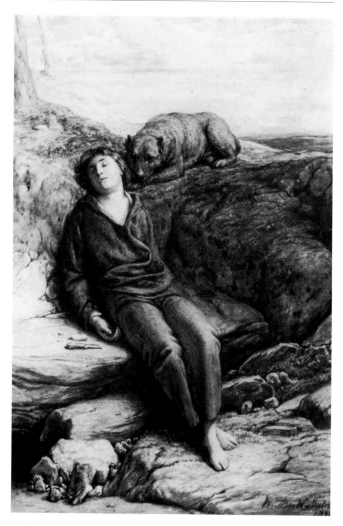

91. A SHEPHERD BOY AND DOG, *location unknown*

beautifully deserted rural setting at a date when illiteracy among servants and labourers was around sixty-three per cent.[5] Of course, what is interesting here is how this very discrepancy is a way of underlining the fact that the subject of *The Sonnet* is not a labourer or a servant.

So if Mulready's vision of the rural is at odds with the facts of rural history, what can be concluded about his project? Is he culpable of deliberate occlusion, distortion or limitation? Are his paintings not really about the rural at all but are philosophical essays on the time-honoured relationship between Art and Nature. Could this be an explanation for a sequence of paintings: *The Last In* (XVII), *Interior of an English Cottage* (XXXII) and *Interior: An Artist's Study* (95) where nature is hypostatised as a framed encap-

sulation in an interior whose occupants are indifferent to it? Is Mulready, in fact, representing a different kind of truth? Is he rather recording how an urban population constructed its idea of the rural in a radical-conservative response to anxiety? Radical because it is artistically innovative and conservative because in its archaising forms and its visible stasis Mulready's art denies the contradictions that the passage of time reveals. It seems unsurprising, in the light of this proposition, to discover that *The Sonnet* was selected to be presented as a *tableau vivant* along with Delaroche's *Lady Jane Gray* at the conclusion of a performance of *Cinderella* in 1855.[6]

All these questions must be answered in the affirmative. Mulready's presentation of the rural functions in many differing ways. We have, therefore, to understand the specific 'questions' which a painting by Mulready addressed even though those 'questions' may not be visible in its agenda and we have to understand the attempted solution. We have to understand 'the senses in which the work formed a dialogue with its own history'.[7] The notion of literacy in *The Sonnet* (XXXIV) presupposes an understanding of how an ability to read and write in a rural setting in 1836 is a way of unequivocally categorising and identifying the subject as not part of a problem group of the population and fixing it in an essentially literary convention. The irony within the painting's communication is produced by the idea of a difficult and refined courtly verse form being written by a country lad for the delectation (or as it turns out, embarrassment) of his girlfriend. It is an irony that is literary both in the sense that it is a literary convention that is the subject matter of the painting and in the sense that the cause of the emotion is not accessible to us in the pages of the poem or the note book from which it has been evidently plucked. The fact that the sonnet was an unfashionable verse form which Wordsworth found it necessary to defend reinforces the declaration inherent in the imagery that we are dealing with something very English but not very actual. The

[5] See K.D.M. Snell, *Annals of the Labouring Poor, Social Change and Agrarian England 1660–1900*, Cambridge, 1985, p. 36; I am much indebted to this book throughout this chapter

[6] Programme from the Theatre Royal, Melton Mowbray 22 February 1855, collection of Mrs. Everel Wood

[7] K.D.M. Snell, op. cit. p. 375

feathered hat and richly coloured, but in terms of fashion, unspecific dress as well as the figures' poses that echo but do not precisely replicate Michelangelo's Jeremiah and Jesse in the Sistine ceiling are part of the same build-up of a process of recognition and evasion which stalwartly denies the documentary.

For a painting like *The Sonnet* to succeed in the market it was necessary that it should hypostatise the rural. *The Sonnet* brings together Love, Poetry and the Countryside in a happy medium somewhere between arcadianism and realism. The interest at the time in the peasant poets John Clare and Robert Bloomfield was a predictable development given the association between the rural and the poetic established in Goldsmith's *The Deserted Village* and the poetry of Burns and reaffirmed by Wordsworth and Coleridge in the Preface to the *Lyrical Ballads*. Nor should we forget the tradition of rustic courtship made popular by Gainsborough to whom Mulready is heavily indebted, especially in his depiction of the female rural type. The faces of the girls in the Victoria and Albert Museum *Giving a Bite* (XXVIII) and *Crossing the Ford* (90) and the mother in *The Toy Seller* (58) are very similar to the representations of young women in fancy pictures by Gainsborough.

The Sonnet (XXXIV), for its contemporary audience, thus connoted the real divorced from the problems that any form of denotation would have involved and associated instead with a set of literary and pictorial conventions that re-asserted to a troubled age the viability of the Pastoral. It is a faux-naive form produced like all Arcadian and Pastoral art by highly sophisticated technical devices: the transparent pigment over a white ground and the system of visual reference to High art. It reminded contemporaries of 'the magnificent genius of Michelangelo in the Sistine Chapel' and the designs of Raphael.[8] In political terms it may be seen as a mode of self-preservation through the obliteration of difference. Always uncomfortable with the faces of mature sexually conscious men – and we may draw a comparison here with *Open Your Mouth and Shut Your Eyes* (XXIX), *Brother and Sister* (XXXVI) and *Interior: the Artist's Study* (95) – Mulready produces an image of extraordinary closure in which the very freedom of drawn line so clearly visible beneath the paint surface and the alluring openness of the rocky upland plateau is no sooner offered

than it is instantly denied by the self-preoccupation of the figures and their rude yet eloquent gestures.

The introduction of water into the foreground of *The Sonnet* (again a recurrent feature with its roots in the early cottage subjects) may signify more than merely the rusticity of the location and the presence of the elements. It may also imply the medium of self-contemplation. Hanging his head the young man is able not only to search for signs on the face of his companion but could, if he so wished, also see his own face. In narcissism the subject and the object are one, difference is negated and unity achieved. The invocation of narcissism in a scene of courtship, a scene which underlines through narration and treatment gender differences (the young man is the creator and the woman receives his act of creation; he solicits and she passes judgement like some latterday Aphrodite) is challenging. It is not, however, an inconsistent feature in a scene of courtship. Indeed narcissism is legitimised by the recurrent self-reference that is a characteristic of those shepherds who sing in Virgil's *Eclogues*.

The self-preoccupation of the participants in Mulready's rustic drama *and* the suggestion of a sentimental sexual communication in nature both play with notions of unity and the idea of an organic society that were central to high Victorian cultural production. This unity, which is achieved through a narrative of difference, is reinforced by visual metonymic connections between, for example, slabs of flat topped rock in the background and the slabby back of the young man, between the feather in his hat which he has placed by his side and the woman's passionately crimson gown of whose colour it partakes.

The Sonnet (XXXIV) is one of a series of archetypal depictions of a man and a woman in a rural setting, sometimes accompanied by a baby which is the accepted visible sign of that sexuality for which there was no public language.[9] The erotic undertones of *Open your mouth and shut your eyes* (XXIX), *Crossing the ford* (90) and *Brother and Sister* (XXXVI, 61) in both its versions are all the more powerful for being less explicit than *The Sonnet* (XXXIV) or the eighteenth-century costume piece *Haymaking* (XXXIII) from *The Vicar of Wakefield* in which Burchell courts

[8] *Art Union*, 1839, p. 81; *Athenaeum*, 1897, 5 March 1864, p. 338
[9] K.H., p. 129

Sophia in the timeless setting of the harvest field, redolent of associations with fertility and fruition. In *Crossing the ford* (90) (which is itself reminiscent of the rescue in chapter III of Goldsmith's novel) the young woman is carried across the water by two young men, a rural version of the courtly Renaissance topos, used again in a key scene in Hardy's *Tess of the d'Urbevilles* where Angel Clare carries Tess across a muddy farm-yard. The young woman carries the hat of one of her swains and gazes into his eyes while the competitor stares into his. The eroticism that was so unacceptable in *The Widow*[10] is beyond criticism when translated into these rural narratives. It is the rural that both conveys the erotic and at the same time sanitises it, draws it into an acceptable cultural system, part of a pattern of increase and prosperity. Here are no reminders of monetary transactions, no overt signs of class and status. The narrative of sexual union is mythicised through the medium of nature.

That Mulready associated the rural and the erotic is clear from the genesis of work never executed. A sketch labelled *Ducks and Geese* (88)[11] depicts a man hiding in undergrowth on a river bank and witnessing the passionate meeting between a man and a woman. The title suggests he was thinking in terms of mating on a basic animal level but the treatment of the theme is a reminder of that paradisal innocence that was lost with the Fall. In *Paradise Lost* Milton, himself an exponent of the Pastoral, makes Satan's sexual jealousy a key factor in the unravelling of the story. The theme of the third party, which was to become a subject explored by Ford Madox Brown and by the Pre-Raphaelites, is also apparent in another drawing in which a woman in a chemist's shop clutches a note in one hand and with her other holds her abdomen while lovers are seen embracing through a window (86).[12]

But the bitter consequences of erotic love as well as its overt physicality are always expunged from the final paintings. The ink sketch for *Brother and Sister* (62) shows a heavily hatched black male figure whose knee is raised to wedge the woman's body which he touches with his left arm while his right swings over her head entirely encompassing her. In both versions of the painting (XXXVI, 61) the man's pose is made more decorous and less sexual than in the sketch. Whilst the function of the knee is retained

in the form of a log in one version and a rock formation in the other, the displacement onto a natural object removes the libidinous act onto the level of metaphor. In the paintings the eroticism is concentrated onto the figure of the woman whose dress is not only inadequately laced[13] but has slipped off her left shoulder. The baby (the brother we may assume) whose ear is being tickled by the young man is the complicit partner; the baby's hands caress the flesh that the young man desires. Only the man's hand, so suggestively flexed in the Tate Gallery version, retains the sexual tension with which the figure in the sketch is endowed.

The first version of *Brother and Sister* (XXXVI) was begun in 1835 and exhibited in 1837. The second version which bore the title *The Younger Brother* (61) was commissioned by Robert Vernon but not completed until eight years after his death. Contemporary critics noted that it had been 'long on Mr. Mulready's easel . . . and cost him much anxiety' and suggested that parts of it had been painted from photographs.[14] Both paintings are brilliantly constructed around a back view (a favourite motif in Mulready) perhaps inspired by Michelangelo's *Judith* in the Sistine ceiling or by a similar figure in Raphael's *Mass at Bolsena*. The earlier version in particular demonstrates an extraordinary coherence of paint surface and composition, the spiralling, turning movement of the group being reiterated in every detail from the corn dolly rattle (which Mulready had already used in *Interior of an English Cottage*) to the apron strings and ringlets of the young woman. Paint is handled in a fluid manner that produces overall an extraordinary effect of movement. The peculiarly clinging and liquid drapery style that Mulready here achieved with virtuoso effect suggests an acquaintance with the Panatheneic frieze of the Elgin marbles.

But despite the timeless, classifying forms in which it is presented here, the erotic is nonetheless historically determined. By the early nineteenth century it was common

[10] See ch. IV
[11] Victoria and Albert Museum 6385, Rorimer, 354
[12] Whitworth Art Gallery, D96
[13] 'Is it not sorrowful,' asked Ruskin, 'to see all this labour and artistical knowledge appointed . . . to paint . . . for the perpetual possession and contemplation of the English people, the ill-laced bodice of an untidy girl,' J. Ruskin, 'Academy Notes', 1857, *The Works*, XIV, 100–2
[14] *Art Journal*, 1857, p. 168

in rural areas for marriages to take place early because, just as with today's council housing, independent accommodation was almost unobtainable for the young unless they were married.[15] The old saying 'No child, no wife' remained throughout the period an important indicator with many women becoming pregnant before marriage, a practice accepted by the community. The massive interference into the conduct of rural families and the horrifying measures adopted to regulate what were imagined to be immoral practices among the rural population by Victorian administrators have been charted by Snell.[16] Rowland Hill, with whom Mulready was to collaborate over the postal envelope was one reformer who advocated extreme forms of control to counter early marriages and limit population growth.[17] Whilst Mulready created an erotic English rural idyll for an urban audience, unmarried women in labour were forcibly removed across Parish boundaries and government officials planned segregated colonies to prevent copulation among the rural poor.

Mulready does not altogether avoid identifiable categories of work or classes of subject in his rural paintings though they are frequently ambiguous and by and large it is a non-labouring, non-specific figure in a non-arable (non-Georgic) landscape that we should expect. Nevertheless *Fair Time (Returning from the Ale House)* (57), c.1808–9 and 1840, which was not liked by critics and which may have been associated with the temperance movement,[18] does present a detailed group in a village environment with an agricultural background. Mulready did not repeat the experiment. *Returning from the Hustings* (two men and a woman lifting a third man who is drunk over a stile) and painted in 1829–30 (R.A. 1830) must certainly be related to the Reform Bill of 1832 though it is by no means clear whose side Mulready was on. Two of his patrons, Lord Grey and Sir John Swinburne, were active in the reform movement but the image of popular democracy that Mulready presents could be an argument against corruption and for reform, or against extending the franchise and therefore against reform.

Mulready's most elaborate essay in the Rural was the painting now known as *Interior of an English Cottage* (XXXII) painted on commission for King George IV in 1828. When he was working on it Mulready referred to it as 'Game-

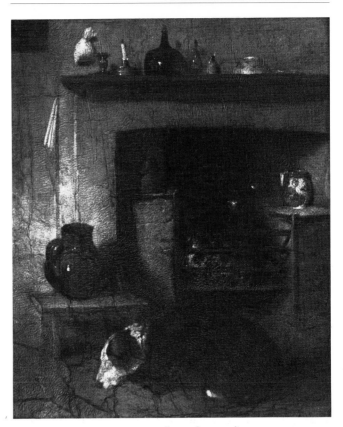

92. THE KITCHEN FIRE, *private collection* (cat. 154)

keeper's Wife' and the artist's family knew it as 'The Gamekeeper's Return'. As with *Train up a child . . .* (XXI)[19] the shift in title opens up for us a glimpse of the painting's interrogation of its own history. Gamekeepers were a hated class of people among the rural poor for they were the arm of the oppressive landowner and traitors to their own class. The game laws, along with enclosures, created more disaffection and were identified as the cause of more misery than any other curtailments of what were seen as people's natural rights.[20] Although the theme of the painting depends on knowledge of this, Mulready discarded the topical title thus reinforcing the painting's affirmation of an orthodox power structure and removing it from an arena of criticism of the contemporary.

[15] K.D.M. Snell, op. cit., p. 350
[16] Ibid, pp. 352–365
[17] Under the title of 'Home Colonies' he published in 1832 a 'plan for the gradual extinction of pauperism and the diminution of crime'. This was followed by a letter to Lord Brougham, see *Dictionary of National Biography*
[18] K.H., p. 81
[19] See ch. III
[20] E.J. Hobsbawm and G. Rudé, *Captain Swing* (1960), 1985, pp. 56–7, p. 246

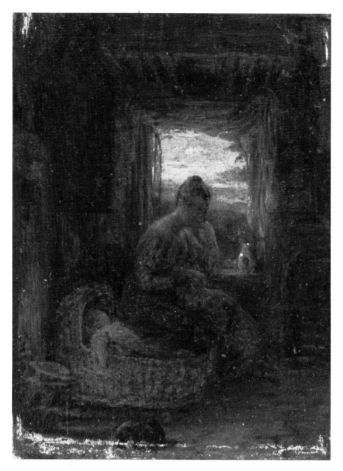

93. INTERIOR OF AN ENGLISH COTTAGE, *Trustees of the Tate Gallery* (cat. 157)

As a precursor of Victorian 'waiting' paintings in which woman is the sorrowful, patient and passive witness to male acts of service (Frank Bramley's *A Hopeless Dawn* of 1888 is a prime example) Mulready's *Interior* of an English Cottage is unparalleled.[21] The dawn is breaking over a high heathland and, on the far horizon the figure of the gamekeeper appears waving his arm. In the middle distance his dog sees him. But his wife who, having placed her husband's slippers by the fire she has carefully maintained, does not yet know that her anxious vigil is at an end. Finely sculpted against the window frame and with an expression of dignified suffering she rests a hand on the head of her daughter who has fallen asleep with her book in her hand, and looks across the room where a younger child has fallen asleep on the top of his cradle. Supper from the night before lies on the table. The group of mother

and child imitates the Antique group of Niobe and her Daughter in the Uffizzi whilst the rich scumbled colour is a reminder of Mulready's seeking after a Venetian tonality. The way in which the eye progresses across light enhanced objects: the rattle on the floor, the girl's shoulders, the eggs on the window sill and the dog to attain and recognise the gamekeeper's figure is masterly. We, the spectators, thus witness what she has yet to acknowledge and we are obliged to negotiate her anxiety in order to reach the cheerfully waving figure.

The interior is warm, well-furnished and comfortable. The fireplace that is the hidden source for the interior glow that matches the glow of the rising sun is a repeated motif in Mulready's work and has important associations with the pastoral. 'Here is the hearth, logs rich in resin, a big fire all the time, and doorposts blackened by constant smoke. We care as little here about the North Wind and the cold as a wolf cares for numbers, or rivers for their banks in time of spate,' says Corydon to Thyrsis in Virgil's Eclogue VII. The fire features prominently in *A Carpenter's Shop and Kitchen* (1808) (67) as well as in *Father and Child* (1828–30) (XIV) where (as in Wilkie's *The Blind Fiddler*) it provides a focus of domestic warmth. Mulready also painted a small panel *The Kitchen Fire* (1811) (92) which according to an old label on the back represents Mulready's own kitchen fire and his old dog. Whilst the formal origin for the motif must lie with the fireside scenes of Dou or Van Brekelenkam it is clear that for Mulready it was a powerful emblem of the domestic. The interior is also, however, oppressive; the storage rack already mentioned and the fireplace to the left and table to the right, crowd us in and render even more sudden the opening rectangle of the window which, with its looped curtain, is revealed as though it were a painting over which a drapery has been hung.

The cartoon in the Victoria and Albert Museum[22] (94) is measured up and inscribed *Ver line* (line of truth?) revealing how carefully the artist constructed this box-like space with its single vanishing point between the

[21] It is worth noting that the engravings after the painting were also given different titles: C. Cousen after Mulready 'The Home Expected' and F. Engleheart after Mulready 'The Anxious Wife'
[22] 6304, Rorimer, 80

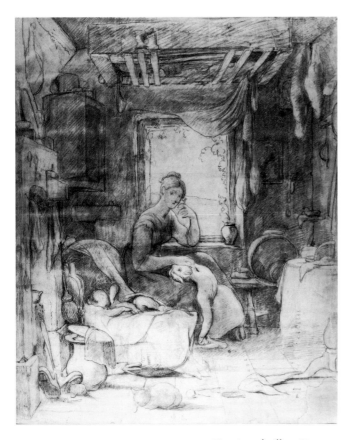

94. INTERIOR OF AN ENGLISH COTTAGE, *Victoria and Albert Museum* (cat. 158)

gamekeeper's figure and that of his wife. Along with the oil sketch (93) it also reveals that Mulready discarded a plant growing in a pot on the windowsill and a climbing shrub on the outside wall of the cottage that would have mediated the transition from inside to outside that is finally so very abrupt. As finally exhibited the painting rigidly separates the female sphere from the male (inside is warmth, passivity, fecundity and provision; outside is open-air, activity and danger). It thus actively produces meanings around gender difference that had profound ideological effects in an age when rural labouring women worked alongside men in all manner of occupations and percentages of female apprenticeships did not fall substantially short of male.[23] The empirical explanation for the abrupt transition from inside to out is that we are dealing here with an unglazed, unshuttered window that has been left open. In fact the size of the window is disproportionate and, with the woman's head seen against it, there is

presented to us a calculated piece of artifice in which one realism (open air, man's space, the countryside) vies with another (the interior, the fireside, woman's space). Those devices that would have helped to negotiate the gap between them have been denied us.

The motif of the window on Nature is reintroduced in 1835 in *The Last In* (XVII) where again the overhanging storage rack creates a claustrophobic effect. This time the window is even more startling in so far as it has the effect of a slightly curved top like a picture frame and is so large that all pretence at plausibility is abandoned. The composition itself is highly formalised with a child dead centre foreground and other figures arranged against the axis provided by the child's back (marked out by details like the string that hangs from his belt and the parting of his hair), the edge of the desk and the tree.

On a narrative level it is easy to see how the outside is more tempting than the inside, how education is really to be had among trees and mossy boulders rather than among slates and schoolroom chalk though, as we have seen, Mulready's position on education in so far as it might be inferred from his paintings is by no means clear-cut.[24] The question of conflicting realisms crops up again here. If we are to believe the chipped flagstones of the foreground how can we be convinced of the beechwood in the picture window? Having constructed a social narrative, Mulready undermines it by invoking in vivid form and confined within a rectangular frame, a glimpse that promises much more, a world of nature in which schoolroom antics have no part.

The dialogue between the social and the natural is taken further in what is undoubtedly the most puzzling of Mulready's works, *Interior: an Artist's Study* of 1840 (95). Here we have another young man whose face we are not permitted to see engaged in an intimate dialogue with a young woman provocatively dressed. Nor are we permitted to see what is inscribed on the canvas that stands in an elaborate gilt frame upon an easel or what is in the painting that hangs on the wall to the left of the window. The bringing together of child, canvas and nature seems on one level to make this a painting concerning art, artifice

[23] See K.D.M. Snell, op. cit., ch. VI
[24] See ch. III

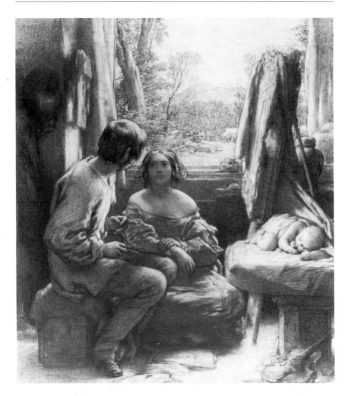

95. AN INTERIOR: AN ARTIST'S STUDY, *Manchester City Art Galleries* (cat. 159)

and nature, an inquiry into Realism and Naturalism, the tutored and the untutored, nature and nurture, in the manner of Courbet's *Atelier du Peintre*. But nothing is clear and Mulready offers us no verbal explanation. He was nearing the end of his innovative painting career in 1840 and he chose at this moment to create a complex scene that is not explicable except by reference to allegory, symbol and the subconscious. One thing seems sure, however, that this exquisitely executed chalk and pencil drawing (the painting is lost) must be an immensely personal document.

If art is a window onto nature, then we have here a window opening onto a second window which offers us a fragment of uninhabited 'pure' nature. We, the spectators, looking at the artist's studio as though through a window unobserved cannot 'read' the result of that artist's practice but are impelled to look on nature. The signs of artifice and creativity are lined up: the Chinese vase, the carved gothic slab on which the baby sleeps, the abandoned violin. The baby is the correlative of the world of nature and the

artist, tense and faceless but adored by his nubile wife through whose expression we must approach him, controls that world with the instrument of his creativity, his projectile finger/brush/phallus. It is useless to ask what story is being told as this is not an overtly narrative drawing. Babies do not sleep on cold stone slabs draped with cloths that also cover paintings. Framed pictures are rarely worked upon on the easel. Even studios seldom had windows that size and in that position and artists, in the main, lived in towns or cities. Mulready's Kensington was by this date a network of streets and houses.[25]

Thinking back to how different the scene must have been in the studio when Mulready was a young artist with a wife and several small children, we are struck by the eager forward thrust of the artist seated on his trunk, by the disjuncture that places him opposite the baby instead of opposite the canvas, by the sacrificial quality of this pale, corpse-like child and by the sheer aching desire expressed for this oft-repeated emblem of the natural, this square of trees and hillside now partly obscured by heads and by the corner of the canvas. We conclude that in the final exercise of ruralism Mulready was telling the story of his professional and spiritual life.

[25] See ch. 1

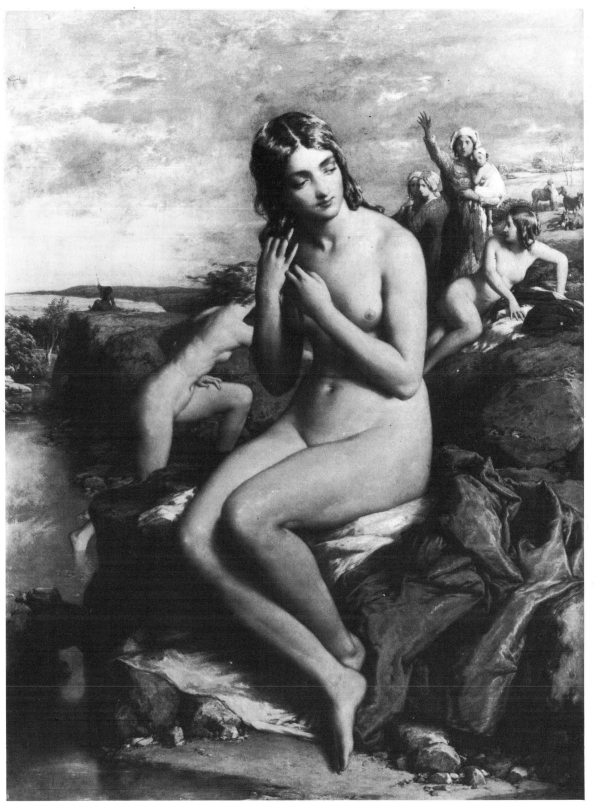

96. BATHERS SURPRISED, *National Gallery of Ireland* (cat. 145)

SECTION V
RURALISM AND ITS DISCONTENTS

'The poor live pleasantly without our help'.
Dr Primrose in Goldsmith's THE VICAR
OF WAKEFIELD

146

A MARKET GIRL, 1804
Watercolour, $9\frac{1}{2} \times 6\frac{7}{8}$ in
Private collection (89)

This very early dated watercolour of a bare-footed country girl on a road with an empty basket suggests a competence with the medium and an interest in rustic subjects such as we find in the work of Joshua Cristall, 1767–1847. The costume is precise though whether or not the young woman is begging is unclear. This modest work is of particular interest as a unique example of a single rustic figure in Mulready's signed work and as a rare indication of his youthful performance outside of the field of book illustration. See 120 and 121. *The Rattle*, Mulready's earliest extant oil painting is signed and dated 1808, see 100.

147

A MARKET GIRL, c.1804
Oil on paper laid down on card,
$7\frac{1}{16} \times 3\frac{1}{16}$ in
Wolverhampton Art Gallery

The attribution is traditional but, in view of Mulready's style and subject matter as indicated by *Horses Baiting* of 1810, 151, it is convincing.

148

AN OLD GABLE, 1809
Oil on panel, $16\frac{3}{4} \times 13\frac{1}{8}$ in
Yale Center for British Art, Paul Mellon Collection

The rural for Mulready in these early years was constituted by an essay in Picturesque architecture enlivened by human narrative. The event depicted is reminiscent of George Morland.

149

FAIR TIME, 1808–9 AND 1840
Oil on canvas, 31×26 in
Trustees of the Tate Gallery (57)

Exhibited in 1809 as *Returning from the Ale House*, this painting has a complicated history. The background was probably repainted in 1817, it remained with the artist until 1840 when Robert Vernon payed £420 for it and when it was re-exhibited at the Royal Academy with the title *Fair Time*. The change of title is significant; this Van Ostade like scene of rural drunkenness touched on the raw sensibilities of an urban audience in 1809 but by 1840 it was possible to view it as offering merely a quaint glimpse of old England.

150

A SEA SHORE, 1809
Oil on canvas, $14\frac{3}{4} \times 19\frac{3}{4}$ in
Trustees of the Tate Gallery (5)

A signature and date are said to have been visible on the sail but can no longer be seen. This is the only known painting of a sea-shore scene by Mulready. He appears here to have been interested chiefly in the narrative and human aspects of the scene – notice the figures swimming – and in this respect the work is divergent from that of Augustus Wall Callcott who was a friend of the artist at this time and who specialised in marine subjects.

151

HORSES BAITING, 1810
Oil on panel, $15\frac{3}{4} \times 13$ in
Whitworth Art Gallery, Manchester (19)

The scene is a roadside inn where horses are being fed or baited. Subject and tonality are both suggestive of Wouwerman but the in-

fluence of Morland and Gainsborough is also evident. A touch that is peculiarly Mulready's is introduced with the distant stocky figure of the shepherd disappearing into the mist at the right. The knobbly trees, at the foot of which stands a similarly knobbly man, are a focus of attention and contrast sharply with the feathery outlines of the background trees. A work like this indicates that Mulready, by the age of twenty-four, was familiar with the conventions of representing the rural from the previous two centuries.

152

SNOW SCENE (attrib. Mulready), c.1811

Oil on panel, $12 \times 17\frac{3}{8}$ in

Trustees of the Tate Gallery

The early history of this work is unknown but, whilst no other snow scenes by Mulready are known, the traditional attribution is plausible. The foreground group of figures is very close to those in the artist's early cottage subjects and it is probably a further example of the Dutch influence on Mulready in these early years.

153

GIPSY ENCAMPMENT, 1810

Oil on canvas, $12\frac{1}{2} \times 16$ in

National Gallery of Ireland, Dublin (15)

A gipsy bender tent, a cart on its end and a family group eating supper round a fire under a blasted tree make up the central feature of the composition. But much attention is devoted also to the varied texture of the landscape and the late evening light that falls on the tent and the child's back. While there are similarities here with Morland, one thinks for example of his *Gipsies* in the Hermitage, Leningrad, the sympathetic narrative detail and the refined paint surface make this the simplest yet most sophisticated of Mulready's early rural subjects. This directness was virtually abandoned after 1812 and the rural is taken up again from the late 'twenties with very different results.

154

THE KITCHEN FIRE, 1811

Oil on panel, $7\frac{7}{10} \times 6\frac{4}{10}$ in

Private collection (92)

An old label on the reverse indicates that this is Mulready's own kitchen fire and his old dog who reappears in a number of Mulready's other paintings, e.g. 132. The hearth with its glowing coals and its mantelpiece of familiar objects is an essential component in the construction of the rural interior and an emblem of security. It appears notably in *Father and Child* but is also a significant, though implied, motif in *Interior of an English Cottage*. See 158, 159.

155

INTERIOR OF A HERD'S HOUSE, MOUNCES, 1814

Pencil, $10\frac{3}{4} \times 15$ in

Trustees of the British Museum (25)

Mounces Knowe was in Northumberland not far from Sir John Swinburne's seat at Capheaton Hall, see 6. This drawing is a rare example in Mulready's enormous output of drawings of a rural interior studied in detail with precision. Some of the features recorded here were subsequently incorporated into *Interior of an English Cottage*, see 158 and 159.

156

BOYS FISHING, 1813

Oil on canvas, $30\frac{1}{2} \times 26$ in

Exhibited by kind permission of His Grace the Duke of Westminster, DL (27)

Mulready can be seen here to be exploring a combination between a finished landscape and a group of rustic figures. This painting comes close in style and treatment to Callcott's work of this period but, most interesting is the fact that in 1813 Constable also painted a *Boys Fishing*, now in the collection of the National Trust at Anglesey Abbey. There are similarities between the two in composition. However, whilst the distant cart on the bridge is suggestive of labour, Mulready's rural subjects do not in any real sense address the question of work.

157

INTERIOR OF AN ENGLISH COTTAGE, 1828

Oil on panel, sketch, $3\frac{1}{4} \times 2\frac{3}{4}$ in

Trustees of the Tate Gallery (93)

This is the oil study for the painting now in the Royal collection. It was referred to by the artist in his account book as 'the Gamekeeper's wife'. The change of title suggests that Mulready wished to distance his most elaborate essay in ruralism from any contemporary associations. The direct depiction of figures in landscape and the concern with the vernacular that are seen in nos. 151, 153 and 156 are here replaced by a complex narrative about rural types overlaid with heavy moral implications. The gamekeeper's wife, having sat up all night, has not yet seen her husband's figure which appears over the horizon. Gamekeepers were much resented by the rural population at the time and this may be one reason for the change in title. The painting employs the window construction that Mulready had used so effectively in *The Last In*, 98 and would use again in *Interior: an Artist's Study*, 159.

158

INTERIOR OF AN ENGLISH COTTAGE, 1828

Drawing in chalk, $24 \times 19\frac{1}{2}$ in

Victoria and Albert Museum (6304) (94)

This drawing, inscribed with the words 'ver line' or true line is measured up in order to establish a precisely constructed box-like perspectival space. It is typical of the rigid control and organisation of Mulready's treatment of rural themes after the late 'twenties.

159

AN INTERIOR: AN ARTIST'S STUDY, c.1840

Red chalk cartoon, $15\frac{1}{2} \times 13\frac{3}{4}$ in

Manchester City Art Galleries (95)

In this extraordinary, highly finished and enigmatic work, nature is framed and viewed

across an interior. In this respect it is similar to *The Last In* and *Interior of an English Cottage*, 98 and 157. But now the narrative in the foreground explicitly addresses the practice of Art. Deference to forms of realism is discarded and the work, mannerist in its handling and in its allegorical overtones, encapsulates the uninhabited rural as a perfect view framed for consumption by the audience but ignored by the artist and his wife.

160

THE SONNET, 1839
Oil on panel, 14×12 in
Victoria and Albert Museum (XXXIV)

One of Mulready's most popular and most brilliantly executed paintings, *The Sonnet* offers a synthesis of the arcadian tradition in literature and the Grand Style in painting. There are overtones from the monumental figures of Michelangelo's Sistine ceiling as well as a precisely delineated but non-specific landscape background. In so far as the narrative involves courtship, rural types who are definitely not workers, and poetry it offers an early Victorian re-working of Virgilian pastoral.

161

THE SONNET,
Pencil and red chalk cartoon,
$14\frac{1}{4} \times 11\frac{7}{8}$ in
National Gallery of Ireland, Dublin
A highly finished study for no. 160.

162

CROSSING THE FORD, 1842
Oil on panel, $23\frac{7}{8} \times 19\frac{3}{4}$ in
Trustees of the Tate Gallery (90)

Here Mulready brings together the theme of courtship and the idea of the Rustic, a synthesis that was well-established in literary convention. The rocky upland and the fluid treatment of elegantly crumpled drapery and thick foliage are typical of Mulready's approach to rural themes in these late years, see 160 and constitute key components in

the construction of a rural idyll that contrasts sharply with a painting like *An Old Gable* of thirty-one years earlier, 148.

163

HAYMAKING, 1846–7
Oil on panel, $23\frac{7}{8} \times 19\frac{3}{4}$ in
Lord Northbrook (XXXIII)

This scene based on Mulready's plate for *The Vicar of Wakefield*, shows Burchell assisting Sophia observed by the vicar who sits with his wife at the right. In the distance boys romping and a couple separated in their work can be seen. These subsidiary figures offer, as with *The Seven Ages of Man*, 118, a continuous narrative of the stages of life. This painting of rural courtship supported by a much-loved literary text was enormously popular. This was not only on account of its brilliant execution and the familiarity of its subject but also because it established clear connections with the rococo idyll of the countryside. For an urban mid-century audience this eighteenth-century costume piece fixed the rural as a historic and literary topos remote from the problematic of country versus city that troubled early Victorian society. The archaism of this interpretation of the rural is reinforced by the fact that the figure of Sophia is extremely close to one of the haymakers in William Henry Pyne's *Microcosm*, a compendium of figures for artists working on landscapes, published in 1808.

164

O. GOLDSMITH
THE VICAR OF WAKEFIELD, 1843
Victoria and Albert Museum

This edition of Goldsmith's famous novel was published in 1843 by Van Voorst and lavishly illustrated by Mulready. By the time Mulready came to the text it had been frequently illustrated and was already the most popular literary source for artists exhibiting at the Royal Academy. Bewick, Stothard, Rowlandson and many other artists had interpreted the text. The success of Mulready's illustrations, which make great capital out of

the vicar's large family of children, led to commissions for paintings. See 139, 141 and 163.

165

FELIX SUMMERLY MILK JUG WITH HAYMAKING SCENE, c.1847
Mrs Peter Hardwick

Henry Cole, under the name of Felix Summerley, initiated a project in 1847 for associating the best art with 'familiar objects in daily use.' He was more successful here than he had been with the Mulready postal envelope. See 125. Negotiations were underway in 1847 for Mulready's *Haymaking*, see 163, to be painted on a Copeland vase. No such vase is known but this jug well illustrates the aims of Summerley's art manufactures and should be seen as one component in a concerted early Victorian campaign to spread 'Taste' to the masses.

166

GRAY'S ELEGY, 1824
Pen and ink, $4\frac{1}{2} \times 3$ in
Mrs Peter Hardwick

Thomas Gray's 'Elegy written in a Country Churchyard' had long been popular with artists and illustrators but it is typical of Mulready's ambivalence towards rural subject matter that in this one known illustration to the best-loved rural poem in the canon he eschews the 'ivy mantled tower', the 'rugged elms' and 'lowing herds'. Instead he addresses the poem's moral core. The scene of corruption, 'the struggling pangs of conscience', that he chooses to represent is precisely what Gray's 'rude forefathers' have managed to avoid. Mulready here deals, albeit obliquely, with that very divide between city and country that so much concerned his contemporaries and which nowhere appears overtly in his paintings. The drawing is dedicated to John Linnell who, more than anyone, must have known Mulready's own 'struggling pangs of conscience'. Executed in the same year as *The Widow* was exhibited, and denounced, this slight drawing embodies a depth of personal pessimism.

98. PREPARATORY DRAWING FOR THE POSTAL ENVELOPE, *John E.C. Stone, Esq.* (cat. 125g)

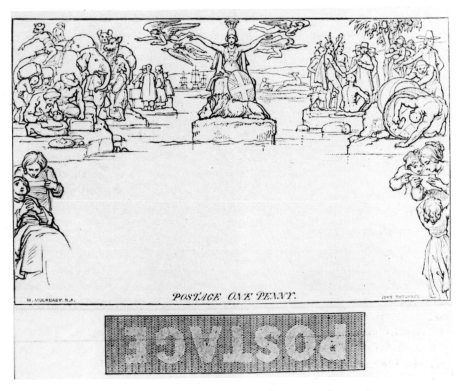

99. CARICATURE OF THE POSTAL ENVELOPE, RELIGIOUS TOLERANCE, *National Postal Museum* (cat. 125p)

97. THE MULREADY POSTAL ENVELOPE, *Victoria and Albert Museum* (cat. 125)

167

MOXON'S TENNYSON, 1857
Victoria and Albert Museum (84)
This was the edition of Tennyson's poems to which members of the Pre-Raphaelite Brotherhood contributed. Mulready was responsible for four illustrations and the most successful is undoubtedly the witty vernacular accompaniment to 'Will Waterproof's Lyrical Monologue'. He received £21 for each plate.

168

FREDERICK BACON BARWELL
PORTRAIT OF MULREADY
Oil on canvas, $39\frac{3}{4} \times 60$ in
Victoria and Albert Museum (40)

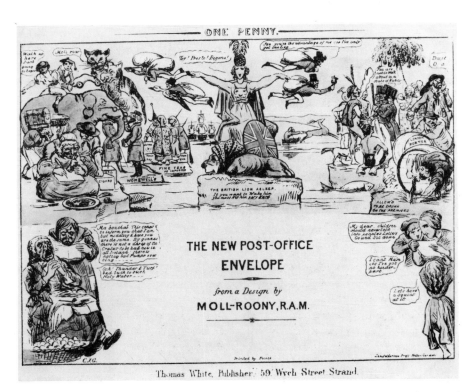

100. CARICATURE OF THE POSTAL ENVELOPE, MOLL-ROONY, *National Postal Museum* (cat. 125r)

EPILOGUE

The season's paintings do not please, Gentlemen,
Like Etty, Mulready, Maclise;
Throbbing romance has waned and wanned;
No wizard wields the witching pen
Of Bulwer, Scott, Dumas and Sand, Gentlemen.

Thomas Hardy
An Ancient to Ancients, 1922

Books and Articles Consulted

(For unpublished and Manuscript sources, see notes)

E. Adams, *Francis Danby: Varieties of Poetic Landscape*, 1973

The Amberley Papers, ed. B. and P. Russell, 1937

W. Ames, *Prince Albert and Victorian Taste*, 1967

Annals of the Fine Arts, 5 vols, 1817–20

F. Antal, *Classicism and Romanticism*, 1966

P. Ariès, *Centuries of Childhood*, Harmondsworth, 1962 (First ed. Paris, 1960)

Sir W. Armstrong, *Art in Great Britain and Ireland*, 1909

B. Arnold, *A Concise Dictionary of Irish Art*, 1969

The Art Journal

The Athenaeum

O. Aubrat, *La Peinture de Genre en Angleterre de la Mort de Hogarth . . . au Préraphaélisme*, Paris, n.d.

J. Barrell, *The dark side of the landscape: the rural poor in English painting, 1736–1840*, Cambridge, 1980

R. Barthes, *Image Music Text* (1977), 1982

P. Bate, *The English Pre-Raphaelites, Their Associates and Successors*, 1910

C. Bell, *The Children's Mirror*, 1859

T.S.R. Boase, *English Art 1800–1870*, Oxford, 1959

T. Bodkin, 'Two English Drawings', *Miscellanea Leo Van Puyvelde*, Brussels, 1949

T. Bodkin, 'William Mulready R.A.', *The Dublin Magazine*, December, 1923

W. Blunt, *The Art of Botanical Illustration*, 1950

Boxiana, or Sketches of Ancient and Modern Pugilism, by one of the Fancy (P. Egan), 1812

A. Brookner, *Greuze*, 1972

D.B. Brown, *Augustus Wall Callcott*, The Tate Gallery, 1981

The Diary of Ford Madox Brown, ed. V. Surtees, 1981

F.K. Brown, *The Life of William Godwin*, 1926

Dr. M. Bryan, *A Biographical and Critical Dictionary of Painters*, 1873

J. Burnet, *The Progress of a Painter*, 1854

J.W. Buxton, *English Painters*, 1883

E.B. Chancellor, *Walks among London's Pictures*, 1910

B. Charlton (née Tasburgh), *The Recollections of a Northumbrian Lady, 1815–1866*, ed. L.E.O. Charlton, 1949

The Child's Remembrancer, Religious Tract Society, 1817

The Child's True Friend, 1808

Sir H. Cole, k.c.b., *Fifty Years of Public Work*, 1884

John Constable's Correspondence, Ipswich: Suffolk Records Society; III, 1965; IV, 1966; V, 1967

O. Cook, *Movement in Two Dimensions*, 1963

C.W. Cope, *Reminiscences*, 1891

M.C. Cowling, 'The Artist as anthropologist in mid-Victorian England . . .', *Art History*, December 1983

A. Cunningham, *Life of Sir David Wilkie*, 1843

J. Dafforne, *Pictures by William Mulready RA*, 1872

E. Dayes, *The Works of the Late Edward Dayes, containing an excursion through the principal parts of Derbyshire and Yorkshire, . . .* 1805

W.F. Dickes, *The Norwich School of Painting*, London and Norwich, 1905

D. Diderot, *Salons*, eds. J. Seznec and J. Adhémar, 1957

Lady Dilke, *The Book of the Spiritual Life*, 1905

Lady Eastlake, *Journals and Correspondence*, ed. Charles Eastlake Smith, 1895

P. Egan, See *Boxiana*

Encyclopaedia Britannica, 11th ed. 1810–11

Major E.B. Evans, *A Description of the Mulready Envelope and of Various Imitations and Caricatures of its Design*, 1891 (facsimile reprint, 1970)

Fables Ancient and Modern, preface by E. Baldwin (W. Godwin), 1805

The Diary of Joseph Farington, eds. K. Garlick, A. Macintyre, K. Cave, New Haven and London, 1978–84

D. Farr, *William Etty*, 1958

Fine Arts Quarterly Review

H.R. Fletcher, *The Story of the Royal Horticultural Society 1804–1968*, Oxford, 1969

M. FOUCAULT, *The Order of Things* (1966) 1970

C. FOX, 'The Engravers' Battle for Professional Recognition in Early Nineteenth Century London'; *London Journal*, II, no 1, June 1976

W.E. FREDEMAN, *Pre-Raphaelitism: A Bibliographical Study*, Cambridge, Mass. 1965

W.P. FRITH, *My Autobiography and Reminiscences*, 1887 (5th ed. 1888)

H. FURBER, *John Company at Work: A Study of European Expansion in India in the late eighteenth Century*, New York, 1970

N. GASH, *Peel*, 1976

T. GAUTIER, *Les Beaux-Arts en Europe*, Paris 1855

The Gentleman's Magazine

A. GILCHRIST, *Life of William Blake*, 1880

W. GODWIN, *The Enquirer: Reflections on Education, Manners and Literature*, 1797, facsimile, ed. A.M. Kelly, New York, 1965

E.H. GOMBRICH, *Art and Illusion: A Study in the Psychology of Pictorial Representation*, 1960

Col. M.H. GRANT, *Old English Landscape Painters*, 1925–47

A. GRAVES, *Art Sales from early in the eighteenth century to early in the twentieth century*, 1918–21

A. GRAVES, *The British Institution, 1806–67*, 1908

A. GRAVES, *A Century of Loan Exhibitions, 1813–1912*, 1913–15

A. GRAVES, *The Royal Academy of Arts . . . 1905–6*

G. GRIGSON, 'The Drawings of William Mulready', *Image*, 1949

G. GRIGSON, 'Gordale Scar to the Pre-Raphaelites', *The Listener*, 1 January 1948

R.G. GRYLLS, *William Godwin and his Circle*, 1953

S.C. HALL, *Retrospect of a Long Life from 1815 to 1883*, 1883

H. HAMMELMAN and T.S.R. BOASE, *Book Illustration in Eighteenth Century England*, New Haven and London, 1975

P.G. HAMERTON, *The Graphic Arts A Treatise on the Varieties of Drawing, Painting and Engraving . . .*, 1882

M. HARDIE, *Watercolour Painting in Britain*, 1967

J.F.C. HARRISON, *Early Victorian Britain 1832–51*, 1979

F. HASKELL, *Rediscoveries in Art: Some Aspects of Taste, Fashion and Collecting in England and France*, 1976

B.R. HAYDON, *Diary*, ed. W.B. Pope, Cambridge, Mass., 1960

V. HEATH, *Vernon Heath's Recollections*, 1892

K.M. HELENIAK, *William Mulready*, 1980

K.M. HELENIAK, 'William Mulready, R.A. (1786–1863) and the Society of Arts', *Journal of the Royal Society for the Encouragement of Arts, Manufactures and Commerce*, July, August and September 1976.

(J.P. HESELTINE), *John Varley and His Pupils W. Mulready, J. Linnell, and W. Hunt: Original Drawings in the Collection of J.P.H.*, 1918

E.J. HOBSBAWM and G. RUDÉ, *Captain Swing* (1969), 1985

The Hive of Ancient and Modern Literature, 1806

J.E. HODGSON and F.A. EATON, *The Royal Academy and its Members 1768–1830*, 1905

J.C. HORSLEY, R.A. *Recollections of a Royal Academician*, ed. Mrs E. Helps

F.M. HUEFFER, *Ford Madox Brown: A Record of His Life and Work*, 1896

W. HOLMAN HUNT, *Pre-Raphaelitism and the Pre-Raphaelite Brotherhood*, 1905

S. HUTCHISON, *The History of the Royal Academy, 1768–1968*, 1968

C.J. KALDENBACH, 'Perspective Views', *Print Quarterly*, June 1985

M. KAUFFMANN, *John Varley (1778–1842)*, 1984

S.D. KITSON, *The Life of John Sell Cotman*, 1937

E. KRIS and O. KURZ, *Legend, Myth and Magic in the Image of the Artist*, Westford, Mass., 1979

Mrs D. LEITH, *The Boyhood of Algernon Charles Swinburne . . .*, 1917

C.R. LESLIE, *Autobiographical Recollections*, 1860

C.R. LESLIE, *Handbook for Young Painters*, 1855 (2nd ed. 1870).

R. LIEBREICH, M.D., *Turner and Mulready: the effect of certain faults of vision on painting with especial reference to their works*, 1888

John Linnell: A Centennial Exhibition, selected and catalogued by K. Crouan, Fitzwilliam Museum, Cambridge and Yale Center for British Art, 1982–3

W.C. MACPHERSON, *Soldiering in India, 1764–1787*, 1928

P.E. MALCOLMSON, 'Getting a Living in the Slums of Victorian Kensington', *The London Journal*, I, 1 May 1975

Manchester Art Treasures, official exhibition catalogue, 1857

T. MARCLIFFE (W. GODWIN), *The Looking Glass . . .*, 1805

J.J. MAYOUX, *La Peinture Anglaise de Hogarth aux Pre-Raphaelites*, Geneva, 1972

DR. H. MIREUR, *Dictionnaire des Ventes d'Art en France et à l'Etranger pendant les XVIIIᵉ and XIXᵉ siècles*, Paris 1911

C. MONKHOUSE, *Earlier English Water-colour Painters*, 1897

NORWICH CASTLE MUSEUM, *A Decade of English Naturalism, 1810–1820*, 1969–70

H. OTTLEY, *A Biographical and Critical Dictionary of Recent and Living Painters and Engravers* (supplement to Bryan), 1877

F.T. PALGRAVE, *Essays on Art*, 1866

The Letters of Samuel Palmer, ed. R. Lister, Oxford, 1974

C.K. PAUL, *William Godwin: His Friends and Contemporaries*, 1876

M. POINTON, 'William Mulready's "The Widow": a subject "unfit for pictorial representation" ', *The Burlington Magazine*, CXIX, no. 890, May 1977

M. POINTON, 'Painters and Pugilism in early nineteenth-century England', *Gazette des Beaux-Arts*, vi ème periode, XCII, October 1978.

M. POINTON, 'William Mulready and the art of pictorial narrative' *The Burlington Magazine*, no. 925, CXII, April 1980

M. POINTON, 'The benefits of patronage: a study of William Mulready and two of his patrons', *Gazette des Beaux-Arts*, September 1980

M. POINTON, 'Urban Narrative in the Early Art of William Mulready', I.B. Nadel and, F.S. Schwarzbach, eds., *Victorian Artists and the City*, New York, 1980

M. POINTON, ' "Voisins et alliés": the French and the British at the Exposition Universelle of 1855', *Journal of European Studies*, XI, 1981

M. PRAZ, *Conversation Pieces . . .*, 1971

J. PYE, *Patronage of British Art*, 1845

W.H. PYNE, *Microcosm or a picturesque delineation of the Arts, Agriculture, and Manufactures of Great Britain . . .*, 1806

G. REDFORD, F.R.C.S. *Art Sales*, 1888

R. REDGRAVE, *The Sheepshanks Gallery*, 1870

R. REDGRAVE, *A Memoir*, compiled from his diary by F.M. Redgrave, 1891

R. and S. REDGRAVE, *A Century of British Painters*, 1866

R. and S. REDGRAVE, *A Century of British Painters*, ed. R. Todd, 1946

R. and S. REDGRAVE, *A Dictionary of Arts of the English School*, 1878 (2nd ed.)

The Richmond Papers, ed. A.M.W. Stirling, 1926

H.C. ROBINSON, *Diary, Reminiscences and Correspondence*, 1872 (3rd ed.)

J.L. ROGET, *A History of the Old Watercolour Society*, 1891

A. RORIMER, *Drawings by William Mulready*, London: Victoria and Albert Museum, 1972

W.M. ROSSETTI, *Pre-Raphaelite Diaries and Letters*, 1900

ROYAL ACADEMY, *Report of the Commissioners appointed to inquire into the present position of the Royal Academy in relation to the Fine Arts . . .*, 1863–4, *British Parliamentary Papers*, Irish University Press Series, Education, Fine Arts, 5

J. RUSKIN, *The Works of John Ruskin*, ed. E.T. Cook and A. Wedderburn, 1903–1912

G.S. ROUSSEAU, *Goldsmith: the Critical Heritage*, London and Boston, 1974

W. SANDBY, *The History of the Royal Academy of Arts*, 1862

SCIENCE AND ART DEPARTMENT OF THE COMMITTEE OF COUNCIL ON EDUCATION, SOUTH KENSINGTON MUSEUM, *A Catalogue of the Drawings, Sketches, etc. of the late William Mulready, Esq. R.A. (1786–1864)* [sic], London 1864, annotated copy, Victoria and Albert Museum

H.I. SHAPIRO, *Ruskin in Italy*, Oxford, 1972

E. SHERSON, *London's Lost Theatres of the Nineteenth Century*, 1925

R. DE LA SIZERANNE, *La Peinture Anglaise Contemporaine*, Paris, 1895

J.T. SMITH, *Vagabondia*, 1817

K.D.M. SNELL, *Annals of the Labouring Poor: Social change and Agrarian England, 1660–1900*, Cambridge, 1985

A. STALEY, *The Pre-Raphaelite Landscape*, Oxford, 1973

A. STALEY (and F. CUMMINGS), *Romantic Art in Britain, Paintings and Drawings 1760–1860*

C. STEEDMAN, C. URWIN and V. WALKERDINE, *Language, Gender and Childhood*, 1985

J. STEEGMAN, *Victorian Taste . . .*, 1970 (first published as *Consort of Taste*, 1950)

F.G. STEPHENS, *Masterpieces of Mulready; Memorials of W. Mulready . . .*, 1867
Memorials of William Mulready, 1879 (revised edition)

MAJOR J.M.W. STONE, R.A.C.M. 'A Second Mulready Sketch', *Pre-Paid Postal Stationery and the Embossed Stamps of the Nineteenth Century*, notes issued by the National Postal Museum, London

A.T. STORY, *James Holmes and John Varley*, 1894

A.T. STORY, *The Life of John Linnell*, 1892

The Swinburne Letters, ed. C.Y. Lang, New Haven, 1960

B. TAYLOR, *Artists of the Victorian Age*, BBC Publications, 1974

R.V. TAYLOR, *Biographia Leodensis*, 1865–7

SIR C. TENNYSON and H. DYSON, *The Tennysons: Background to Genius*, 1974

H. TENNYSON, *Alfred Lord Tennyson: A Memoir*, 1897

W.H. THACKERAY, *Contributions to the Morning Chronicle*, ed. G.N. Ray, Urbana and London, 1966

D. THOMAS, 'Victorian Painting in England', *Antiques*, 94, November 1968

E.P. THOMPSON, *The Making of the English Working Class* (1963), 1982

W. THORNBURY, *The Life of J.M.W. Turner, R.A.*, 1862, revised and rewritten, 1877

The Times

CAPT. L. TROTTER, *History of India under Queen Victoria*, 1886

G. WAAGEN, *Treasures of Art in Great Britain*, 1854

T.G. WAINEWRIGHT, *Essays and Criticisms*, 1880

E. WALFORD, *Old and New London: A Narrative of its History, its people, and its Places*, 1892

J. WHALLEY, *Cobwebs to Catch Flies*, 1974

W.T. WHITLEY, *Art in England, 1800–1820*, Cambridge, 1928

W.T. WHITLEY, *Art in England, 1821–1837*, Cambridge, 1930

R.G. WILSON, *Gentlemen Merchants: the Merchant Community in Leeds, 1700–1830*, Manchester, 1971

C. WELSH (WILLIAM ROSCOE), *The Butterfly's Ball and the Grasshopper's Feast*, 1808

M. WOLLSTONECRAFT, *Vindication of the Rights of Woman*, 1792, Harmondsworth, 1982

A. WOOLNER, *Thomas Woolner, R.A. Sculptor and Poet. His Life in Letters*, 1917

INDEX

CT 109681 — 5ro
Ian Shipley £8.95 A